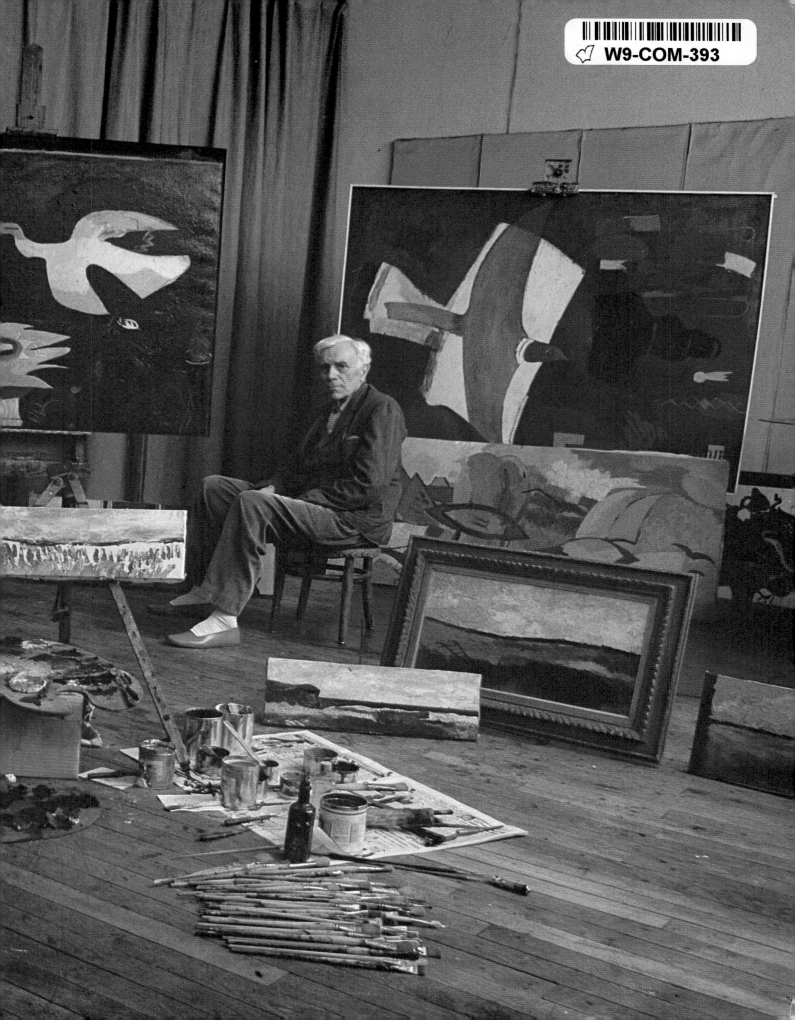

GEORGES BRAQUE

MODERN MASTERS

GEORGES BRAQUE

KAREN WILKIN

Abbeville Press · Publishers
New York · London · Paris

Georges Braque is volume fourteen in the Modern Masters series.

To my mother

ACKNOWLEDGMENTS: I would like to thank Vincent Barré for his invaluable part in carrying forward this project. Thanks are due, too, to John Golding and Quentin Laurens, for generously sharing information, and to Archie Rand, William Edward O'Reilly, and Donald Clinton for their encouragement, insights, and helpful advice. I am also indebted to Hilton Kramer and the *New Criterion* for the opportunity to test some of my ideas about Braque before the publication of this book. Special thanks to Nancy Grubb, as always, an editor of incomparable sympathy and expertise.

FRONT COVER: *Still Life—"Le Jour,"* 1929. See plate 54.
BACK COVER: *The Mauve Garden Chair,* 1947–60. See plate 72.
ENDPAPERS: Georges Braque in his Paris studio, 1956. Photographs by Alexander Liberman.
FRONTISPIECE: *My Bicycle,* 1941. Oil on canvas, 36¼ x 28⅜ in. (92 x 73 cm). Private collection.

Series design by Howard Morris
Editor: Nancy Grubb
Designer: Paul Chevannes
Picture Editor: Carol Haggerty
Production Manager: Dana Cole
Chronology, Exhibitions, Public Collections, and Selected Bibliography compiled by Carol Lowrey

Marginal numbers in the text refer to works illustrated in this volume.

Library of Congress Cataloging-in-Publication Data

Wilkin, Karen.
 Georges Braque / Karen Wilkin.

 p. cm. — (Modern master series, ISSN 0738-0429; v. 14)
 Includes bibliographical references and index.
 1. Braque, Georges, 1882–1963—Criticism and interpretation.
1. Braque, Georges, 1882–1963. 11. Title. 111. Series.
N6853.B7W53 1991 759.4—dc20 91-12247
ISBN 0-89659-944-2
ISBN 0-89659-947-7 (pbk.)

First edition, second printing

Contents

Introduction

Georges Braque is one of the best-known and least-understood painters of our century, a paradigmatic modernist who only now, more than a quarter-century after his death, is beginning to be evaluated accurately. Characterized variously as radical innovator or elegant stylist, as serene classicist or temperamental individualist, as Picasso's sidekick or as the grand old man of French painting, Braque has lacked neither attention nor admiration. Since at least the 1920s he has been regarded as an essential figure in the evolution of art in our time. Art history texts and museum installations have underlined his role as a vital collaborator in the modernist adventure, stressing, in particular, his intimate relationship with Pablo Picasso during the formative years of Cubism. The two artists' works are hung side by side more often than not, and the phrase "Picasso and Braque" recurs as though it stood for a single being. Braque himself may have encouraged the idea when he said that he and Picasso were "roped together like mountain climbers" during those crucial years, and there are famous stories told by each artist about mistaking the other's work for his own. While this has assured Braque's place in the history of twentieth-century art, it has made him seem less interesting and less important in his own right, and his real individuality and real strengths have not always been fully appreciated.

Conversely, if being linked with Picasso has in some ways diminished Braque, his position in his later years as elder statesman of French painting sometimes led to his work's being esteemed beyond its worth. Braque is unquestionably one of the giants of modern painting, but he produced many failed or weak pictures, often at the same time that he was making masterpieces. Problematic works occur more frequently toward the end of his life, when he was ill and feeble, but it is undeniable that at intervals after the late 1910s he produced ingratiating but second-rate works—pleasant but distinctly minor still lifes, tentative sculptures, uninspiring prints—that undiscriminating collectors have nonetheless found attractive. Acute eyes have always been able to distinguish between Braque's best and lesser works, but the uncritical acceptance of secondary

1. *The Blind*, 1954–61
Oil on canvas, 63¾ x 28⅜ in. (162 x 72 cm)
Galerie Louise Leiris, Paris

efforts has done little to enhance his reputation. Yet when Braque fails, he does so primarily in relation to the high standard set by his own finest work, and it is by his own highest level that he must be judged.

Braque is so clearly one of this century's great painters—quite apart from his historical importance—that it is sometimes difficult to remember that he never laid claim to the popular imagination. He was a quintessentially unspectacular artists' artist who led a life of exemplary dullness. There was no familial resistance to his wish to be a painter, no years of acute deprivation or struggle for recognition, no flight to exotic parts, no severed ear. Instead, there are charming anecdotes about his sturdy good looks, his prowess as an amateur boxer, his strength and athleticism. He is reported to have been a good musician, a singer with a pleasant voice, and an accomplished, enthusiastic dancer. Photographs and the recollections of his contemporaries bear out these legends. Braque's dealer, Daniel-Henry Kahnweiler, remembered that he boasted of being able to "play Beethoven symphonies on the accordion."[1]

Perhaps even more than his musical ability and his strength, Braque's looks seem to have impressed everyone. Kahnweiler described him as tall, "very handsome," and "a complete dandy." "In those days," Kahnweiler recalled, "he used to wear very simple blue suits with a special cut, which I never saw on anyone but him. He also had black, square-toed shoes that did not have a thick sole, which he said came from Abbeville. Like Max Jacob, he had a black string tie, and he wore all this with a great deal of chic."[2] Gertrude Stein's companion, Alice B. Toklas, recalled that when she first met Braque, his robust appearance and carefully chosen workman's clothes "reminded her so much of an American cowboy that she always had the impression he could understand English, and so was careful in what she talked about."[3] Braque remained impressive. People who knew him in his old age remember him as "the best looking man in Paris," with his clear-cut features and silver hair.

From recollections and anecdotes a portrait emerges of a cheerful, energetic artist, but the persona suggested by Braque's paintings is rather different. He appears to be intensely serious, disciplined—especially in comparison to the mercurial Picasso—relentless in his determination to see his paintings through to the end, meticulous about the physical quality of his pictures. In interviews Braque often said that he "always had a feeling for painting,"[4] insisting that he never chose to be an artist but came to it inevitably. "I never had the idea of becoming a painter any more than I had the idea of breathing,"[5] he once said. Yet curiously, he seems to have been anything but a natural, neither a virtuoso draftsman nor, at first, a notable colorist. Despite this apparent lack of early distinction, Braque was encouraged by his family, and by the time he was twenty-two, he had declared himself a full-time artist. Two years later he was exhibiting in the 1906 Salon des Indépendants for the first time, and a year later, in his second appearance at the show, he sold all six of his submissions. By the time of his first one-man show, at Kahnweiler's new Paris gallery in 1908, Braque was already part of the circle of artists and writers we now regard as creators of some

2

2. Braque, c. 1904–5

of the most advanced and provocative art of the early twentieth century—individuals whose work helps to define what we mean by *modernism*. The poet Guillaume Apollinaire wrote a rapturous introduction to Braque's exhibition catalog. In spite of Apollinaire's and Kahnweiler's enthusiasm, Braque's commercial success at the 1907 Salon des Indépendants was not repeated (nor would it be for many years), but he had already begun to attract the attention of a few enlightened observers.

Just as Braque's early years lack the struggles of the misunderstood artist celebrated in fiction—except, of course, for private, self-imposed aesthetic struggles—so, too, is novelistic romance lacking. There is no succession of discarded mistresses in his history, no litigious offspring. Braque married Marcelle Lapré when he was thirty and they remained together, childless, until the end of his life, more than half a century later. All but the first dozen years of their married life were spent in the substantial house and studio, designed by the architect Auguste Perret, that Braque had built on a quiet cul-de-sac (now called rue Georges Braque) near the Parc Montsouris, in Montparnasse. Summers were spent at their house in Varengeville, on the coast of Normandy.

Except for one dreadful incident when he served in World War I, Braque's life was devoid of conventional drama. Having suffered a severe head wound, First Lieutenant Braque was left for dead on the battlefield. Rescued by stretcher bearers the next day, he remained in a coma for several days, recovering consciousness on his birthday. He is reported to have lost his sight temporarily, and from then on there were no more stories about Braque's extraordinary strength (although there is a photograph of the painter standing on his head, at the beach, in 1924). For undergoing this ordeal Braque was awarded the Croix de Guerre and made a chevalier of the Légion d'Honneur.

The greatest adventure of Braque's life was the six-year exchange with Picasso, which generated some of the most innovative and beautiful paintings in all modernism. The other significant moments in Braque's long life tend to be formal and stately, such as receiving first prize at the Carnegie International Exhibition of 1937 and at the Venice Biennale of 1948. Major exhibitions of his work toured Europe and the United States during his lifetime, and a retrospective exhibition even went to Tokyo, long before the Japanese became significant consumers of modernist French art. Special issues of important art magazines were devoted to his work. Toward the end of his life he was invited to decorate the ceiling of the Louvre's Salle Henri II, where the Etruscan collection was then displayed, and at seventy-nine Braque became the first living artist ever accorded a one-man exhibition at that august museum. When he died in 1963, at eighty-one, Braque was granted state honors at his funeral; André Malraux, the minister of culture, delivered the funeral oration in the Cour Carrée of the Louvre.

Braque thought long and hard about his art and about art in general, but the writings he left are masterpieces of the elliptical that conceal more than they reveal. His introspective notebooks, with their epigrammatic texts and shorthand drawings, are almost Oriental in their economy. When the first section was published, in

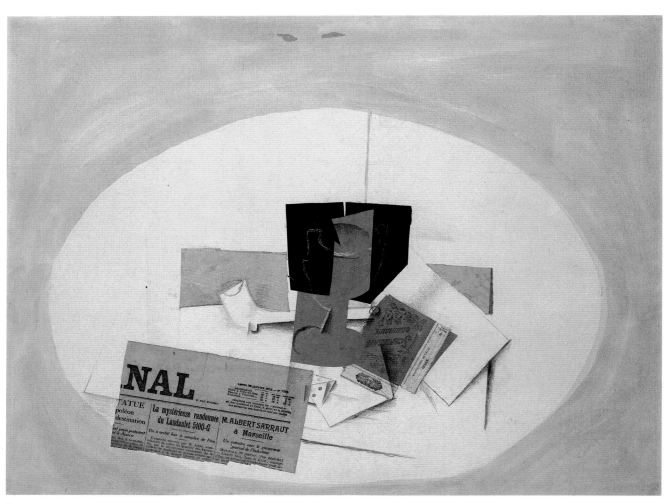

3

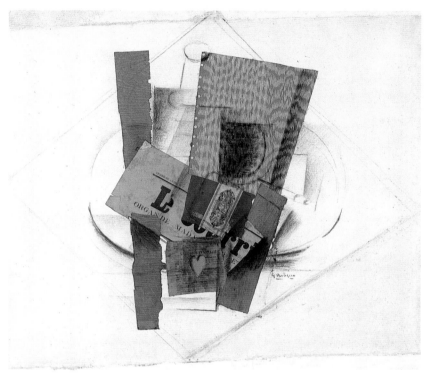

4

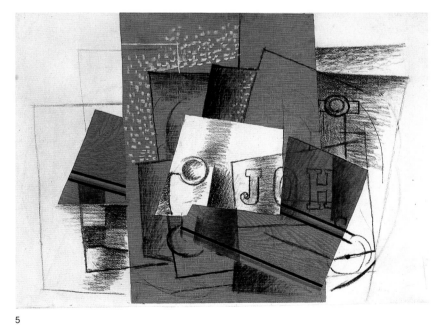

3. *Pipe, Glass, and Die*, 1914
Watercolor, lead pencil, and glued paper,
19⅝ x 23⅝ in. (50 x 60 cm)
Sprengel Museum Hannover, Hanover,
Germany

4. *Newspaper, Bottle, and Packet of
Tobacco*, 1914
Charcoal, gouache, and painted paper on
paper, 20¼ x 22¾ in. (51.4 x 57.8 cm)
Philadelphia Museum of Art; A. E. Gallatin
Collection

5. *Still Life with Glass and Letters*, 1914
Cut-and-pasted papers, charcoal, and pastel
on paper, 20⅜ x 28¾ in. (51.8 x 73 cm)
The Museum of Modern Art, New York;
The Joan and Lester Avnet Collection

5

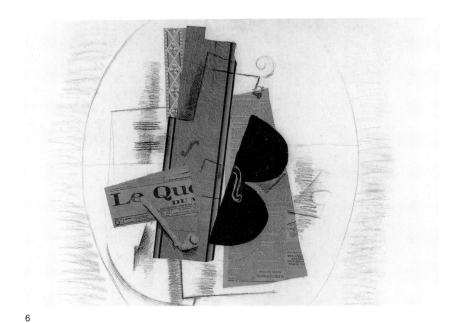

6

1948, Rebecca West commented, "Nothing in these notebooks, however, sheds the slightest light on Braque's private life, his passions, his ideas, his fantasies."[6] There are no heartfelt letters available to outsiders (if, indeed, they exist), no private journals that make us privy to hidden agonies.

Interviews prove only slightly more illuminating, yielding provocative but often tantalizingly oblique replies. Speaking of the time he and Picasso reintroduced color into Cubism, after years of working in near monochrome, Braque once said: "I don't want to pretend that this was a discovery: on the contrary, this independent impact of color had already been sensed by painters, but we gave it all our attention. We made it our point of departure, but as soon as we got down to work, all calculation had to cease—and that's the only reason our painting is alive. It ceased being speculative and became real . . . I have often reflected upon all that and I find it very difficult to grasp it all."[7]

Braque demands to be judged by his art, not by his life. In a single-minded pursuit of excellence, he devoted himself to the making of thoughtful, deeply felt images, and—like many of the best artists of his time, like Picasso, like Henri Matisse, like Pierre Bonnard—he trusted the results to speak for themselves, without benefit of theory or explication. In his notebooks he wrote: "In art, there is only one thing that counts: the thing that you can't explain."[8] Treading the boundary between the verifiable and the inexplicable, between perception and conception, Braque changed art irrevocably. Under the tutelage of his pictures and those of likeminded colleagues such as Matisse and Picasso, artists and viewers alike came to value invention as highly as they did faithful depiction and to accept the reality of the art object as equal to the reality of anything in the existing world.

Despite the enormous implications of these notions, Braque's own investigations were deliberately limited. It is not that he was

6. *Violin and Pipe: "Le Quotidien,"* 1913–14
Charcoal and pasted paper on paper,
29⅛ x 41¾ in. (74 x 106 cm)
Musée National d'Art Moderne, Centre
Georges Pompidou, Paris

7. *Bottle of Rum,* 1914
Oil on canvas, 18⅛ x 21⅝ in. (46 x 55 cm)
Private collection

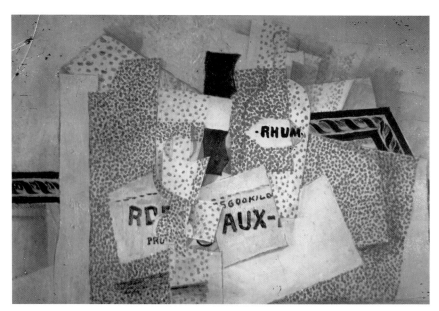

7

unadventurous. In terms of materials and techniques he was only too willing to experiment, testing the possibilities of a great variety of media, as European artists tend to do. He worked in plaster, bronze, and a range of graphic techniques; he designed theater decors and costumes, stained glass and jewelry. The results are, at best, mixed, usually lacking the sense of deep engagement that characterizes even his lesser paintings. (His sculpture is better left ignored.) In spite of his curiosity about other approaches, Braque was first and foremost a *painter,* someone who always thought in terms of moving a more or less fluid substance across a surface.

The aesthetic territory that Braque chose to explore was relatively narrow, especially compared to the limitless field claimed by Picasso, who restlessly tried and discarded new approaches throughout his career. Unlike Picasso, Braque remained faithful to the possibilities of Cubism for most of his life. For Picasso, some aspects of Cubism became part of a manner, rather than formal imperatives. Braque, on the other hand, seems to have regarded Cubism as an infinitely flexible and variable language capable of accommodating everything he could possibly wish to say—rather like French itself, with its unbreakable rules and precedents that nonetheless allow writers to speak in individual voices. Braque may have stayed within self-imposed boundaries during his long and productive life as a painter, but he did so with a seriousness, a lucidity, and an intensity that make his best paintings unforgettable. As he wrote in his notebooks: "Limited means produce new forms, inspire creativity, make a style. Progress in art does not consist in reducing limitations, but in knowing them better."[9]

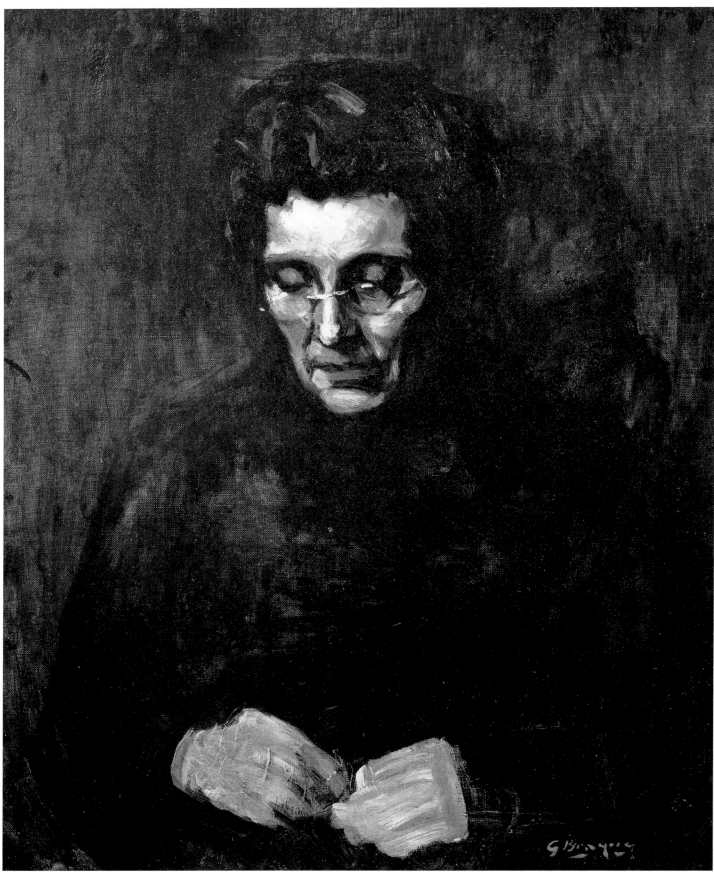

1 Early Life and Work

Braque was born May 13, 1882, in Argenteuil-sur-Seine, not far from Paris. Today, Argenteuil has been swallowed by the city's out-reaches, but in Braque's childhood it retained something of the character of the small market town where the Impressionists had painted. Claude Monet, who lived there in the 1870s, left us images of Argenteuil as it was then—beginning to turn into an industrial suburb, but with the river dotted with boats and its banks lively with weekend holiday makers. Gustave Caillebotte—the Parisian naval architect who championed the Impressionists, collected their work, and sometimes painted alongside them—had a house built in Argenteuil while Braque's family lived there, and Braque remembered having it pointed out to him as a landmark. When Braque was eight, the family moved to Le Havre. This port city, too, had provided the Impressionists with subject matter. Monet had been raised there, and like Eugène Boudin (his teacher and Le Havre's most celebrated native painter), he had painted the harbor and the sparkling beaches nearby.

Braque maintained that having spent his early years in places so closely connected with the advanced art of the time contributed to what he called his "feeling for painting." Yet it seems unlikely that newfangled Impressionism found much favor in the Braque household, a family of painting contractors. Making art was clearly considered to be a legitimate and serious undertaking; both Braque's father and grandfather were amateur artists. Braque's father painted landscapes in the manner of Jean-Baptiste-Camille Corot, with enough success to exhibit them from time to time in the conservative Salon des Artistes Français. His son accompanied him on Sunday painting expeditions and watched him work, surely a more direct influence than the aura of notorious visitors who had long since left the area.

Braque's formal art education was scanty, and in his later years he claimed that he had taught himself, at about the age of twelve, by copying the illustrations in the popular paper *Gil Blas*, to which his father subscribed. The young Braque particularly liked the lively drawings by Théophile Steinlen and Henri de Toulouse-Lautrec. He

8. *The Artist's Grandmother*, 1900–1902
Oil on canvas, 24 x 19⅝ in. (61 x 50 cm)
Mr. and Mrs. Claude Laurens, Paris

was fascinated, too, by the Art Nouveau posters of the period and would peel his favorite Lautrecs off the walls at night. Braque's family encouraged his interest in art. He was given a bicycle and allowed to buy a paint box, with his savings, at about the same time. While still at the lycée, he started taking evening art classes at the local Ecole des Beaux-Arts, although he remembered their being little different from his ordinary school drawing classes, which bored him. Braque's friendship with Raoul Dufy, apparently the only other boy in Le Havre who was trying to paint at the time, dates from these years; Braque took flute lessons from Dufy's older brother.

Braque's family may have fostered his interest in making art for reasons other than aesthetic appreciation: gifted students from the Ecole des Beaux-Arts, if they passed a series of examinations, could have their term of military service significantly reduced. Braque, however, had a far from brilliant record at the Ecole des Beaux-Arts. He was no more remarkable at his books, and in 1899, instead of sitting for his final exams, he left school to become an apprentice in the family house-painting and decorating trade. Again, several interests were served. In the long term, if Braque learned how to do something practical, he would be equipped to earn his living; more immediately, if he could qualify as a skilled artisan, his military service would be shortened, just as if he had been an outstanding pupil at the Ecole des Beaux-Arts. To this end Braque was sent to Paris the following year to complete his apprenticeship with a family friend. He was to learn special decorating techniques that would be useful to the family firm and enhance his standing as an artisan: how to paint imitation marble, exotic wood grains, mosaics, cornices, moldings, paneling—in short, how to render all the expensive embellishments of turn-of-the-century interiors as relatively inexpensive two-dimensional illusions. But Braque had not abandoned his other aspirations, and he also enrolled in a series of evening drawing classes at the Batignolles town hall.

The stratagem worked. Braque's military obligations were reduced from three years to one, which he spent near Le Havre. He was apparently so mute about his real ambitions that an art dealer in the same barracks said that he had no idea that his fellow soldier even painted. But as soon as Braque was released from the army, in the fall of 1902, he returned to Paris to continue not his education as an artisan but his self-education as an artist. He spent most of his time in the Egyptian and Greek galleries at the Louvre and at the small collection of Impressionist paintings then housed at the Musée du Luxembourg. He had first visited these places on school holidays and later recalled that while the Louvre had attracted him initially, he soon found that he was more interested in what he could see at the Luxembourg. This included forty or so pictures from the legacy of his former neighbor Caillebotte, who had left his entire collection of Impressionist works to the nation on condition that they be exhibited at the Luxembourg. The bequest was refused at first, which caused an enormous outcry among artists and enlightened viewers, but after several years of acrimonious debate the state grudgingly accepted a portion of the gift. (Caillebotte's pictures are now considered to be among the greatest treasures in the

Musée d'Orsay.) The first works by Paul Cézanne that Braque saw were Caillebotte's, and they impressed him deeply. Curious about what he was seeing at the museum, Braque began to frequent the galleries of the Impressionists' dealers, Durand-Ruel and Vollard.

Braque enrolled, too, at the Académie Humbert, which he found no better than any other formal institution. (Years later he said, "I've always had a horror of official painting—and it's still as intense as ever."[10]) The students at the Académie Humbert included Marie Laurencin and Francis Picabia (Braque described the latter as "the first painter I'd ever met"[11]). The following year, his "horror of official painting" notwithstanding, Braque studied briefly at the most official of the official schools, the Ecole Nationale des Beaux-Arts, in the studio of the distinguished academician Léon Bonnat. He is supposed to have renewed his acquaintance with Dufy and with another native of Le Havre, Othon Friesz, at this time, since they were also in Bonnat's class. In spite of these sympathetic connections, Braque soon returned to the Académie Humbert. Though far from progressive, the teachers there apparently left students more or less to their own devices, an arrangement more to Braque's liking than the Beaux-Arts' regimented system. But his interest in obtaining any sort of formal art education had been exhausted. In 1904 the twenty-two-year-old Braque rented a studio on the rue d'Orsel, in Montmartre, and began his career, not as *peintre-décorateur* but as *artiste-peintre*.

Few of Braque's early, essentially student works survive. There are several rather ambitious portraits, such as *The Artist's Grandmother*, painted in 1900 and reworked in 1902. It is conventional, almost academic, although the young Braque's admiration for Toulouse-Lautrec is visible in the thinly brushed dress and ground and the expressive contouring of the old woman's face. The most striking aspect is the robust paint handling in the head and hands, but the rigid half-length figure also has some of the conviction and awkwardness of Cézanne's early monochrome portraits of his family; there's a comparable sense of a struggle to make paint carry the burden of intensely felt perceptions. The schematic and slightly clumsy hands make clear why Braque and his family despaired of his passing the Beaux-Arts examination that would have exempted him from long military service, yet head and hands loom out of darkness just as objects loom up in the mature Braque's still lifes, twenty years later. The way that lighter, brighter planes are pulled out of shadow and the way that three-dimensional forms are reduced to simplified, flattened shapes predict lifelong habits of composition.

In the summer of 1905 Braque returned to Normandy, in the company of the Spanish sculptor Manolo and the fledgling critic Maurice Raynal. A view of the park above Honfleur, *The Côte de Grace, Honfleur*, exemplifies Braque's manner at the time. Like the portrait of his grandmother, the park scene is rather clumsily painted, with strong tonal contrasts that again recall the work of early Cézanne more than the light-struck Impressionist paintings Braque had studied at the Musée du Luxembourg. The glitter of Boudin's beach scenes, the sparkling light and snapping breezes of Monet's early views of the Norman coast are nowhere to be found

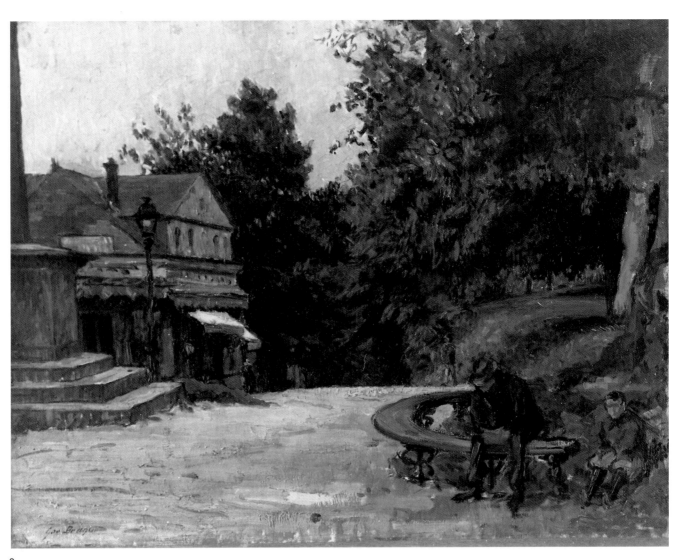

9

in Braque's picture. Though he painted it at the top of a long path, La Côte de Grace, which climbs the hillside to a chapel famous for its panoramic view of the coast, Braque portrayed neither the colorful harbor nor the celebrated view from above. Nothing in his picture suggests even the bright light of a seaside town. The midsummer greens of trees and grasses are tempered by deep shadows, and the cool grays and gray greens of the sky, buildings, and bench, the uninflected pale ocher of the path evoke only the flat gray light of northern France.

The rigid figures that populate the little park obviously gave Braque trouble. He had difficulty, too, conveying any sense of distance. The space between the man on the bench and the illogically diminished standing figure behind him telescopes, as it does in Mannerist pictures; there seems to be little relation between the actual area allotted on the canvas and the distance Braque wished to imply. Yet the overall structure of the picture is surprising, original, and given Braque's later work, prophetic, pointing—albeit a little

9. *The Côte de Grace, Honfleur*, 1905
Oil on canvas, 19⅝ x 24⅜ in. (50 x 62 cm)
Musée des Beaux-Arts du Havre—André Malraux, Le Havre, France

18

shakily—to what he might be capable of in the future. The center of *The Côte de Grace*, traditionally the site of greatest incident in a picture, is virtually blank, with the most complex areas pushed to the edges. In the center the empty ocher path slips over the edge of the hill and meets a dark wall of foliage. Yet in terms of *painting*, the greatest drama occurs in this void: the meeting of a warm, light, thickly brushed color with a cool, dark, more broken expanse; the aggressive gray green arc of the bench points to this nicely modulated depiction of a nonevent. This seemingly incidental bit of painting encapsulates much of what makes Braque "Braque," as a mature artist. It anticipates the way a crusty ocher plane defines a guitar in a still life in the 1920s, or the way a flattened pale shape evokes, as much through its density as its color and form, a fruit against the dark interior plane of a compote. Even the gray, green, and ocher palette of *The Côte de Grace* prefigures later works.

But even with this brief glimpse of what Braque was to become, it is difficult to remember that his essentially conservative early paintings were made after a generation of daring colorists had intensified the inventions of the Impressionists. Vincent van Gogh and Paul Gauguin had already transformed their broken, out-of-door color, making exaggerated hues the carriers of intense feelings. Paul Signac and his colleagues, taking their cue from Georges Seurat, were already attempting to apply "scientific" principles to picture making by applying pure color to their canvases in small, distinct units that were obviously artificial and intended to produce dazzling effects. Braque's work before the middle of 1905 may have represented an alternative to the traditional values of "official" painting, but it was not noticeably adventurous. He is said to have copied works by van Gogh, along with those by Raphael, Nicolas Poussin, and Corot, during his period of self-imposed apprenticeship; there may be a faint echo of van Gogh's rigid figures and exaggerated space in pictures like *The Côte de Grace, Honfleur,* but little else. The overall impression given by Braque's earliest work is one of caution. Color is restrained, and drawing—even allowing for his lack of native facility—is conventional. Occasionally there are glimpses of a nice sense of touch, an obvious pleasure in the sensual quality of paint, but otherwise such paintings are undistinguished, careful, even tame. (It is worth noting that while Braque was painting landscapes in Normandy, Picasso was still producing the classicizing, romantic pictures of his Rose period—pictures that, although more ambitious than Braque's, are no more indicative of what their maker would become.) It would have been all but impossible to foretell, from the way Braque was painting in the summer of 1905, that within a year he would be a fully accredited member of the Parisian avant-garde.

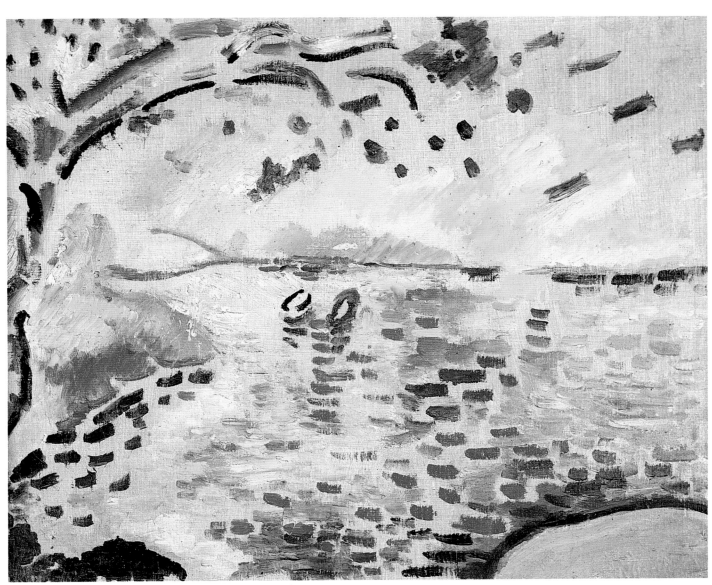

2 The Fauve

Impetus for change came in the fall of 1905, when Braque returned from Normandy in time to see the Salon d'Automne. The most controversial work that year was by Matisse, who, along with André Derain and Maurice de Vlaminck, exhibited brilliant canvases that tested the expressive possibilities of full-throttle color and bold drawing. Braque's friends and compatriots Dufy and Friesz, along with a handful of other younger painters, showed pictures in a similar spirit. For anyone who had been paying attention to advanced French painting at the turn of the century, it was plain that these artists simply intensified what the Impressionists and Post-Impressionists had begun, by adopting the brilliance of the work by van Gogh and Gauguin and purging it of Symbolist, expressionist overtones. To present-day audiences, paintings by Matisse and his colleagues of the kind exhibited in that Salon d'Automne still look audacious. To viewers in 1905, who had only just gotten used to Impressionist color, what Matisse and his fellows were doing appeared barbaric. Confronted by a room of paintings made with unbroken areas of saturated hues, unaffected by any concern for local color and unmodulated by illusionistic shading, one critic wrote that it was a room full of wild beasts—*fauves*—and gave the group its name.

Braque was excited by the energy and intensity of the Fauves' pictures, but he continued to work in the cool, tonal mode of his Norman paintings, with apparent success. When he submitted seven pictures of this type—landscapes, still lifes, and a nude—to the Salon des Indépendants in the spring of 1906, they were all accepted and hung. It was Braque's first exhibition, and it would have been understandable if the young painter had taken the jurors' enthusiasm as encouragement to continue working in the manner in which he had begun, but instead he seems to have regarded the show as the summing up of a phase, not the beginning of a career. Braque was evidently ready for some kind of change, and seeing works by Matisse, Derain, Dufy, Friesz, and other members of the Fauve circle in close proximity to his own at the Indépendants may have crystallized his dissatisfaction and made him decide to alter his approach radically.

10. *The Little Bay, La Ciotat*, 1907
Oil on canvas, 14⅛ x 18⅞ in. (36 x 48 cm)
Musée National d'Art Moderne, Centre
Georges Pompidou, Paris

To do so, he traveled to Antwerp, in the summer following the exhibition, to paint alongside Friesz for several months. The pictures from this trip are unlike anything Braque had done before. They are wholehearted, accomplished Fauve paintings.

In the best of these, such as *Landscape near Antwerp*, Braque's color is still relatively subdued—possibly a response to the cool coastal light of the region. Paint is applied in bold patches or in small, detached strokes, with untouched areas of canvas in between, so that each area declares itself independently and, at the same time, in clear relation to its surroundings. The generally pastel, whitened character of the color, combined with the unifying flashes of unpainted white canvas, results in an unexpectedly delicate, nuanced harmony, despite the intensity of individual hues. In *Landscape near Antwerp*, Braque's tender colors—sugary pink, pistachio green, pale sulphur yellow—detach themselves from slightly more saturated versions of the same hues concentrated in the foreground, to imply distance and moist air. Yet it is the overall orchestration of fragile, close-valued colors that makes the painting breathe and come alive, not the vague suggestion of space.

In other paintings from this series Braque's insistent use of spectrum opposites, turned into pastels, can be less felicitous; instead of the intricate harmony of *Landscape near Antwerp*, the result can be a patchwork of Easter-egg hues. The majority of the Antwerp paintings, however, have a freshness and liveliness that sharply criticize Braque's previous efforts. (He was certainly aware of this, since he later destroyed all of the paintings of Normandy and Paris that he had exhibited in the 1906 Salon des Indépendants.) Perhaps the most striking aspect of the Antwerp paintings is their heightened materiality. Braque gave freer rein to his feeling for the physical quality of paint itself, as though he was beginning to think of each patch of pigment as an expressive element in its own right, not simply a means of replicating something else.

The Antwerp pictures are the first evidence of what was to be Braque's lifelong commitment to modernism. Some are very good, quite apart from their importance within Braque's development, and sharply criticize many other Fauve works—except Matisse's—but Braque was not completely pleased with them. He may have felt that their whitened palette was timid, compared to the heated colors of the first Fauve paintings he had seen. Or he may have found Antwerp's northern light and character too much like Le Havre to be stimulating. In search of stronger color, more intense light, and a landscape new to him, Braque moved south in October 1906 to spend the fall and winter in L'Estaque, the little town near Marseilles where Cézanne had often painted. Many years later Braque recalled how excited he was by the novelty of being in the Midi on that first trip, and how some of that had already worn off on his second visit, less than a year later: "The first year, it was pure enthusiasm, the surprise of a Parisian who discovers the South. The following year, that had already changed. I would have had to push on to Senegal. You can't count on enthusiasm's lasting more than ten months."[12]

Was the choice of a place intimately associated with Cézanne fortuitous? Not entirely, although Braque's explanation varies from

interview to interview. On one occasion he maintained that while he must have been aware of Cézanne's connection with L'Estaque, the promise of good weather for painting out-of-doors and a remarkably cheap hotel were the principal attractions. Yet when asked some years later if Cézanne had been a motivation for the trip, Braque replied: "Yes, and I already had an idea in mind. I can say that my pictures of L'Estaque were already conceived before my departure. I nonetheless applied myself to subjecting them to influences of light and the atmosphere, and to the effect of the rain, which brightened up the colors."[13]

Cézanne may seem an unexpected influence for a young painter newly exploring Fauve ideas, but Braque was simply returning to the origins of Fauvism. There are enormous differences between Cézanne's cool, solidly constructed images and the loose-jointed, radiant compositions made by Matisse and his colleagues in the Fauve years, but the basis of the Fauves' way of implying form and space by setting unmodulated hues side by side is to be found in Cézanne's method of making equivalents for three-dimensional forms with planes of varying warmth and coolness. Like Cézanne, the Fauves eschewed traditional modeling with dark and light; instead, they exaggerated Cézanne's nuanced planes and delicate touch and turned them into patches of strongly contrasting, near-primary colors. Most important, the Fauves shared Cézanne's desire to make pictures that were not mere replicas of something seen but possessed an evocative power equal to anything in nature. Braque had admired Cézanne since he first saw his work at the Musée du Luxembourg, and he had almost certainly paid attention to the large group of Cézannes exhibited, along with the Fauve paintings, in the 1905 Salon d'Automne. (Braque's interest in Cézanne may have helped him to assimilate the Fauves' ideas in the first place.) When Braque left for L'Estaque for the first time, Cézanne would have been particularly fresh in his mind, since he would have seen yet another exhibition of his work, just before his departure, at the 1906 Salon d'Automne.

But if we expect to see obvious reflections of Cézanne's work in the pictures Braque painted in L'Estaque during the fall and winter of 1906–7, we will be disappointed. Overt similarities became visible only much later. Most of Braque's first paintings of the Midi are less atmospheric and more solidly constructed than the relaxed Antwerp pictures, but they are completely Fauvist, with clear and intense color. Sometimes Braque so intensified color that these early paintings of L'Estaque seem jammed and airless. Sometimes, too, he appears to have concentrated so hard on the structural particulars of place that a stiff, albeit intensely colored naturalism replaces his usual sense of the picture as a breathing fabric of color. Yet this rigidity also seems the result of a deliberate effort to solidify the color patches of Fauvism, to subordinate them to a more rational articulation of form, as though Braque was already striving to make his landscapes less dependent on random associations of colors across the surface of the canvas and more structurally coherent. Cézanne's influence is probably behind this new effort.

When Braque succeeded best, at this time, he did so not because he created dense, articulate forms, but because of how he used color

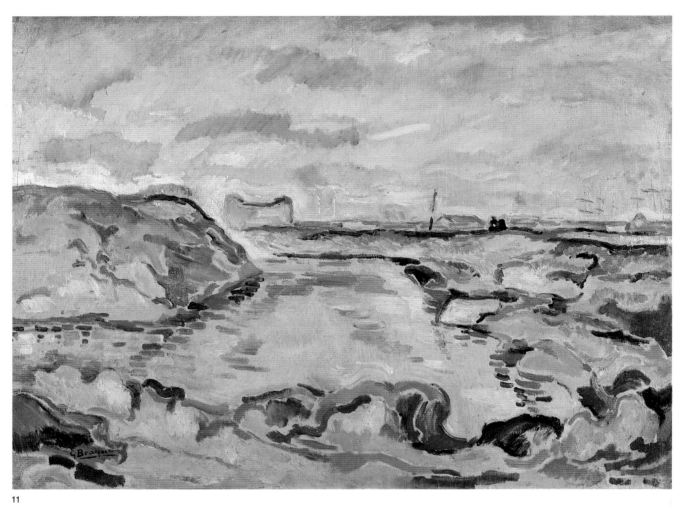

11

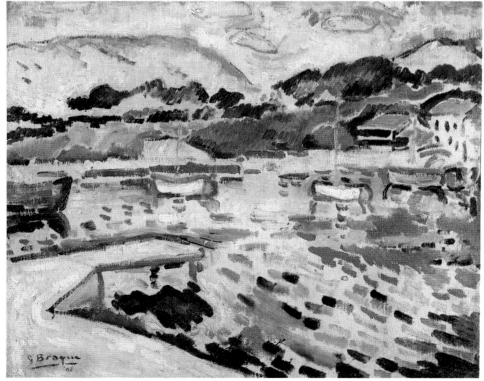

12

24

and how he inextricably united image and facture. In paintings such as the glittering *The Landing Stage, L'Estaque,* painted in November 1906, or the delightful *The Little Bay, La Ciotat,* painted at a nearby town in the following June, on Braque's second trip, everything appears to have fallen effortlessly into exactly the right place. Each stroke retains its identity as the record of a gesture made by the painter at the same time that it conjures up a boat, a roof, sunstruck waves. Each touch remains so distinct and vigorous that these paintings seem drawn as much as painted. Larger color masses fray into smaller areas or turn into clusters of broken, detached brushwork, adding to the remarkable sense of immediacy.

Braque later said that he felt at the time that his paintings of L'Estaque were his first good ones. He proudly exhibited six of them (including, possibly, *The Landing Stage, L'Estaque*) in the Salon des Indépendants in the spring of 1907—his first exhibition as a Fauve. To Braque's astonishment, five pictures were purchased by the German collector Wilhelm Uhde, who later became a dealer in Paris. The sale provided confirmation not so much of Braque's way of painting as of his chosen vocation. He later said, "When, in 1907, the . . . canvases I had exhibited at the Salon des Indépendants had been sold, I told myself there wasn't any need for me to do anything else."[14]

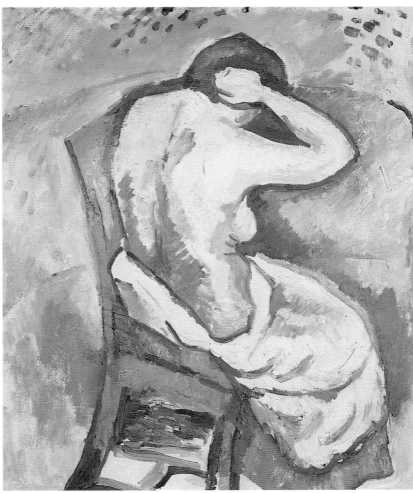

11. *Landscape near Antwerp*, 1906
Oil on canvas, 23⅝ x 31⅞ in. (60 x 81 cm)
Solomon R. Guggenheim Museum, New York;
The Justin K. Tannhauser Collection

12. *The Landing Stage, L'Estaque*, 1906
Oil on canvas, 15¼ x 18⅛ in. (38.5 x 46 cm)
Musée National d'Art Moderne, Centre
Georges Pompidou, Paris

13. *Seated Nude*, 1907
Oil on canvas, 21⅝ x 18⅛ in. (55 x 46 cm)
Musée National d'Art Moderne, Centre
Georges Pompidou, Paris

13

Braque continued to be closely associated with the Fauves throughout 1907, exhibiting with them in Le Havre and submitting Fauve paintings to the Salon d'Automne of that year. (In contrast to his previous successes, all but one of his submissions were refused.) By then Braque seems to have been losing faith in Fauvism, and Cézanne's influence was becoming increasingly important. In an interview at the end of his life Braque described his views unequivocally: "The source of everything—contact with Cézanne. It was more than an influence, it was an initiation. Cézanne was the first to break with the erudite, mechanical perspective that had been practised by artists for centuries, and that ended up by closing off all possibilities."[15] Braque may have seen a large exhibition of Cézanne's watercolors at the Bernheim-Jeune gallery, in Paris, in the spring of 1907, although it is not clear whether he left for his second stay in the Midi before it opened. There is no doubt, however, that when Braque went south for the third time, to spend October and November 1907 in L'Estaque, he did so with new aspirations and a radically changed approach, almost certainly intensified by his having seen, just before leaving, yet another large retrospective exhibition honoring Cézanne, who had died the previous year.

When Braque returned to Paris in the winter of 1907, he continued to revise and work from the canvases that he brought back from the south. There is a new clarity and angularity of structure in these pictures and, in many, a new sonority of color quite different from the "traditional" Fauve palette. Braque sometimes maintained that his abandoning Fauvism had been inevitable: "I knew the paroxysm it contained could not go on forever. How? When I returned to the south of France for the third time, I noticed that the exaltation that had filled me during my first stay there and that I transmitted to my paintings, was not the same any more. I saw that there was something else."[16]

The "something else" was, in part, a new relation to the motif, which partially liberated Braque from the need to be in specific places: "I noticed one day that I could return to the same subject no matter what the weather. I didn't need the sun any more; I carried my light with me."[17] Even so, Braque's choice of subjects during that third trip to Provence can be interpreted as following the path of his chosen master. It was not so much that Braque was painting in "Cézanne's places," although he did that on occasion, but that he emulated Cézanne's habits of composition, his choice of viewpoint. Braque would often forgo the naturalistic long views of his Fauve paintings for layered arrangements of clearly bounded planes, pulled parallel to the surface of the canvas. Often these paintings fragment or go slack in the foreground, but for the first time there are unequivocal indications of the daring reinvention of pictorial space that would preoccupy Braque, one way or another, for the rest of his life. The critic Jacques Lassaigne described this phenomenon, in a neat play on words, as "the angles of the Annunciation of Cubism."[18]

Perhaps the change was inevitable, as Braque maintained. A small and somewhat atypical figure painting, *Seated Nude*, helps to clarify where his strengths and weaknesses lay in these early years. The figure, seen from the back, is an orthodox Fauve effort, con-

structed with contrasting pinks and greens that are intended both to describe anatomy and pose and to situate the figure in space. In this Braque failed noticeably, for the figure dissolves into a random arrangement of patches. When he could attach colors to the multiple incidents of a busy harbor scene or an irregular landscape, he could make sense out of the abrupt, disjointed juxtapositions of Fauvism. But it is obvious in *Seated Nude* that without such justification Braque's Fauve palette could seem arbitrary, and its oppositions and separations could obscure rather than enhance structure. He may have been aware of this, which may account for both his dwindling enthusiasm for Fauvism and his burgeoning interest in Cézanne. In Cézanne's minutely adjusted nuances of color and, above all, in the unshakable, intuitive sense of order that underlies even Cézanne's most complex and loosely painted pictures, Braque found clues to a new approach that could give his own pictures an unprecedented lucidity and logic. This new approach led Braque in a direction that not only transformed his own art but altered the way almost everyone since Braque has thought about pictorial space and illusion. What is perhaps most fascinating is that this major change came about not only because of Braque's own explorations, but because of a concentrated collaboration with one of his peers—a relationship unique in the annals of modernism.

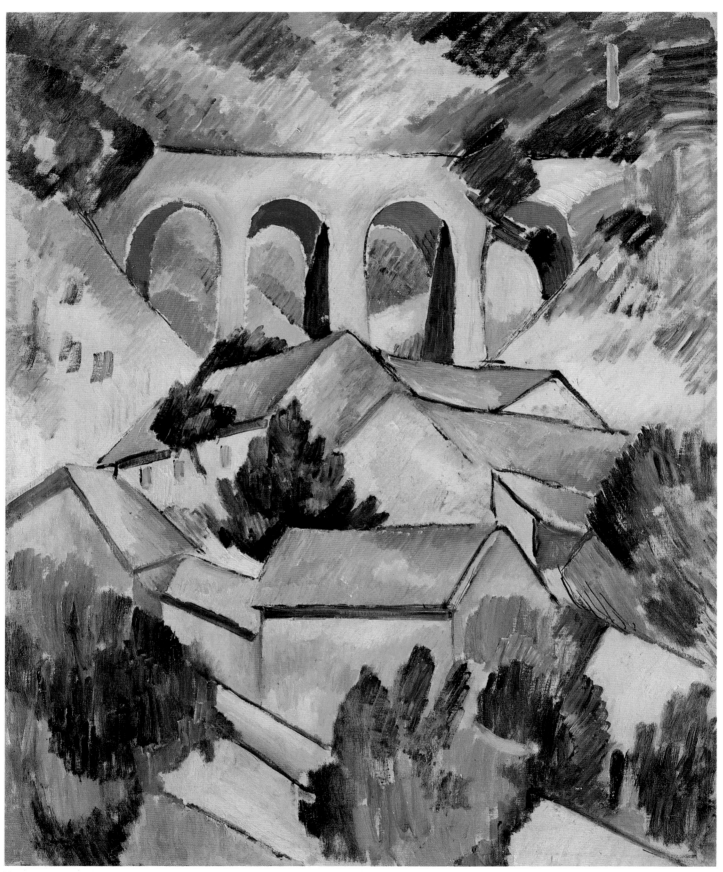

14

③ Braque and Picasso

In March or April 1907, about the time of the Salon des Indépendants, Braque paid his first visit to the studio of a Montmartre neighbor. Finding him out, he left a calling card on which he'd written "Anticipated memories." The neighbor was the young Spanish painter Pablo Picasso. The precise time of their meeting is still a matter for speculation. Certainly they had friends and acquaintances in common before the spring of 1907, but nothing confirms that they were particularly aware of each other. Possible connections abound. Manolo, the sculptor with whom Braque had spent the summer of 1905 in Normandy, was (according to the admittedly unreliable Gertrude Stein) "perhaps Picasso's oldest friend . . . the only person in Paris with whom Picasso spoke spanish."[19] Maurice Raynal, the critic who was Braque and Manolo's companion in Normandy, was also part of the Picasso circle; Apollinaire, Derain, Matisse, and Uhde provide other possible links between the two painters before Braque left his card at Picasso's studio in the famous "Bateau Lavoir." Many sources claim that Braque met Picasso through Kahnweiler, but Braque insisted that it was Picasso who introduced him to the young German dealer, about the time he opened his gallery in Paris, in the spring of 1907.[20] Kahnweiler, who is erratic about dates and sequences in his recollections of the crucial first years of his gallery's existence, said it was Apollinaire who introduced Braque and Picasso.[21] Whatever the exact time of their meeting and whoever the instigator, the results of their encounter are well known. The casual connection between two ambitious young artists became, in the years that followed, a partnership that is one of the legends of twentieth-century art.

It is remarkable that two painters so unlike should have become so essential to each other, forging a connection that was part intimate friendship, part rivalry, part two-man expedition into the unknown. Braque and Picasso were of an age—when they met, Braque was just short of his twenty-fifth birthday, Picasso only six months older—but in most other ways they were opposites. Braque was tall, robust, intensely French, while Picasso was small, fierce,

14. *Viaduct at L'Estaque*, 1908
Oil on canvas, 28⅝ x 23¼ in. (72.6 x 59 cm)
Musée National d'Art Moderne, Centre
Georges Pompidou, Paris

persistently Spanish. Their formations as artists were even more diverse. Picasso was a precocious virtuoso, raised among artists and given a thorough academic art education, in contrast to Braque, with his smattering of formal art training, his lack of conventional facility, and his artisan origins. In later years Braque often pointed out the unlikeliness of their alliance. "Since then it has been obvious—Picasso is a Spaniard, I am a Frenchman. All the differences that implies are pretty well known, but during those years, the differences didn't count."[22]

What outweighed the differences was that when they met, each painter was independently striving for change, seeking more rigor in his work. Braque was still more or less a Fauve, but he had begun to impose a new sense of underlying geometry and solidity on his paintings. Picasso had rejected the delicacy and near sentimentality of his Blue and Rose period pictures and had begun to simplify and harden forms to the point of making them appear crude or brutal. Perhaps Braque and Picasso's collaboration simply accelerated what might have happened anyway, but that seems improbable. Their working friendship, the dialogue between them, the connection that Braque called "an idea that we had in common,"[23] seem crucial to what developed. From the end of 1907 through much of 1914 they were constantly in each other's studios, exploring the implications of the ideas they provoked in each other, scrutinizing each other's work, challenging, goading, and encouraging each other. They worked near each other or went off to paint in different places and returned to compare results, to exchange ideas, and to spur each other on.

Some of it was simply high-spirited fun. There are stories about absurd, vaudeville-style turns and rowdy evenings in Montmartre. There were silly nicknames. Picasso sometimes called Braque "my wife," which, coming from an arrant male chauvinist, could be construed as condescending, if it weren't for the other things he called his friend. "Mon vieux Vilbure" (or "Wilbourg"), for Wilbur Wright, suggests that the two young painters saw themselves as daring pioneers, like the Wright brothers, jointly entering new territory. The Wild West aspect of Braque's appearance that had so impressed Alice B. Toklas caused Picasso and Apollinaire to call Braque "notre pard," a phrase they found in a favorite book of American adventure stories, *Les Histoires de Buffalo Bill*.[24]

Picasso and his pard shared jokes and pranks; they dressed up in each other's clothes and took photographs to prove it. They also spent a good deal of time in passionate, serious talk. Of this, nothing remains. Years later Braque reminisced about those heady years: "We lived in Montmartre, we saw each other every day, we used to talk. . . . During those years Picasso and I said things to each other no one would ever be able to say to anyone again, that no one would be able to understand any more . . . things that would now be incomprehensible and that gave us so much joy . . . and that will be gone with us."[25] What Braque and Picasso *made*, the work provoked by this dialogue stretching over six years, remains as eloquent testimony to their collaboration. These pictures affirm that together Braque and Picasso created a new conception of what painting could be, destroying, along the way, almost all time-

honored conventions of representation in Western art; they invented what came to be known as Cubism.

Largely because of the superb exhibition *Picasso and Braque: Pioneering Cubism*, organized by the Museum of Modern Art, New York, in 1989, there has been a good deal of discussion about the role of each artist in the Cubist enterprise. As the exhibition made clear through the accumulation of visual evidence, the popular notion that Picasso was the innovator in whose shadow Braque labored is not true—something that was usually evident to anyone close to them during the years they worked together. The critic André Salmon, who was part of the Montmartre "inner circle" and an early supporter of Cubism, provided an illuminating description of the relationship: "Georges Braque didn't need to be anyone's disciple. His friend's audacity simply persuaded him of the truth, the health of everything toward which he had been impelled for a long time."[26] Kahnweiler explained further: "People tended to identify Cubism with Picasso. Braque was very wrongly considered to be a plagiarist. . . . Picasso always defended him with great generosity, and said: 'Not at all, he's an absolutely authentic creator who paints in his own style.'"[27]

It is not altogether surprising that Picasso should be assumed to have been the dominant figure, even in so patently cooperative an effort as the development of Cubism. His dazzling virtuosity, his productivity, his lightning changes of style were apparent almost from the beginning of his career. For decades *Picasso* has been the nearest thing we have had to a household word for modern art or, at least, for modern artist. Braque has remained in another category, admired by his peers rather than adulated by the public. If we judge by the art and not by the anecdotes, Braque's intelligence and importance as an equal partner in the Cubist venture are immediately visible. So are his originality and his ability to invent. Since there are no undisputed proofs of sequence, no firm chronology that allows unquestionable priority to be assigned to either artist, the question of who did what first is almost beside the point. What is far more compelling is the extraordinary symbiosis between the two painters, the way each responded to pressure exerted by the other, the way limits were expanded and tenuous suggestions carried to full realization.

When the two young painters first began seeing each other frequently, toward the end of 1907, they were affected by quite different influences. Braque had gone back to the Midi soon after meeting Picasso in the spring, and in the months that followed he spent little time in Paris. (He sent Picasso a short but cordial postcard from La Ciotat.) While Braque was in the south, intensifying his exploration of Cézanne's territory (literally and aesthetically), Picasso had discovered the African objects in the Trocadéro, the ethnographic museum, and had begun to paint nudes with masklike faces and strange anatomies of angles and projections. While Braque was at L'Estaque painting geometricized houses and viaducts, Picasso began the monumental figure composition known as *Les Demoiselles d'Avignon*, now in the Museum of Modern Art, New York, and a related painting, *Three Women*, now in the Hermitage Museum, Leningrad—one a "display" of five savage god-

desses, the other a tangle of bodies that look as though they had been carved from a single block of red stone.

Braque probably had his first view of these startling pictures in late November or early December 1907, when he and Apollinaire visited Picasso's studio. Opinions differ as to whether this was Braque's first visit there, but accounts vary little about his reaction. The aggressive primitivism and deliberate incoherence of *Les Demoiselles* disturbed him—as they still can disturb today, when the painting is revered as an icon of modernism. Kahnweiler recalled Braque's saying something to the effect that Picasso's pictures looked as though he "wanted to make us drink kerosene to spit fire."[28] But Braque was impressed enough to start work on atypically aggressive figure paintings of his own before the end of 1907 and to continue to do so into the spring of 1908. Photographs of lost paintings and drawings leave no doubt about the connection between Braque's figures and Picasso's.

In 1908, when the American writer Gelett Burgess paid a visit to "The Wild Men of Paris," as he called Picasso, Braque, and some of their associates, he described Braque as a figure painter only: "And so first to visit Braque, the originator of architectural nudes with square feet, as square as boxes, with right-angled shoulders." (Burgess, like so many who met Braque in his twenties, could not resist adding: "Braque's own shoulders were magnificent. He might be a typical American athlete, muscular, handsome. . . ."[29]) The illustrations that accompany Burgess's article include Picasso's *Les Demoiselles,* Braque's square-footed nude, and a lively Braque drawing that plainly owes an enormous debt to Picasso's *Three Women*. Burgess was anything but sympathetic to these works, but he seems to have been an accurate reporter. He quotes Braque as explaining that "to portray every physical aspect of such a subject . . . required three figures, much as the representation of a house requires a plan, an elevation and a section." Braque politely answered Burgess's dismayed questions about the deformations of the figures: "I couldn't portray a woman in all her natural loveliness. . . . I haven't the skill, no one has. I must, therefore, create a new sort of beauty, the beauty that appears to me in terms of volume, of line, of mass, of weight, and through that beauty interpret my subjective impression . . . I want to expose the Absolute and not the factitious woman."[30]

Judging only by the nudes that illustrate Burgess's article, it would be reasonable to believe that in 1908 Braque was merely following Picasso's lead, but Braque's other paintings of the period undo the neatness of this theory. He tackled landscapes and still lifes more often than he did nudes, reworking some of the pictures he had brought back from L'Estaque and painting others, with similar images, from memory. Since the figure seems never to have been Braque's strong point, it is not surprising that he looked to Picasso, a figure painter by instinct, for guidance, but landscapes such as 14 *Viaduct at L'Estaque* make it clear that Braque was preoccupied with ideas of his own. The urgent forward thrust of the picture— the sense that the geometric buildings press out from the surface of the canvas, while the viaduct carves out a narrow space of its own, between surface and illusion—is, of course, an extreme version of

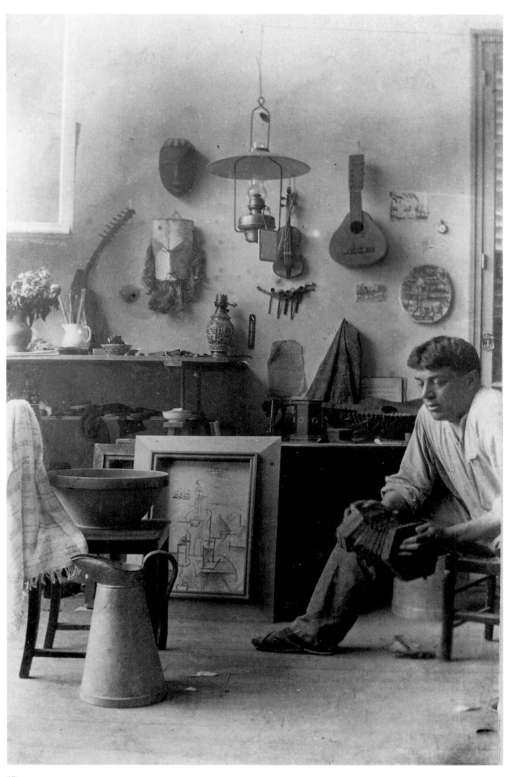

15

15. Braque in his studio, c. 1911

the spatial conceptions implicit in Cézanne's landscapes and still lifes, but it is also startlingly new. Braque was fully conscious that he was rethinking ideas about structure that had been fundamental to Western painting since the Renaissance. "Instead of painting by beginning in the foreground," he explained later, "I concentrated

16

on the center of the picture. Soon I even inverted the perspective, the pyramid of forms, so that it would come toward me, so that it would come at the spectator."[31]

These are notions essential to fully developed Cubist pictures, with their overlapping, transparent planes and shallow, tipped, shifting spaces. Picasso's work of the same time is superficially more daring but no more adventurous formally. His attention was largely given not to a reconception of space but to a reinvention of anatomy. Picasso's nudes of 1907 and 1908 are shocking because we measure their angular, wrenched forms against our knowledge of the human body, but despite their otherworldly physiques these women occupy space in believable, almost familiar ways. Braque's houses and viaducts do not; quite the contrary, they redefine how mass and distance can be depicted.

16 Two still lifes of 1908, Braque's *Plate and Fruit Dish* and Picas-
17 so's *Fruit Bowl with Pears and Apples,* make the differences between the two artists obvious. Braque spreads his picture across the surface of the canvas, suggesting rather than describing the compote, plate, fruit, and delightful pink-handled knife with gatherings

17

16. *Plate and Fruit Dish*, 1908
Oil on canvas, 18 x 21¾ in. (46 x 55 cm)
Private collection, New York

17. Pablo Picasso (1881–1973)
Fruit Bowl with Pears and Apples, 1908
Oil on panel, 10⅝ x 8¼ in. (27 x 21 cm)
Berggruen Collection; on loan to the National
Gallery, London

of relaxed, rhythmic strokes. Everything exists only in terms of paint on canvas, not as an imitation of reality. Picasso's bowl of fruit, while tipped and pulled in ways that are far from naturalistic—and like Braque's, ultimately indebted to Cézanne—is as solidly rendered as any academic study. The pears and apples are slightly prismatic, "anatomically" exaggerated in the same way that Picasso's nudes of the period are, but like the nudes, they occupy space in a wholly traditional manner. It is possible to imagine lifting these geometric solids out of their painted context, as though they were actual sculptural forms, something that is inconceivable with Braque's purely painted images. These differences manifested themselves throughout the artists' collaboration—indeed, throughout the rest of their lives. Braque is the painter, Picasso the draftsman. In *Plate and Fruit Dish*, Braque was already aware of the total expanse of his picture, aware that he was spreading pigment on a surface, constructing a two-dimensional whole. Picasso was more concerned with rendering illusionistic forms—however unrealistic they might be—in illusory space, willfully creating believable images of an invented world.

18

One of Braque's rare surviving figure paintings from the period—
Large Nude, painted in Paris during the spring of 1908—makes
clear both the closeness of his relationship with Picasso and the
complexity of influences, apart from Picasso's, to which he was re-
sponding. It is plain from the rather schematic modeling and mask-
like face of *Large Nude* that Braque, like his friend (and like Derain
and Matisse before either of them), was aware of African sculpture.
He probably admired it for the same reasons that he admired work
by Cézanne—for its spatial adventurousness. The way African car-
vers turned human anatomy into voids and convexities, translating
hollows into geometric projections and solids into flat planes, must
have seemed allied to Cézanne's way of reversing traditional per-
spective, making the solids of his painting press forward in space. It
is plain, too, that *Large Nude* has a good deal to do with what
Braque was able to see in Picasso's studio. Its large scale and ambi-
tion may have been Braque's answer to Picasso's heroic figure com-
positions; the prismatic background drapery of *Large Nude* may

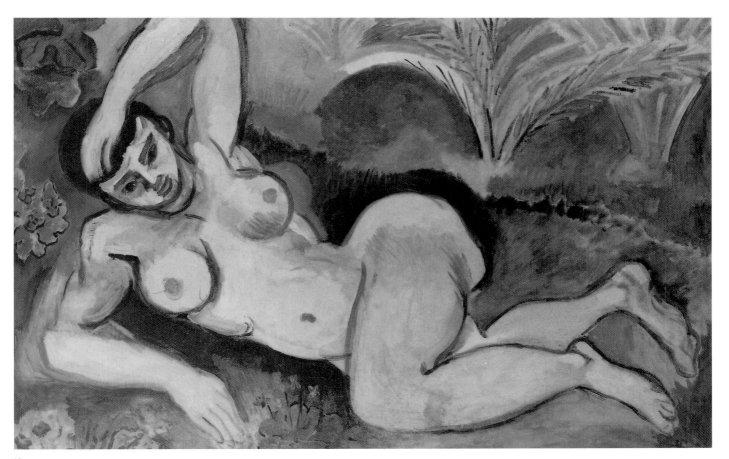

19

18. *Large Nude*, 1908
Oil on canvas, 56 x 40⅛ in. (142 x 102 cm)
Alex Maguy, Paris

19. Henri Matisse (1869–1954)
Blue Nude (Souvenir of Biskra), 1907
Oil on canvas, 36¼ x 55¼ in.
(92.1 x 140.3 cm)
The Baltimore Museum of Art; The Cone
Collection, formed by Dr. Claribel Cone and
Miss Etta Cone of Baltimore, Maryland

refer directly to the crystalline blue setting of *Les Demoiselles d'Avignon*. Both artists may have been thinking about Cézanne's great cycle of bathers, but Braque's voluptuous figure is more curvilinear than any of Cézanne's austere nudes—or any of Picasso's from this time. The bold, arching outlines and compressed pose of Braque's figure owe more to Matisse than to anyone else, particularly to his *Blue Nude (Souvenir of Biskra)*, a tense figure against a 19 background of stylized plants, which Matisse exhibited in the 1907 Salon d'Automne. Like Matisse, too, but with much less effect, Braque used thick, cursive strokes to articulate his figure.

Braque was clearly ready to take cues from anything that interested him, but throughout Cubism's early years he continued to rely most on Cézanne for guidance. Picasso, who admired Cézanne no less, seems to have appropriated what he wanted from him quite quickly and to have used it as the basis for improvisation. The more cautious Braque seems to have repeatedly checked his new ambitions for what painting could be against his memory of Cézanne, just as he and Picasso checked what they were doing against each other's work. As late as 1909, when Braque seemed to be pressing on quite independently, he still seems to have been haunted by Cézanne's ghost. He spent summer of that year in the town of La Roche-Guyon, north of Paris, and repeatedly painted the château, 23 its towers, and the pale cliff behind them as a centralized, pyramidal mass, a surrogate Mont Sainte-Victoire.

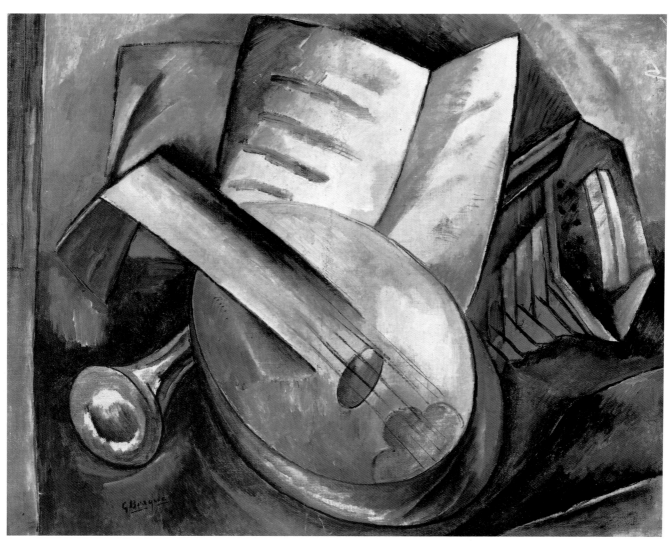

20

Not surprisingly, the painting that Braque considered to be his
first Cubist effort, *Musical Instruments* (1908), is virtually an
homage to Cézanne—in color, in touch, and in its spatial tipping
and elongation. The subject matter, however, is personal and pro-
phetic; the instruments that Braque kept in his studio and played
for his friends became part of Cubism's iconography. The angular
construction of the painting, the tipped space, and the restricted
palette are harbingers, too, of mature Cubism. What makes the
painting truly radical is the way Braque defied all conventional no-
tions of rendering by pulling side and back views of his subjects
toward the surface of the canvas. The mandolin and the concertina
become monumental, overwhelming. They seem too large to be
contained by the canvas, almost too large to be contained by our
field of vision. We feel, irrationally, that we are being confronted by
things we should not be able to see. The whole composition bulks
toward us, but since it is obviously a painted surface, tension grows
between undeniable fact and incipient illusion. The slightly uncom-
fortable vertical slice off the left side of the picture makes the com-

20. *Musical Instruments*, 1908
Oil on canvas, 19⅝ x 23⅝ in. (50 x 60 cm)
Mr. and Mrs. Claude Laurens, Paris

21. *House at L'Estaque*, 1908
Oil on canvas, 16 x 12¾ in. (40.5 x 32.5 cm)
Musée d'Art Moderne, Villeneuve d'Ascq,
France; Gift of Geneviève and Jean Masurel

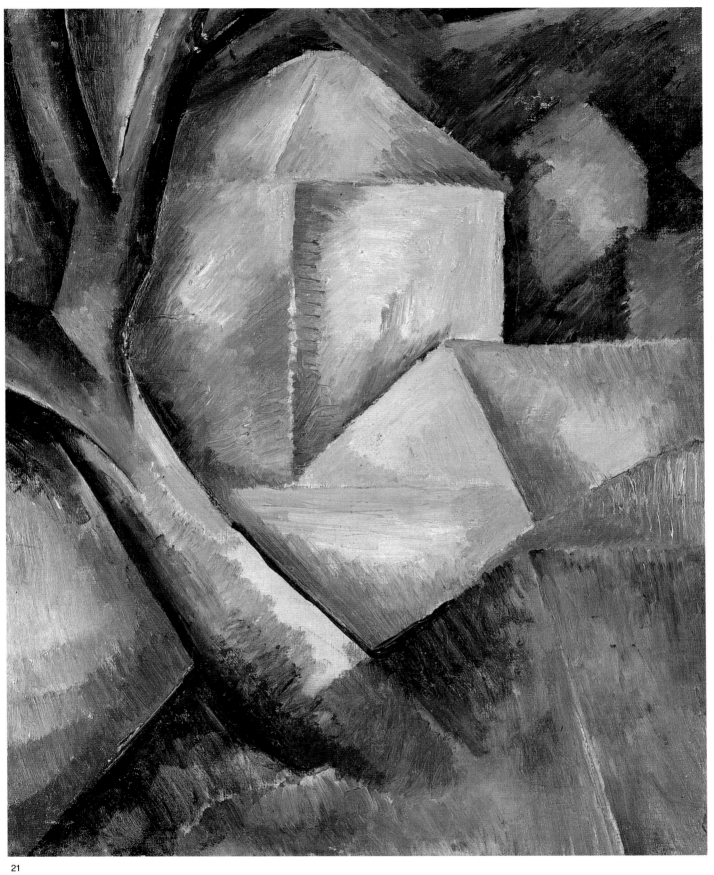

21

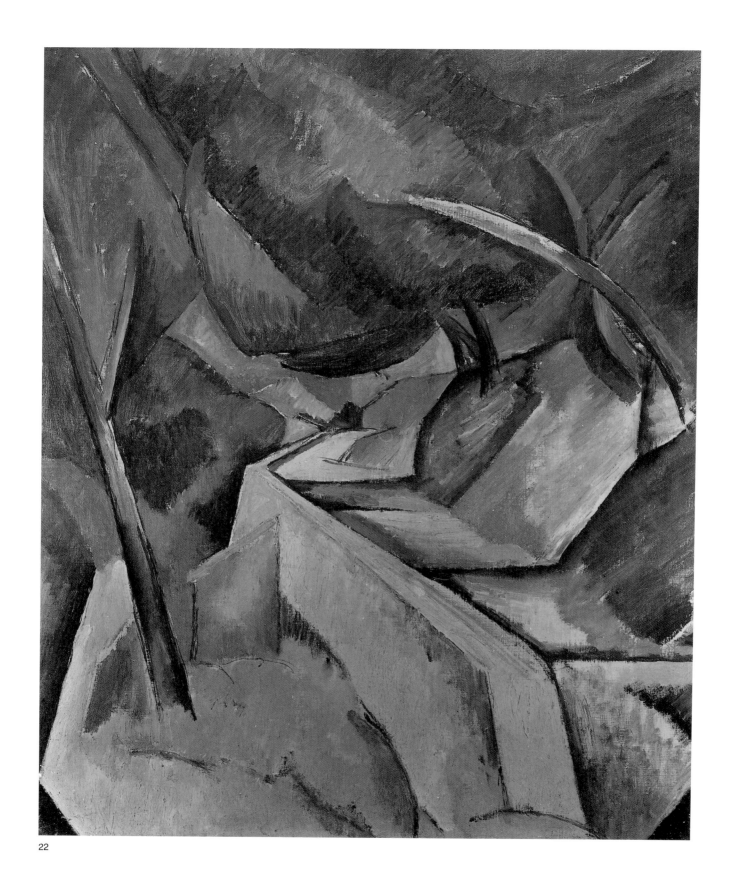

22

22. *Road near L'Estaque*, 1908
Oil on canvas, 23¾ x 19¾ in. (60.3 x 50.2 cm)
The Museum of Modern Art, New York; Given
anonymously (by exchange)

position even more tense by tightening the relationship between the edge of the canvas and the instruments.

Braque may have considered *Musical Instruments* to be his first Cubist painting, but its monumentality and solidity are prefigured by the landscapes he had painted slightly earlier, during the summer of 1908, when he returned once again to L'Estaque to paint the geometric houses, the viaduct, and the hills according to his new concerns. Unlike his earlier paintings of the region, which emphasize multiplicity in order to justify Fauvism's patchy color, Braque's outdoor pictures from the summer of 1908 are spare and concentrated. Paintings such as *House at L'Estaque* and *Road near L'Es-* 21, 22 *taque* are strict, economical compositions of rock-solid houses and trees reduced to Euclidean essentials. The conviction of these tightly focused works makes even the best of Braque's Fauve compositions seem random.

Kahnweiler liked the paintings from this sojourn at L'Estaque so much that he decided to show them in his gallery in November 1908—Braque's first one-man exhibition (and his last for many years). Apollinaire, in his preface to the catalog, described Braque's pictures as part of an important new movement: "There is now room," Apollinaire wrote, "for a more noble, more measured, more orderly and more cultivated art."[32] Apollinaire may have seen himself as the apologist for this more noble art, but it was the critic Louis Vauxcelles who gave the movement its name. Reviewing Braque's show for *Gil Blas,* Vauxcelles wrote: "Mr. Braque is a very audacious young man. The misleading examples set him by Derain and Picasso have emboldened him. Perhaps he has also been obsessed inordinately by Cézanne's style and by recollections of static Egyptian art. He constructs deliberately deformed, metallic people that are terribly oversimplified. He is contemptuous of form, reducing everything—sites, figures, and houses—to *cubes.*"[33] (The use of the word *cube* in this context was not original to the critic, as Braque and Apollinaire always pointed out; Matisse had used it first and Vauxcelles appropriated it.[34])

Unimpressed by Braque's exhibition, Vauxcelles was slightly condescending but tolerant. "Since he is working in good faith," Vauxcelles concluded, "let us not make fun of him. Let us wait and see."[35]

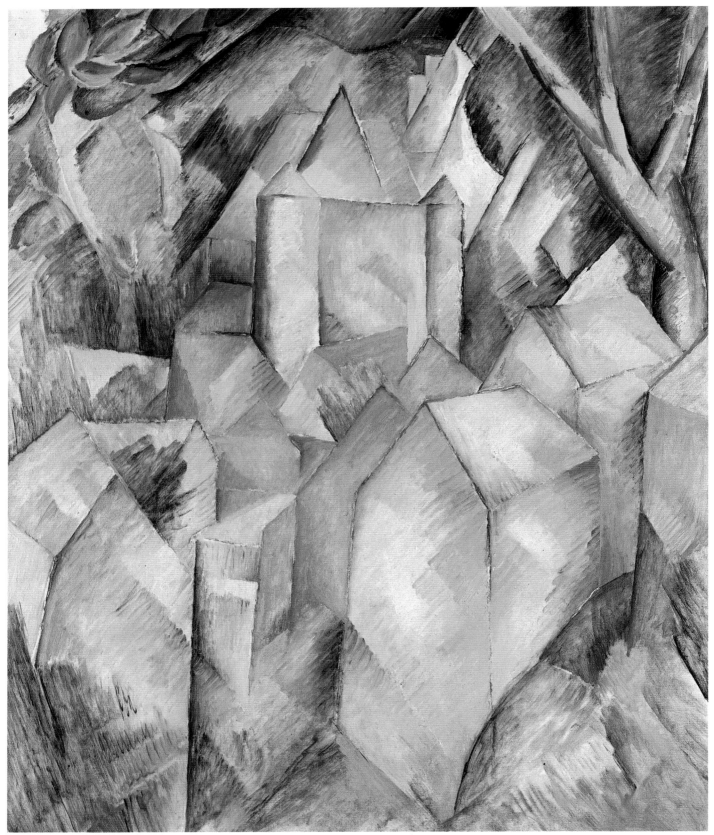

23

4 The Cubist

The uncompromising geometric paintings that Braque showed at Kahnweiler's announced the presence of a young artist to be reckoned with. If he had continued to make paintings like them, he would still be regarded as an important member of his generation, but less as an innovator than as someone who profoundly understood and enlarged the legacy of Cézanne. But as Braque wrote in his notebook at least ten years after his first exhibition with Kahnweiler, "You must not imitate what you wish to create."[36] Braque was not imitating Cézanne in 1908, any more than he was trying to reproduce faithfully what he saw in nature, but it is clear from what followed that he felt it necessary to further distance himself from his chosen master. Cézanne had shown Braque how to evoke the sensation of bulk and solidity on canvas without depicting literal mass, but toward the end of 1909 Braque, in tandem with Picasso, began to be increasingly interested in the space between masses rather than the masses themselves—in what he called "this path that one takes to go toward the object."[37]

Cubism, Braque often declared, was primarily about space. "The first Cubist painting was just that," he said, "a quest for space." He added, "What attracted me immensely—and was to be the guiding light of Cubism—was the materialization of this new space that I could feel."[38] Paradoxically, the means of "materializing" this new space led to the dematerialization of the forms it surrounded.

Over the next few years, from about 1909 through 1912, Picasso and Braque began to dissect the geometric solids of their first Cubist pictures, transforming them into accumulations of tenuously associated planes. It is convenient to refer to this phenomenon as "fragmentation"—Braque did, himself—but it is not so much that objects have been shattered as that every nuance of their spatial relation to the surface of the canvas has been turned into a pictorial event. The space between objects is treated the same way, as though solid bodies generated force fields in the air that surrounds them. The best of these paintings demand that we pay attention to each shift of the transparent planes, to ephemeral-seeming images that appear to be suspended in an impossible zone just behind and just

23. *Castle at La Roche-Guyon*, 1909
Oil on canvas, 28¾ x 23⅝ in. (73 x 60 cm)
Musée d'Art Moderne, Villeneuve d'Ascq,
France; Gift of Geneviève and Jean Masurel

in front of the canvas, gathering most densely in the center of the picture and sinking back into the surface at the edges. Our efforts to read these contradictory images as both paint and illusion create—materialize, to use Braque's word—a potent, exhilarating sensation of space that is entirely different from the mental transportation into an illusory world that we experience in front of a Renaissance painting.

Braque's and Picasso's prismatic images of this type are usually referred to as "Analytic Cubism," which implies that the artists had dissected perceived reality in order to scrutinize it scientifically. Some apologists for Cubism have, in fact, stressed the scientific modernity of such paintings, insisting that Picasso and Braque were the first painters who strove not to evoke the three spatial dimensions on a flat surface but to deal with the fourth dimension—time—in a pictorial way. Some commentators have even tried to relate the "fragmentation" of Analytic Cubism to atomic theory, and innumerable other explanations have also been offered for these difficult, introspective paintings. One of the most common suggests that the artists were attempting to show multiple views of their chosen subjects, since no single perception is any more or less true than any other. Unlike things seen from a single vantage point, rendered according to the traditional rules of mathematical perspective, the components of a Cubist picture are seen in many different ways at once. Up and down, near and far, front and back all become interchangeable within the confines of a Cubist canvas. A fruit dish can be shown simultaneously from above and in profile, resting on a tabletop that seems to tilt upward, but is supported by legs that are rendered head on. Transparency abets these multiple views.

Ironically, the quest for a method of representation that owed nothing to conventional rules led to the invention of a Cubist "system" as recognizable as anything generated by the application of three-point perspective. Round forms, such as wineglasses or bottles, for example, become circles and ovals, split and offset or shaded down one side; musical instruments are reduced to similarly offset planes, with violins signaled by scrolls and f-holes, guitars by frets and pegs, and so on. Simultaneity and multiplicity are crucial to Analytic Cubism, but this doesn't mean, as some critics have suggested, that the paintings are elaborate puzzles that the viewer must reconstruct, using such clues as guides. Nothing could be less true. The demands of the new painted whole always take precedence over the need to convey information about the picture's nominal subject, so much so that fragments that might help to decode the image are often transformed to the point of being unidentifiable.

Apollinaire, in his book *Les Peintres cubistes: Méditations esthétiques* (1913), made grandiose claims for the work of his friends: "Cubism differs from old schools of painting in that it aims, not at an art of imitation, but at an art of conception, which tends to rise to the height of creation," he wrote, and he added, "The modern school of painting seems to me the most audacious that has ever appeared. It has posed the question of what is beautiful in itself."[39] In his zeal to be comprehensive (and possibly outrageous), Apollinaire included along with Braque and Picasso many of the painters directly influenced by them who had by this time joined the Cubist

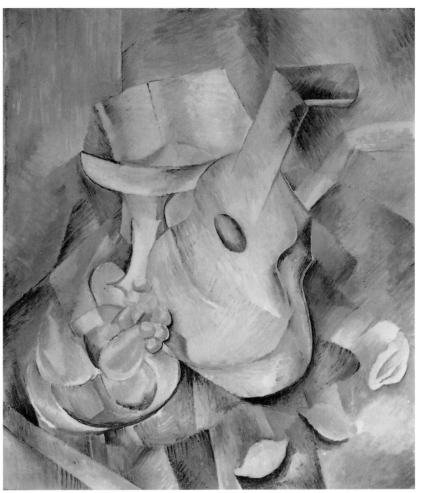

24

venture—Fernand Léger and Juan Gris were probably the most original and committed of these—as well as several non-Cubists. He also provided a bizarre and largely incomprehensible discussion of four "categories" of Cubism: Scientific, Physical, Orphic, and Instinctive. Braque elegantly dismissed all such discussion many years later: "If a critic's explanation adds to the general obscurity, that's all to the good. French poets are particularly helpful in this respect. Few of them have understood the first thing about modern painting, yet they're always writing about it. Apollinaire, for instance: a great poet and a man to whom I was very attached, but he couldn't tell the difference between a Raphael and a Rubens. The only value of his book on Cubism is that, far from enlightening people, it bamboozles them."[40]

However we choose to interpret them, the pictures that Braque and Picasso made during the years of Analytic Cubism have readily identifiable characteristics: overlapping planes, shifting space, elusive focus. It is easy to recognize a vocabulary of images as well. The numerous still lifes of these years depend on the everyday objects of the studio and the café: wine bottles and glasses, newspapers, guitars and mandolins, bowls of fruit. The very familiarity and repetitiveness of these objects neutralized them, allowing the painters to

24. *Guitar and Fruit Dish*, 1909
Oil on canvas, 28⅜ x 23⅝ in. (72 x 60 cm)
Kunstmuseum Bern; Hermann and Margrit
Rupf Foundation

45

fix their attention on matters other than depiction. In the same way, the palette is restricted to earth colors, tempered by black and white. Economy may have been a factor, since ochers and umbers are among the cheapest oil colors available, but Braque declared that the choice was deliberate, not expedient. Like neutral subject matter, neutral, nearly monochrome color allowed concentration on other things. "Color came later," Braque said. "It was necessary to create a space before setting out to furnish it."[41]

The space created in Braque's pictures of the time is immensely complex. Paintings of 1908, such as *Musical Instruments* or the chunky L'Estaque landscapes, use a fairly straightforward inversion of perspectival conventions, but later works, such as *Pedestal Table,* don't invert perspective so much as make it irrelevant. Only drawn fragments, scattered across the canvas, bear witness to the arrangement of objects that generated the composition—the scroll of a violin, the curl of a roll of music paper, the parallel slashes of strings—and their disposition has little to do with their position in actuality. The table that supports these objects exists only as a memory, alluded to by drawn planes and a slight shift in color in the lower part of the canvas. The disembodied "objects" on this tipped table seem unstable, as though both attracted and repelled by the surface of the picture. Braque's line breaks free of the planes it purports to define, setting up new, independent rhythms. Everything pulls front and center, but the cumulative effect is surprisingly insubstantial; the mass of creamy, shimmering strokes is not so much an evocation of something seen as an abstract visual metaphor for sight itself.

Original and radical as paintings like *Pedestal Table* unquestionably are, they have curious precedents in traditional French painting. Nicolas Poussin's early paintings, for example, can be read as precursors of Analytic Cubism's rethinking of systematic illusionism. The intricacies of Poussin's pictures, with their masses of carefully adjusted figures frozen in violent action—each stylized heroic pose answering a stylized heroic pose, so that geometric relationships cut through the general tangle—seem comparable to the active shifts and momentary clarifications of Braque's paintings between about 1909 and 1912. Poussin's compositions of this type were often based on Roman reliefs, which explains, in part, their compressed, dislocated space; this, too, seems related to the shallow fluctuations of Cubist works. Braque is supposed to have copied works by Poussin when he first came to Paris, but it would be difficult to prove a direct connection, and this tantalizing similarity remains inexplicable. That Braque paid attention to the work of Poussin's near contemporary Louis Le Nain also remains pure speculation. Le Nain was the best of a family of genre painters, known for his groups of peasants. His pictures often have a kind of spatial anarchy that uncannily prefigures the shifting viewpoints of Cubism. Each figure or group in a complex composition usually occupies a wholly autonomous space, unrelated to any other. This is almost certainly due to Le Nain's having failed to consolidate an assembly of separately composed vignettes, but the result is no less surprising. Even the gray-ocher palette he favored seems apposite.

Braque's strength during the early years of Cubism was in paint-

25. *Pedestal Table*, 1911
Oil on canvas, 45⅞ x 32 in. (116.6 x 81.3 cm)
Musée National d'Art Moderne, Centre Georges Pompidou, Paris

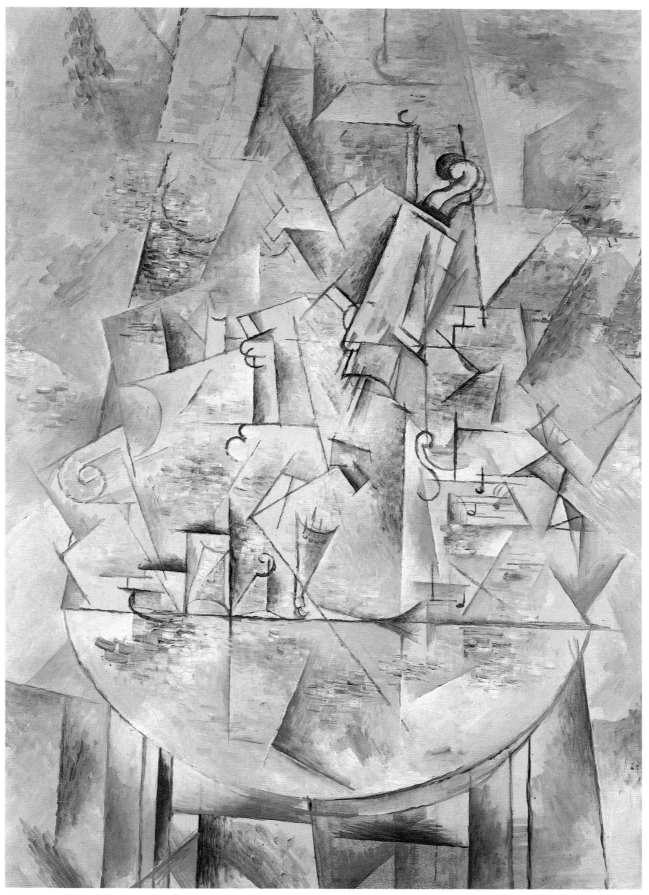

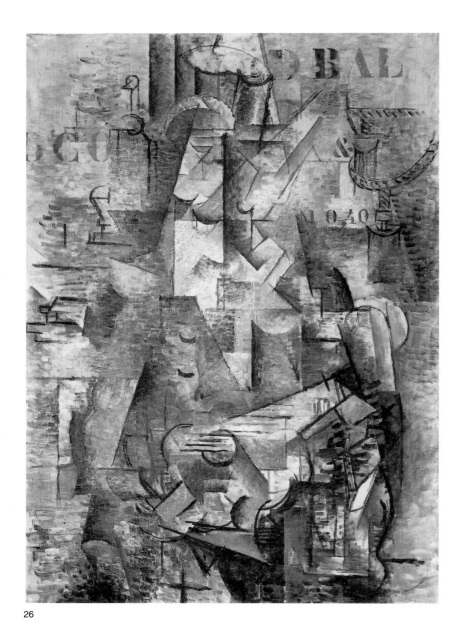

26

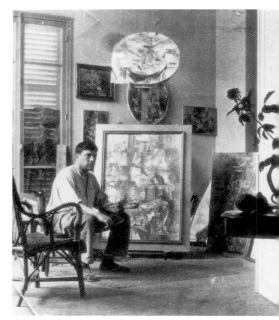

27

ings, like *Pedestal Table,* that slide and sparkle across the surface. Fragmentary images float against staccato brushstrokes, momentarily coalescing into the suggestion of a still life and then drifting away again, only to be fixed in place by a clearly defined detail—a table edge, a wineglass, a clarinet—threaded like a pin among pulsing planes. They are elusive paintings that seem to slip away as we look, yet the elusiveness is paradoxical because they reveal so much about the history of their making. We can momentarily lose our sense of the whole as we mentally follow the progress of Braque's stuttering brush as it lays down rows of squared-off dots across the surface of the canvas.

The range, richness, and inventiveness of the paintings that Braque and Picasso produced in these years attest to the extraordinary effect they had on each other. Yet close as they were, each remained an individual. In general, Braque's paintings appear more worked than Picasso's. Lacking Picasso's facility, Braque often

26. *Le Portugais (The Emigrant),* 1911–12
Oil on canvas, 46 x 32⅛ in. (116.7 x 81.5 cm)
Öeffentliche Kunstsammlung Basel,
Kunstmuseum, Basel, Switzerland

27. Braque in his studio at 5, impasse de
Guelma, Paris, c. early 1912. *Le Portugais
(The Emigrant)* is on the easel.

28. Pablo Picasso (1881–1973)
"Ma Jolie," 1911–12
Oil on canvas, 39⅜ x 25¾ in. (100 x 65.4 cm)
The Museum of Modern Art, New York;
Acquired through the Lillie P. Bliss Bequest

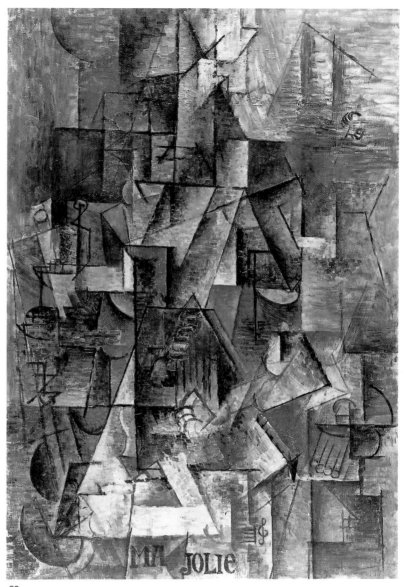

28

spent months on his canvases, adjusting, altering, refining. He
fought his paintings through to the end, rather than letting them
stand as records of inspired improvisation, as his friend often did.
Even more profound differences of conception are also evident.
Braque's *Le Portugais* (*The Emigrant*), and Picasso's *"Ma Jolie"* 26, 28
were painted at more or less the same time, during the fall and win-
ter of 1911–12. Both are half-length figures, Braque's male, Picasso's
female, and both hold musical instruments, but these superficial
similarities belie the individuality of each work.

Picasso's figure separates itself from the surrounding space to be-
come a dominant central axis, a pale slanting column that attracts
all other planes and keeps them from sliding into the atmospheric
reaches along the edges of the canvas. Each plane is sharply defined
and shaded, as though to assert its tactile reality. Braque's figure
takes up less room; there's more air, more ambiguous painted sur-
face space around him. Planes are less distinct, less modeled. Every-

thing in Braque's picture knits together on the surface of the canvas, while everything in Picasso's is clearly articulated, almost as if it depicted an actual three-dimensional, planar, faceted structure. Picasso all but denies that his image is made of paint on canvas, while Braque emphasizes material means. In Braque's picture, planes fray into feathery strokes or pulse under dense loads of pigment. The stenciled letters (here making an early appearance) assert both the act of putting paint on a surface and the surface itself. Painting takes precedence over what has been painted.

There were also moments during these intense years of collaboration and almost-daily exchanges when Picasso and Braque appear to have deliberately tried to paint like each other, as though responding to advice given during a studio visit. There are paintings by Picasso with more relaxed contours and a looser touch, which open up and breathe the way Braque's do, and works by Braque that are unusually crisp and defined—Picasso-like. Braque's series 29 of narrow, vertical still lifes with musical instruments, such as *Violin and Pitcher* are uncharacteristically edgy and brittle, as though the elongated format had squeezed the painted planes into tight formation. Played against these sharp-edged planes are illusionistic inclusions: the scroll and tuning pegs of the violin and the famous nail that casts a shadow at the top of the picture. (A palette hangs from it in some versions.) The contrast between these elements and their "abstract" context recalls Picasso's arresting disjunctions more than Braque's typical overall harmony.

As early as 1908 or 1909 the two painters, so closely associated in most ways, were already pursuing different conceptions. Whereas Braque seemed to think of a picture as a continuous, inflected surface, Picasso conceived of it as an accumulation of independent images set against a background. This may account for his preference for traditional, almost academic subjects—nudes, complex figure compositions, portraits—while Braque concentrated on still lifes and, at least at first, landscapes. Of course, these choices may simply reflect the contrasting temperaments of the two men; the flamboyant Spaniard tackled great themes, while the more reserved Frenchman explored more modest subjects, but Braque's predilections also seem related to what he later described as "the desire that I have always had to touch things and not only to see them." His choice of subject matter seems to have followed, quite consciously: "So I began to paint mainly still lifes, because in nature there is a tactile space, I'd say almost a manual space."[42]

A few years later Braque enlarged upon this idea: "I found [in still life] a more objective element than in landscape. The discovery of the tactile space that set my arm in motion in front of a landscape made me seek an even closer, palpable contact. If a still life isn't within reach of my hand, it seems to me that it ceases to be a still life, ceases to be affecting."[43] Even Braque's choice of still-life objects was influenced by his sense of "manual space." He explained that his now-familiar Cubist iconography was not accidental: "Musical instruments, considered as objects, were special in that a touch would bring them to life."[44]

Braque may have realized that, with few exceptions, Cubism doesn't lend itself to good figure painting, since the anatomical

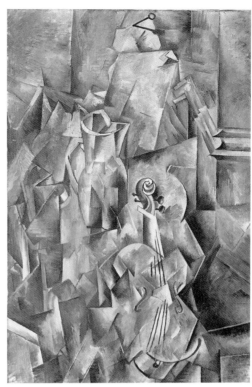

29

deformations of Cubist figures often seem perverse rather than expressive. Even landscape is problematic, for it requires the reduction of an enormous chunk of actuality to the size of the canvas, just as it did in the Renaissance. Space in Cubist landscapes may not be rendered according to a system of mathematical perspective, but it is still subject to a fairly traditional process of reduction and depiction. To minimize this, Braque tended to forgo deep space in his Cubist landscapes and to fill up his pictures with piles of relatively large-scale buildings, walls, viaducts, and the like, so that structurally they resembled still lifes. The more they did so, the better they usually were, but they retained a lingering sense of referring primarily to something that already existed. When Braque took as his point of departure the everyday objects of the studio or the café table, something extraordinary happened. Since most of the time these objects were translated into images that were the same size as the originals, there was no question of depiction but rather of invention of a new equivalent reality whose objects have the same size and function as their prototypes in the everyday world, but utterly new forms. If a viewer could pick up a Cubist "shattered" wineglass, it would fit his hand just the way a real wineglass would. What we know about real wineglasses (or fruit bowls or guitars) must be tested against the painted image, and the radical differences between them are part of the meaning of the Cubist picture.

When the tabletop that supports these objects is tipped up and made congruent with the surface of the picture or, as often happens, the canvas itself is made to assume the oval shape of the tabletop, then the canvas is neither a background nor even a necessary support but a confronting plane that presents the image, just as the real

29. *Violin and Pitcher*, 1910
Oil on canvas, 46⅛ x 28⅞ in. (117 x 73.5 cm)
Öeffentliche Kunstsammlung Basel,
Kunstmuseum, Basel, Switzerland

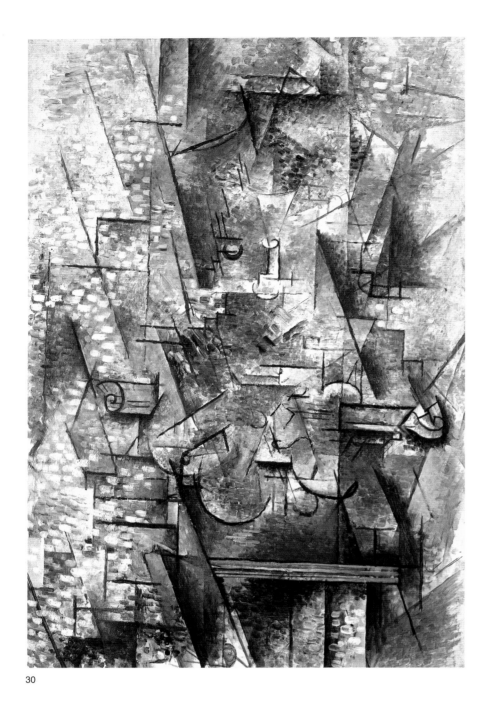

30

tabletop presents the still life. The conceit of suggesting an open drawer in the front of the table—like the habit, derived from Cézanne, of painting a knife angling into the picture—adds to the complexity of the image. The tension between what is implied and what is literally there becomes palpable; the painting's meaning, its very presence, resides somewhere in the zone between what we associate with the nominal subject and what we recognize as pure invention. Like James Joyce's portmanteau words, which compress a host of associations into not quite intelligible sounds, the unstable imagery of the best Cubist still lifes refers both to our everyday, observable world and to an intangible but resonant visual world.

The still life remained Braque's principal theme for most of the

30. *Still Life with Violin,* 1911
Oil on canvas, 51¼ x 33 in. (130.2 x 83.8 cm)
Musée National d'Art Moderne, Centre
Georges Pompidou, Paris

31. *Fruit Dish and Glass,* 1912
Charcoal and pasted paper on paper,
24⅜ x 18⅞ in. (62 x 48 cm)
Private collection

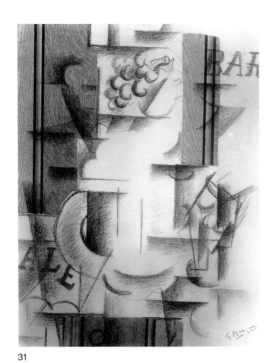

31

rest of his life. Occasionally a figure entered the studio or Braque ventured out onto his terrace; more rarely, he went to the beach or to the fields near his house at Varengeville. But most often he focused on a small group of familiar objects that were scaled to the hand, whose function depended on being picked up or touched—compotes, pitchers, teapots, musical instruments—sometimes enlivened by flowers or things to eat, all placed within reach of his hand, on a pedestal table, a sideboard, or a mantelpiece.

The tactility that Braque strove for, his wish to "materialize" space, took the form in his Analytic Cubist paintings of a new kind of pictorial singleness, wholeness, and even in the most complex and prismatic of these pictures, an assertive two-dimensionality. Braque seems to have discovered how to use this to best advantage when he began to paste wood-grain paper on his drawings, in September 1912. He later recalled that he had noticed the paper in a wallpaper shop in Avignon—the Braques had joined Picasso and his companion, Eva Gouel, in the nearby town of Sorgues—and when Picasso left for a short trip to Paris, Braque quickly bought some and began to incorporate it in his work. The first of these *papiers collés, Fruit Dish and Glass,* was probably made, along with several others, before Picasso's return. Given Braque's training in trompe-l'oeil finishes, the wood-grain paper, a mass-produced version of an effect he knew how to create with paint and a special comb, must have amused him enormously. Here was a further removal from the original—a facsimile of a facsimile—and, as John Russell has pointed out, using a frankly bogus, ready-made illusionistic element at a time when official art still highly valued slick verisimilitude gave the inclusion of the patterned paper extra charm.[45]

Pasted paper served strong formal purposes as well. By cutting, Braque had found a way to make planes as single, continuous units, instead of with repeated touches of the brush. Pasted paper turned the spatial ambiguities of Analytic Cubism into two-dimensional planes that could be held, momentarily, in the artist's hand, but became ambiguous again as soon as they were placed in their new context. Instead of a painted fictive element, like the celebrated nail in *Violin and Pitcher,* the pasted wood-grain paper was both illusion and real substance. The pasted plane, the fragment of actuality made to serve as the background for an invented Cubist image—as it did in Braque's first *papiers collés*—fluctuated between its new identity as part of the picture and its uneqivocal presentness as an infinitesimal relief against the flat surface of the picture. In Braque's Analytic Cubist paintings, shifting planes seem to hover in a shallow space, a little behind or a little in front of the surface of the canvas, so that no matter how aware he made us of that surface, he also denied its existence by suggesting that parts of the image existed in some other space. In the *papiers collés* the literal surface of the picture is established by the pasted planes, but at the same time, the invented context becomes more of an illusion, with the drawn and shaded lines even more elusive and weightless. Yet the whole gains a new clarity.

The lettering that Braque incorporated into his paintings, beginning in 1911, served a similar function, reaffirming the difference between the fact of surface and the fiction of image. Braque said

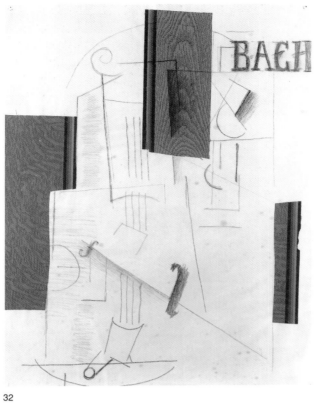

32

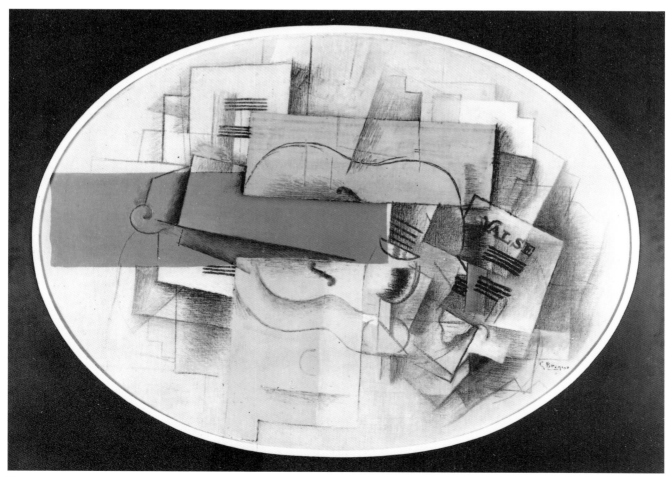

33

that when he introduced lettering he was "still wishing to come as close as possible to some kind of reality. . . . These were forms where nothing had to be distorted: since they were flat surfaces, letters were outside space and their presence within the painting, by contrast, made it possible to distinguish the objects situated in space from those that were outside space."[46] When Braque began to include newspaper in his *papiers collés,* lettering at once became integral to the construction of the picture rather than applied, and ready-made rather than drawn. The cropped headlines sometimes allowed for puns and private messages, while at the same time introducing a host of new associations into the Cubist image, echoes of the world outside the studio.

Braque's collages are among his best works. He must have known how good they were and how rich their implications, since he made more than fifty of them between 1912 and 1914 and several more around 1918. The technique allowed him to compose with new economy and daring and to insert color in new ways. Picasso was quick to adopt the technique—he had already done something similar in his famous oval still life painted on oilcloth that mimics chair caning—but he used it to different ends. Braque's collages are severe and pared down. Pasted elements are always subsumed by their new context and serve merely as components, albeit major ones, in a whole. Picasso's use of collage is more self-conscious. We are meant to recognize the head or guitar and, at the same time, to realize that it has been made by the cunning assembly of improbable parts. In Braque's works, we are primarily absorbed by the image and only secondarily made to think about the intelligence behind it. Picasso, like a precocious child, makes us first aware of the immense cleverness of the person who turned that triangle of paper into a portrait. (Perhaps Braque was thinking of his former collaborator and ally when he wrote, many years later: "Some works of art make you think about the artist, others about the man. I have often heard people speak about Manet's talent, never about Cézanne's. Let's be cautious; talent is dazzling."[47])

The *papiers collés* helped to transform Braque's and Picasso's paintings. Both artists soon imitated the clarity and textural distinctions of collage on canvas, using larger-scale elements and more insistent patterns than they typically had in their Analytic Cubist works. The broad planes of the *papiers collés,* the simplified shapes, lucid space, and structure that the method encouraged considerably influenced the look of all of Braque's subsequent work. This is particularly true after about 1918, but as early as 1913 he began to use his artisanal training to paint wood grain and other trompe-l'oeil motifs in his pictures. At the beginning of 1913 he produced a superb series of still lifes—including *The Violin: "Valse," Pedestal Table,* and *Violin and Glass*—which develop the implications of the *papiers collés* in painterly terms. Like some of the best and best known of the pasted papers, they are horizontal pictures, oval or with inscribed ovals and virtually empty corners. Unlike vertical ovals, which carry a lingering memory of eighteenth-century trophy pictures that confront the viewer with a display of their contents, these horizontal pictures seem relaxed, almost effortless. Line drifts across unbroken planes, crossing boundaries, defining and

33, 36

37

32. *Still Life—BACH,* 1912
Charcoal and faux-bois paper on paper,
24¾ x 18⅞ in. (63 x 48 cm)
Öffentliche Kunstsammlung,
Kupferstichkabinett Basel, Basel, Switzerland

33. *The Violin: "Valse,"* 1913
Oil and charcoal on canvas,
25¾ x 36¼ in. (65.4 x 92.1 cm)
Museum Ludwig, Cologne, Germany

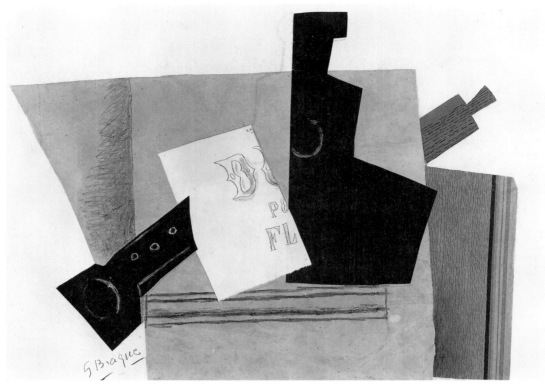

34

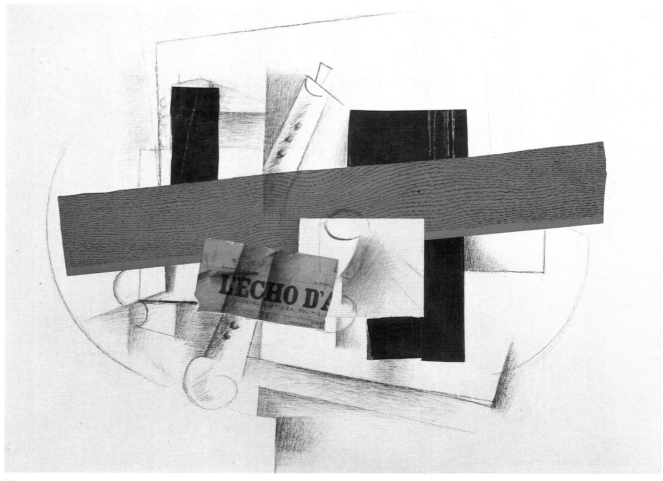

35

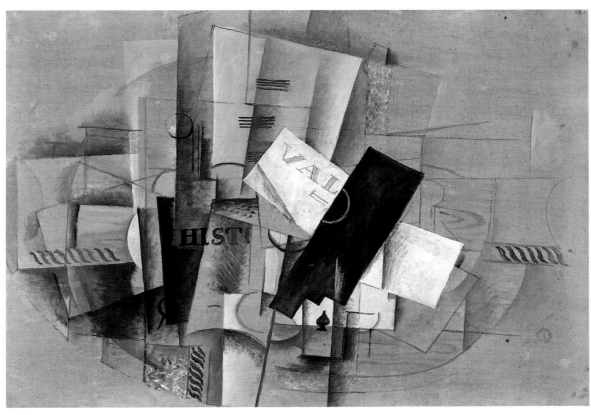

36

34. *Still Life with Flute*, 1912–13
Paper, pencil, gouache, and distemper on
cardboard, 20½ x 29½ in. (52.1 x 74.9 cm)
The Fogg Art Museum, Harvard University,
Cambridge, Massachusetts; Gift of Joseph
Pulitzer, Jr.

35. *Clarinet*, 1913
Cut-and-pasted paper, charcoal, chalk, pencil,
and oil on canvas,
37½ x 47⅜ in. (95.3 x 120.4 cm)
The Museum of Modern Art, New York;
Nelson A. Rockefeller Bequest

36. *Pedestal Table*, 1913
Oil and charcoal on canvas,
25¾ x 36¼ in. (65.4 x 92.1 cm)
Öeffentliche Kunstsammlung Basel,
Kunstmuseum, Basel, Switzerland

unifying. Well-known objects surface fleetingly, indicated by short-hand signs that we read largely because of our experience of other such signs, in other pictures. Fragments of trompe-l'oeil molding, a relic both of Braque's past and of the *papiers collés,* form a stabilizing vertical and horizontal axis, cardinal points against which everything fans out in a casual scattering of luminous planes. Braque turns the commonplace, by now predictable iconography of the Cubist studio into some of the most elegant, intelligent painting of the twentieth century.

Braque believed that using collage greatly influenced how he used color. It wasn't simply that pasted paper gave him new places to put color or that it introduced a range of hues somewhat different from the pervasive earth colors of Analytic Cubism. Collage, Braque said, helped him to realize that "color acts simultaneously with form, but has nothing to do with it"[48]—something his spotty Fauve paintings of figures might have suggested to him years before. Using collage, though, provoked "the final grasp of color. . . . There it was possible to disassociate color clearly from form and see its independence in relation to form." Instead of using color to model or

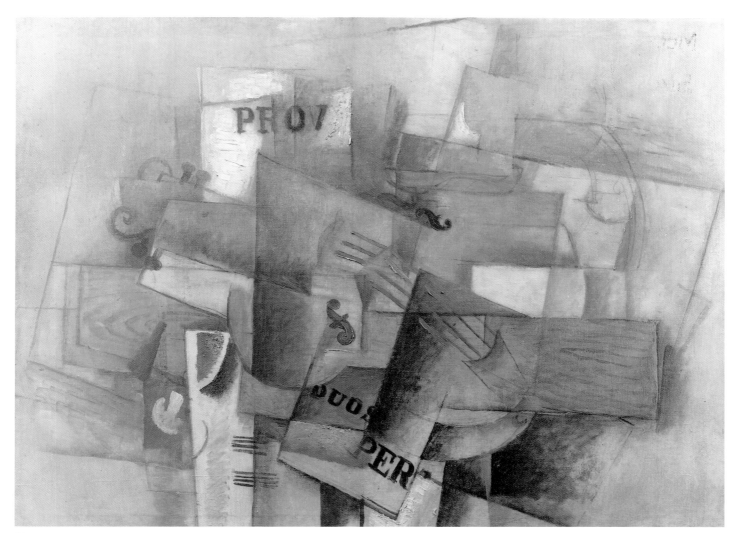

identify elements, Braque became increasingly aware of what he called "the dependence that binds color to matter," an awareness that led him to introduce sand and other textural materials into his paint, perhaps in imitation of the subtle textural differences of the pasted papers.

By 1914, probably because of the lessons of the *papiers collés*, Braque's and Picasso's paintings had taken on characteristics quite different from the complex, transparent, monochromatic constructions of the earlier years of their collaboration. Forms were no longer so assiduously dissected but instead were suggested by generous planes differentiated as much by texture as by color and drawing. Chromatic color, too, began to appear in the earth-colored Cubist world; surprising washes of crimson or green sometimes erupted at the edge of a monochrome canvas, while stippled dots of color sometimes engulfed large neutral planes. Picasso was beginning to experiment with three-dimensional constructions, like collages brought to life, and there is a photograph that suggests that Braque, too, was working the same way, although no such constructions survive. Braque's *papiers collés* took on a new richness and complexity, incorporating a greater variety of elements and bolder shapes, perhaps because of Picasso's helpful example. Yet the inherent differences between the two artists were becoming clearer, as though their remarkable aesthetic sympathy was at last beginning to erode.

In restrospect, the beginning of 1914 looms as a crucial moment in the evolution of Cubism; canvases and *papiers collés* from this period seem at once fully mature and poised for further evolution. But further evolution, at least on Braque's part, would have to wait. Soon after war was declared in August 1914, Braque was mobilized. Picasso saw his friend off at the Avignon railroad station. He later told Kahnweiler that after this he never saw Braque again. It was not literally true, but their years of collaboration and exchange were over. Could either painter have done it alone? What we know of their later work suggests that their unique combination of like-mindedness and rivalry was essential to the radical innovations of the years between 1907 and 1914. Braque's later work is supremely elegant, cool, dependent on nuances of tone, texture, and color; Picasso's is irrepressibly inventive, capricious, personal to the point of self-indulgence. Braque no doubt offered Picasso helpful discipline at the same time that he made him more aware of the possibilities of painterly painting. Picasso, in turn, must have acted as a gadfly, goading and prodding Braque. What is more astonishing than the ending of this fertile relationship is its endurance—more than six intense years, despite Braque's belief that "you can't count on enthusiasm's lasting more than ten months."

37. *Violin and Glass*, 1913
Oil on canvas, 25³/₁₆ x 36⅛ in. (64 x 92.1 cm)
Perls Galleries, New York

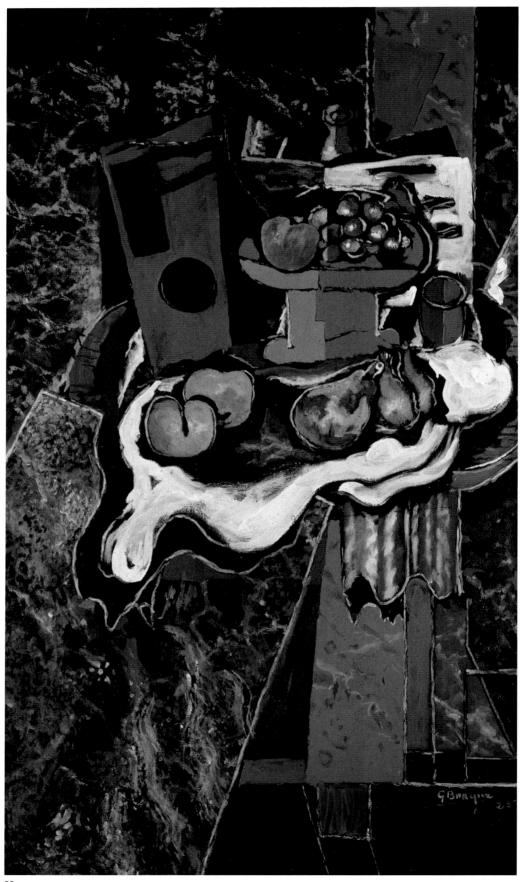

5 The 1920s and 1930s

Braque's frontline military service, his head wound, and his long convalescence kept him out of the studio for almost three years. By January 1917 he was well enough for his friends to organize a banquet to celebrate his recovery, but he was not able to begin painting again until the summer of that year. He later said that he spent this time away from his easel meditating on what he called the "poetics" of painting.

After he was invalided out of the army, in 1916, Braque divided his time between Paris and Sorgues, more or less as usual, but his companions were no longer the same. His friendship with Picasso had shown signs of strain even before Braque was mobilized, and the war itself must have made things more difficult. Braque, along with several other members of the Cubist circle (notably Derain and Apollinaire), had risked his life for his country. Picasso, citizen of a country that took no part in the war, had not. During the last years of the war and during much of Braque's convalescence, Picasso was out of Paris, even out of France. That, plus his marriage in 1918 to the dancer Olga Koklova, of the Ballets Russes, and the couple's subsequent entry into elegant society, added further distance.

Braque and Picasso continued to have many friends in common, mostly associates from their Cubist years—Apollinaire, the poet Pierre Reverdy, and the composer Erik Satie, all of whom Braque remained close to for many years. At times Braque and Picasso showed with the same dealers, but despite the many links between them, the character of their friendship had utterly changed. Braque grew closer to Juan Gris and to the sculptor Henri Laurens during these years. Laurens, in particular, remained an intimate (the Laurenses' children were the Braques' heirs); Derain, a colleague from the Fauve years and later a neighbor, also remained a significant friend. But these relationships seem to have been no more than the straightforward camaraderie of colleagues with shared aesthetic concerns, not the basis of a provocative and challenging collaboration. Perhaps the time for that kind of working friendship had passed.

Remarkably, the paintings Braque produced when he was able to

38. *Fruit on a Tablecloth with Fruit Dish*, 1925
Oil on canvas, 51³⁄₁₆ x 29½ in. (130 x 75 cm)
Musée National d'Art Moderne, Centre
Georges Pompidou, Paris

work again seem to pick up where he had left off in the summer of 1914. The dialogue between allusion and invention that is at the core of Braque's prewar *papiers collés*—indeed, at the core of all Cubism—is not only continued but intensified in such small, tightly focused still lifes as *Glass, Pipe, and Newspaper*. The familiar objects of Braque's earlier still lifes reappear as clearly defined, opaque planes, aggressively patterned or textured, or both, pulled parallel to the surface and tightly centered. There is a new density of paint in these pictures and a newly somber, saturated palette that adds still more visual weight to the crusty surface. Braque's point of view is mobile and restless, but each object has been distilled into a single expressive shape that amalgamates many viewpoints.

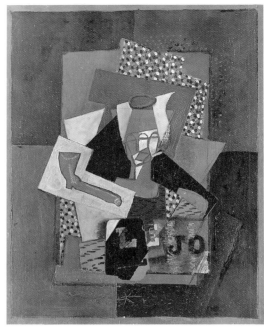

40

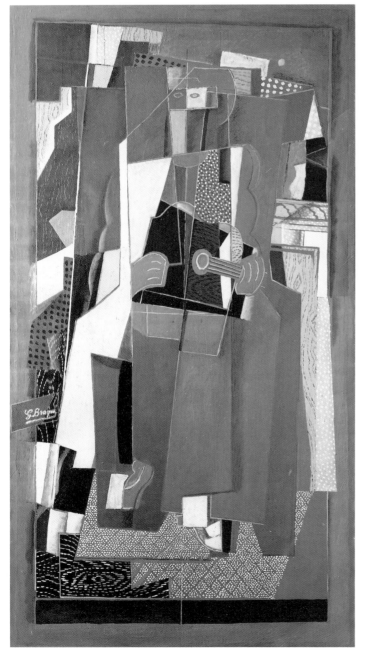

39

39. *The Musician*, 1917–18
Oil on canvas, 87³⁄₁₆ x 44½ in. (221.5 x 113 cm)
Oeffentliche Kunstsammlung Basel,
Kunstmuseum, Basel, Switzerland

40. *Glass, Pipe, and Newspaper*, 1917
Oil on canvas, 21¹⁄₁₆ x 16¹⁵⁄₁₆ in. (53.6 x 43 cm)
Mr. Eric Estorick—Family Collection

41. *Guitar and Clarinet*, 1918
Pasted paper on paper,
30⅜ x 37⅜ in. (77.2 x 95 cm)
Philadelphia Museum of Art; Louise and
Walter Arensberg Collection

These are all characteristics of what has been called "Synthetic Cubism," a term that suggests that having taken things apart, in the Analytic phase of Cubism, painters now reconstituted them. Transparency and multiplicity are replaced by unequivocal silhouettes and unbroken shapes that conflate the ambiguous fragments of Analytic Cubism into declarative, interlocking planes. Generally, the "conventions" of Synthetic Cubism provided the basis of Braque's art for most of the rest of his life. Specifically, he spent much of the 1920s and '30s exploring and expanding the notions proposed by the first paintings he made on his return to the studio in 1917, working with great single-mindedness and apparent introspection. The ambitious, subtle paintings of these years make it seem as though Braque was striving to redefine himself now that his long dialogue with Picasso was at an end. With few exceptions, the still life remained his dominant motif, a pretext for examining increasingly complex spatial notions. There's a new monumentality in his pedestal tables and mantelpieces of the 1920s and '30s. Their formats are often extreme—exaggerated verticals or horizontals that imply that the confining oval of Analytic Cubism has been wrenched open by the force of new concerns. Often, the format seems at odds with the nominal subject, but in a way that benefits the picture. Braque would crowd his lexicon of still-life objects into the upper part of his canvases and lavish his attention on their surroundings, delighting, it seems, in fusing support and supported, near and far into economical, taut, two-dimensional structures. The canvas is no longer an equivalent for the tabletop, but a multipurpose surface that absorbs much of what is visible beyond the table.

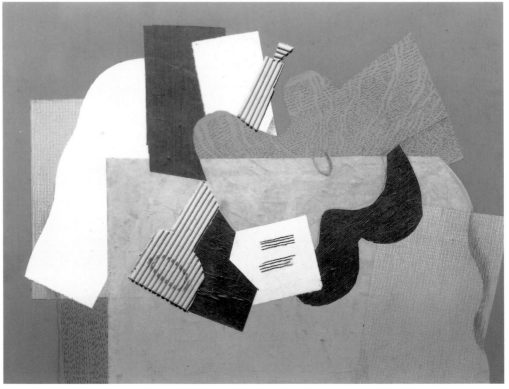

41

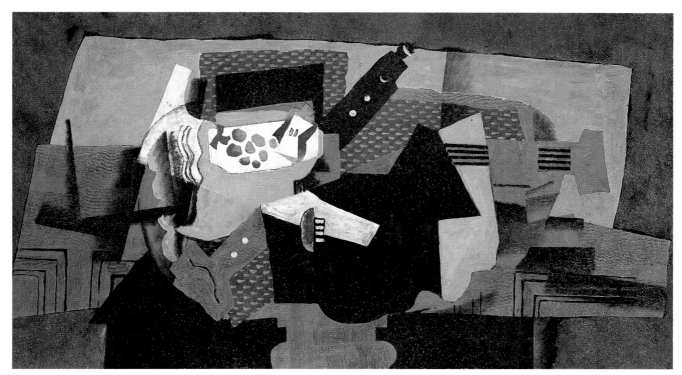

42

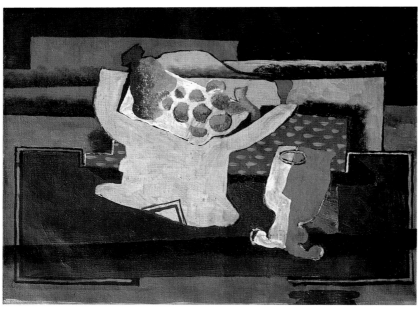

43

42 In pictures such as *Guitar and Fruit Dish*, for example, the oval top of the pedestal table is expanded by the sidewise tug of planes that extend to the edge of the canvas, carrying the color of the table and its truncated base far beyond its logical confines. These planes properly belong to the sideboard behind them (or perhaps to the paneling of the room itself), but they fuse with the table to form a powerful horizontal shape, which is opposed by a cool blue gray rectangle in the upper part of the canvas. These stacked planes,

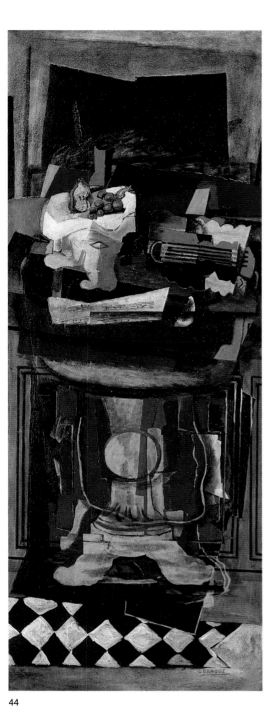

44

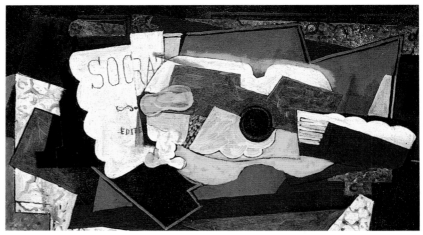

45

whose earth and sky colors oddly evoke the big divisions of land-scape, dominate the picture and establish a stable context for the lively pile of musical instruments and the fruit bowl. These are pushed forward and isolated by an angular green shape dotted with pink, a pattern that recalls the short-stroked passages of Analytic Cubism—once an evocation of planes dissolving under scrutiny but now solidified, made cheerful, playful, even decorative.

The large Guéridons, such as *The Table*, are among the most im- 44 posing pictures of this type. Braque often returned to the image, working on variants in 1928, 1929, and at intervals for many years afterward. They are, perhaps, twentieth-century equivalents of Manet's large paintings of single figures isolated against neutral grounds, or even of the heroic, full-length aristocratic portraits that were Manet's inspiration. Manet replaced the highborn patrons of his seventeenth-century predecessors with friends, colleagues, and undisguised professional models; Braque further demystified the motif, substituting for the human figure unabashed studio setups of homely fruit bowls and guitars, set on ordinary domestic furniture. (The portrait aspect of these pictures was not lost on the sculptor David Smith, whose many "table-torsos" make the association ex-plicit.) Unlike his portrait-painting ancestors, Braque resisted iso-lating his image against a neutral ground. Instead, he made enormous efforts to integrate his loaded tabletops with the voids beneath, treating the entire canvas as a single expanse that was uniformly worthy of interest, if not uniformly inflected.

Some of the forcefulness of these pictures, and of Braque's best work of the 1920s and '30s in general, is due to their physicality. As early as 1912 Braque's desire to "materialize" what he referred to as "manual space" caused him to alter the texture of his paint radi-cally, by incorporating sand, sawdust, iron filings, and other mate-rials. He wanted, he said, to make "touch a form of matter." Using pasted papers in his collages had heightened Braque's awareness of how physical differences in surface could affect perception. "What I liked a lot was indeed that 'materiality' yielded by the different materials that I kept bringing into my paintings. In fact, it was for me a means of being further and further away from idealistic paint-

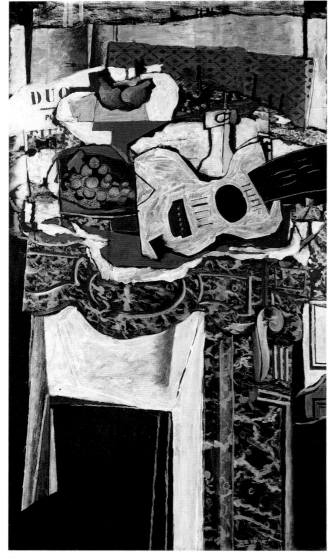

46

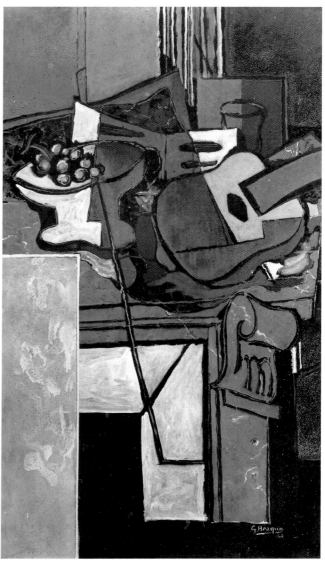

47

48

49

ing and closer and closer to the sort of representation of things that I was looking for."[49]

Variations in texture affected color, and the relation between the two increasingly preoccupied Braque as he allowed more and more chromatic color into his paintings. Color *as* texture was already present in his pictures of 1914; sheets of varicolored dots defined transparent planes. In the 1920s and '30s, however, the solidity and clarity of each element forced Braque to consider color and texture both separately and simultaneously; it also provided a new way to make subtle distinctions—planes of similar hues could have different textures and vice versa. The insistent materiality of his paintings from the 1920s on sharpens our sense of them as self-sufficient objects. Not only do Braque's grainy, gritty textures emphasize the literal surface of the canvas, but the dryness and lack of fluidity of the paint makes us conscious of the slow, deliberate process of depositing stubborn pigment on a surface; there are no bravura gestures in these paintings, only determination and thoughtful perseverance.

The robust textures, clearly bounded shapes, and crisp patterning of Braque's paintings of the 1920s and '30s counteract, to a considerable degree, their spatial complexity. They are insistently two-dimensional, testimony to Braque's enduring conception of a painting as a continuous expanse. Just as the drawing in his Analytic Cubist paintings often broke free of the edges of planes to animate the surface of the entire picture, so the planes of his Synthetic Cubist works refuse to dispose themselves in consistent spatial relationships, but expand across the canvas. The deep void of the fireplace in *The Mantelpiece*, for example, is pulled forward by its texture and color and made to occupy the same space as the guitar and compote insecurely poised on the shelf above. Braque seems to have envisioned everything in silhouette. When he describes an object best it is as a distillation, a spare planar image that stands for all of the object's most telling characteristics at the same time that it exists as a clearly invented shape—such as the fruit bowl in the marvelous *Still Life with Clarinet*.

This accounts for the unsatisfactoriness of most of Braque's figures—in particular, the group of large-scale classicizing nudes, the so-called Canephorae, which preoccupied him at about the time he was working on the large vertical Guéridons. The nearly life-size women, standing or seated, are composed more or less as the Guéridons are. Their loaded baskets are surrogate still lifes, elevated as though placed on a table. Their feet, as square as anything Braque painted in 1908, and their stylized drapery lock the figure's legs into the rectangular composition, just as the elaborations of pedestal and setting do in the Guéridons. But in the Canephorae there is that vast, problematic stretch of head, arms, and torso in between. The figures, though ample, are oddly papery, as though steamrollered, with modeling reduced to surface patterns on amorphous shapes. Braque was apparently looking again at Corot, even painting a free interpretation of one of his sturdy Italianate figures, about the time he was working on the monumental nudes, but none of Corot's sense of plasticity has infused Braque's women. The drawing of their torsos relies on the conventions of classical male sculptures, the so-called tortoise pattern of musculature—an odd

48

47

50

49

46. *The Mantelpiece*, 1922 (1925?)
Oil on canvas, 51³⁄₁₆ x 29⅛ in. (130 x 74 cm)
The Metropolitan Museum of Art, New York;
Anonymous loan

47. *The Mantelpiece*, 1923
Oil on canvas, 51³⁄₁₆ x 29¹⁄₁₆ in. (130 x 74 cm)
Kunsthaus Zurich; Vereinigung Zürcher Kunstfreunde

48. *Clarinet and Bottle of Rum on a Mantelpiece*, 1911
Oil on canvas, 31⅞ x 23⅝ in. (81 x 60 cm)
Tate Gallery, London

49. *Nude Woman with a Basket of Fruit*, 1926
Oil on canvas, 63¾ x 29¼ in. (162 x 74.3 cm)
National Gallery of Art, Washington, D.C.;
Chester Dale Collection, 1962

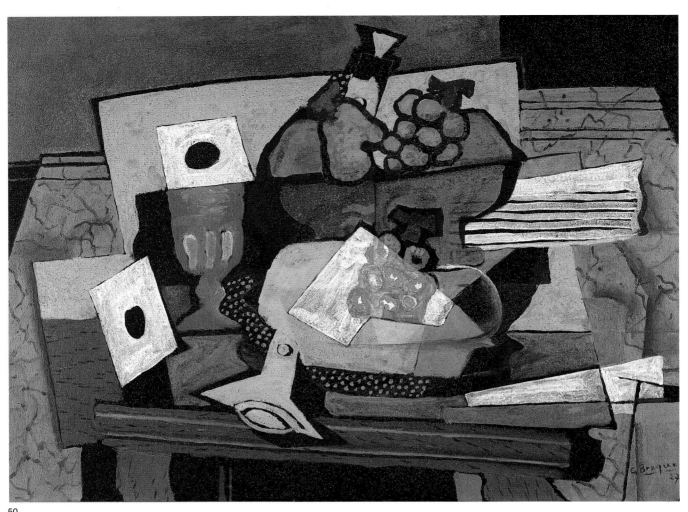

50

choice for anyone as opposed to the Academy as Braque, particularly anyone with his fine appreciation of "woman in all her natural loveliness." Yet the Canephorae, painted between about 1922 and 1926, predate Braque's 1928 trip to Italy, which might otherwise furnish an explanation for their rather arid classicism. For all the intended seriousness and ambition of the series, these paintings seem curiously trivial and superficial compared with their inanimate but more adventurous relatives.

Braque's other departure from his by now habitual still-life themes was more successful. In 1929, instead of summering in the Midi as usual, the Braques returned to Normandy, and Braque liked the region so much that he purchased and renovated a house at Varengeville, near Dieppe. The small, intense beach pictures,
51 such as *The Beach at Dieppe*, that Braque painted at wide intervals
52 between that first trip and 1938 attest to his continued fascination with the landscape of his childhood and early years as a painter. In them he concentrates on what is closest, as though painting a still life, pulling a distant horizon forward just as he pulled the interior

50. *Still Life with Clarinet*, 1927
Oil on canvas, 21¼ x 28¾ in. (54 x 73 cm)
The Phillips Collection, Washington, D.C.

51. *The Beach at Dieppe*, 1929
Oil on canvas, 9⅝ x 13¹¹⁄₁₆ in. (24.4 x 34.8 cm)
Moderna Museet, Stockholm

52. *Rocky Beach*, 1938
Oil on canvas, 9⅛ x 13¾ in. (23 x 35 cm)
Galerie Louise Leiris, Paris

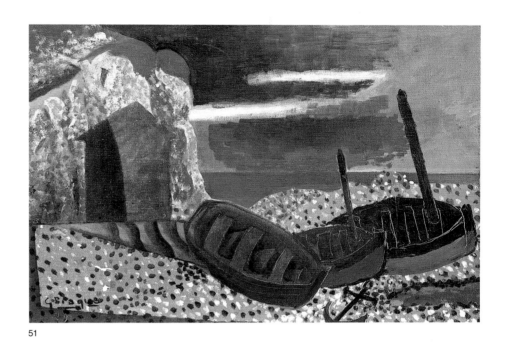

51

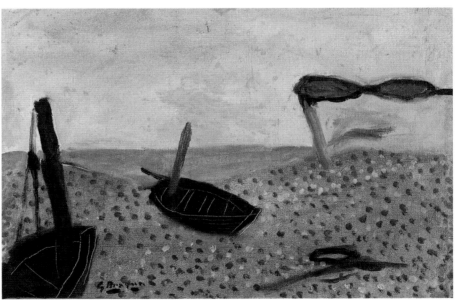

52

of the fireplace forward in *The Mantelpiece*. The sea, the tumbled boats, the cliffs, the patterned, rough-textured shingle are all unequivocally on the surface, as though the physical density of this wonderful little picture were an equivalent for the dramatic cliff-side setting. These playful little landscapes, for all their throw-away charm, are powerful evocations of place, with their simplified, bulky forms and cool, northern palette. Perhaps Braque was thinking of Gustave Courbet's tough, uningratiating beach pictures of the same region, with their rugged, drily painted cliffs, their turbulent waves and pebbly shores. Whatever the impetus, these small beach paintings are unusual in Braque's mature work; he would return to landscape in a concentrated way only during his last years.

If there is one thing that sets Braque's paintings apart after 1920, it is their color. Braque's strength as a colorist was to sustain him for the rest of his career. In his later years color could save an over-complicated picture or stiffen a weak one, transforming it and giving it unexpected power. Braque's mature palette is as far removed from the full-spectrum chroma of his Fauve years as possible, but despite its deliberate restrictions, it is more sensuous and richer. The sheer number of colors in Braque's Fauve pictures often cancel each other out. In paintings of the 1920s, such as *Still Life with Clarinet* or *The Mantelpiece,* Braque employed a much narrower range—grays, unnameable "tinted" blacks, sinister greens, slate blues—but the cumulative effect of these "non-colors" is of an infinitely varied, complex orchestration of many hues. Something of this was already present in the shimmering, subtly varied hues of his Analytic Cubist pictures, with their creamy off-whites, glowing ochers, and silvery grays, but the effect, though sumptuous, was of monochrome. After about 1920 the reverse is true; relatively little color reads as a surprising polychromy.

The chromatic colors Braque permitted himself are equally surprising. He delighted in a unifying, enveloping black and in assonant harmonies—rose, salmon, and mauve, for example, sparked by dull olive. Braque's black, like Matisse's, is as vibrant as any spectrum hue, but unlike Matisse, who turned black into an equivalent for dazzling light, Braque turned darks into a palpable atmosphere from which other colors could be dragged to the surface. The lesson of the *papiers collés,* the sense of the material presence of each element, is translated into a way of scumbling light, bright colors over a continuous darker ground. Black grays permeate and unify more brilliant colors at the same time that they set them off; patches of color become luminous, discrete, brushy shapes, as defined as pasted planes, at once detached from their surroundings and inextricable from the allover painted surface. Braque realized his ambition "to make touch a form of matter."

The materiality and odd color of Braque's paintings are so much his own that they seem virtually unprecedented, yet one precursor comes to mind. Edouard Vuillard's crusty paint handling and brooding palette, with its innumerable permutations of gray, seem to anticipate, or at least parallel, some of the characteristics of Braque's mature work. Like Braque, too, Vuillard concentrated on his immediate surroundings, turning relentlessly decorated fin-de-siècle French interiors into patterns and shifts of light that threaten to

53. *The Table*, 1928
Oil and sand on canvas,
70¾ x 28¾ in. (179.7 x 73 cm)
The Museum of Modern Art, New York;
Acquired through the Lillie P. Bliss Bequest

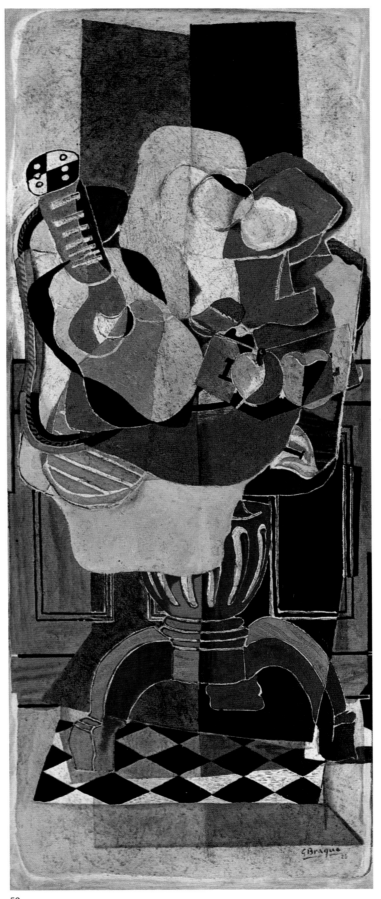

53

engulf the figures that populate his rooms. The resemblance is probably fortuitous since there is no evidence that Braque was particularly interested in Vuillard, but the similarities are nonetheless striking.

Braque's work of the 1920s and '30s is more frequently discussed in relation to Picasso's than anyone else's. Inevitably, Braque has been accused of continuing to look to Picasso for direction, even after they ceased to frequent each other's studios. Parallels exist, of course, but it would be surprising if they didn't since the language in which Braque worked for most of his life—and to which Picasso periodically returned—was a joint invention, made during their intimate years of collaboration. On occasion, during his first decades of "independence," Braque does seem to have been influenced by images that we associate with Picasso, but such works are exceptional and often among his least successful. A series of stylized, near-abstract figures of the early 1930s, seemingly indebted to Picasso's ectoplasmic bathers of the same period, are among Braque's more conspicuous failures. Braque was best when he was most himself, and happily the differences between the two painters, visible even when they worked together most closely, persisted. Even when Braque's Synthetic Cubist inventions seem to parallel Picasso's, his distinctive sense of color and his sense of the total expanse of the picture establish his individuality.

No matter how individual his work, after the war Braque was forced to reintroduce himself, in a new role, to a world that he and Picasso had once dominated. Artists who had once followed his lead, such as his friend Gris, had been perceived as innovators during the years of Braque's absence. In 1919 he declared his presence with his first one-man exhibition since 1908, at Léonce Rosenberg's Galerie de l'Effort Moderne. His former dealer, Kahnweiler, as a German citizen had been forced to leave Paris during the war and did not return until 1920. (Braque did illustrations for the fine editions Kahnweiler began to publish on his return—three woodcuts for *Le Piège de Méduse,* by his good friend Satie.) Kahnweiler's collection and inventory had been impounded by the French government and sold at auction, over three years, which his artists feared would lower their prices. Léonce Rosenberg acted as an expert adviser for these sales, and Braque is supposed to have publicly punched him in the nose for having taken part in something detrimental to the painters he represented; Braque also terminated his contract, in 1921. Three years later he began what was to be a long and fruitful connection with the dealer Paul Rosenberg.

In general, the 1920s were a decade of increasing recognition for Braque. In 1920 the first monograph on his art, by Roger Bissière, was published. Two years later the room of honor at the 1922 Salon d'Automne was devoted to an exhibition of his recent work. Over the next few years Braque—like Picasso, Gris, Fernand Léger, and many other of his colleagues—was commissioned to do costumes and decor for several productions of the Diaghilev ballet company. From this decade on, Braque exhibited fairly regularly in Paris and began to show abroad as well.

By the 1930s it was evident that the one-time avant-garde radical was beginning to be regarded as a modern master; in 1933 the Basel

54. *Still Life—"Le Jour,"* 1929
Oil on canvas, 45¼ x 57¾ in.
(114.9 x 146.7 cm)
National Gallery of Art, Washington, D.C.;
Chester Dale Collection

55. *Still Life with Fruit Dish, Bottle, and Mandolin,* 1930
Oil on canvas, 45⅝ x 35⅜ in. (116 x 90 cm)
Kunstsammlung Nordrhein-Westfalen,
Düsseldorf, Germany

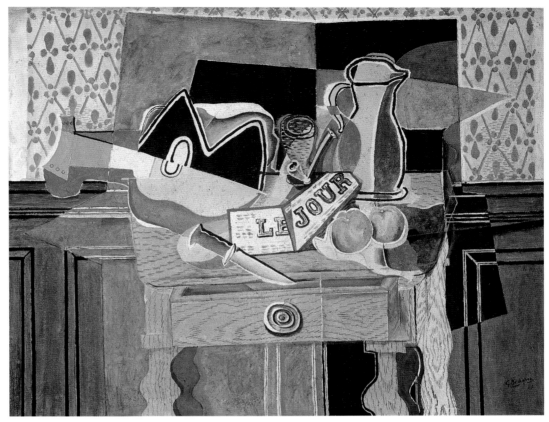

54

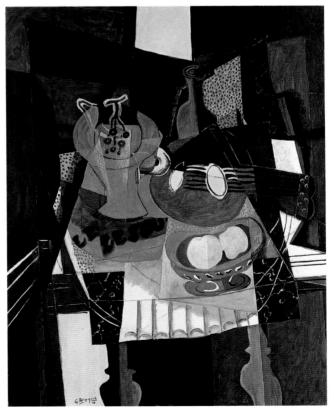

55

56

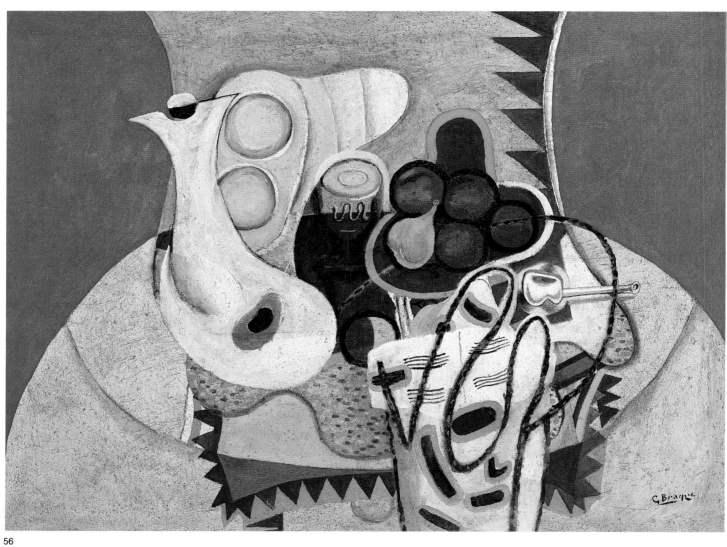

56. *The Pink Tablecloth*, 1933
Oil and sand on canvas,
38¼ x 51¾ in. (97.2 x 131.4 cm)
The Chrysler Museum, Norfolk, Virginia

Kunsthalle organized Braque's first retrospective exhibition, and to celebrate the event a special issue of *Cahiers d'art* was published, with reproductions of his work from the Fauve period on, reprints of early texts by many of Braque's colleagues, and new tributes from artists and critics. Braque was fifty-one in 1933, acclaimed and prosperous enough to have been living in his specially designed house and studio in Montparnasse for almost ten years. (The Varengeville house had been completed in 1931.) Honors and recognition continued to accumulate as he was awarded prizes and touring exhibitions of his work were organized internationally. A major exhibition, for example, traveled across the United States in 1939 and 1940.

Braque seems to have maintained a healthy detachment from his growing success. He wrote in his notebook: "For every acquisition, there is an equivalent loss. That is the law of compensation." But he added: "Whatever is not taken from us remains with us. It is the best part of ourselves."[50] Most tellingly, he declared: "If I had only one goal, it was to realize myself from day to day. In realizing myself, it so happens that what I do looks like a picture. I go my way and continue doing so, that's all there is to it."[51]

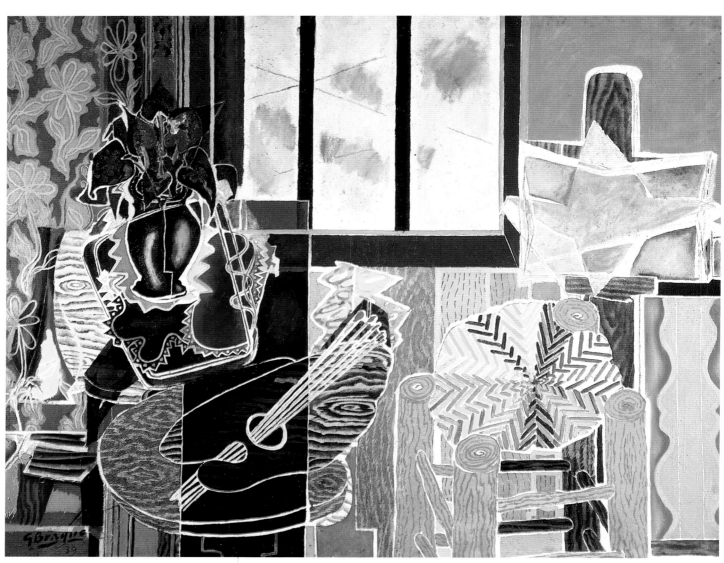

57

 # Salons, Studios, and Birds

The last entry in the 1948 edition of Braque's notebooks reads: "As you grow older, art and life become one and the same."[52] At the top of the page: a drawing of a teacup, a lemon with a slice off the end, and a knife—the unremarkable trappings of a familiar domestic ritual, the subjects of countless still-life paintings. Braque increasingly made clear how inseparable his art was from his orderly life. The studio, the salon, and occasionally the terrace or the rooms nearby defined both his daily routine and the themes of his pictures. His images are not guideposts to biography, as Picasso's often are, but we become aware, as we do in Cézanne's paintings, of particular objects and places, the furnishings and settings of a rather circumscribed, apparently calm existence. In Braque's feebler efforts a soft naturalism prevails, so that we simply recognize these motifs without testing perception against invention. But when he is at his best, we all but forget the subject and concentrate on what has been done to it, on how it has been transformed by the artist's intelligence.

Braque's preoccupation with the everyday, like his essential approach, was more or less fixed by about 1920. This single-mindedness makes it difficult to assess changes to his work from midcareer on, and his working habits, especially after the late 1930s, make it harder still. Not only did he work in repetitive series, but he often returned to related motifs at intervals over long periods and frequently worked and reworked pictures over many years. Although he had no single way of making a picture and (especially in his last two decades) he could be surprisingly uneven, Braque spoke the language of Cubism for most of his life as a painter. As a result, his development often appears seamless and remarkably consistent, but it is never a tidy, linear progression—instead, Braque seems to have repeatedly probed a clearly defined territory, exploring it from many viewpoints, testing its limits, but rarely venturing outside its boundaries.

The great cycles of paintings from Braque's mature years—the salons, the domestic interiors and still lifes, the studios, the billiard tables, the garden chairs—are, in a sense, simply expansions of the

57. *The Studio*, 1939
Oil on canvas, 44½ x 57½ in. (113 x 146 cm)
From the Private Collection of Mr. and Mrs. Walter Annenberg

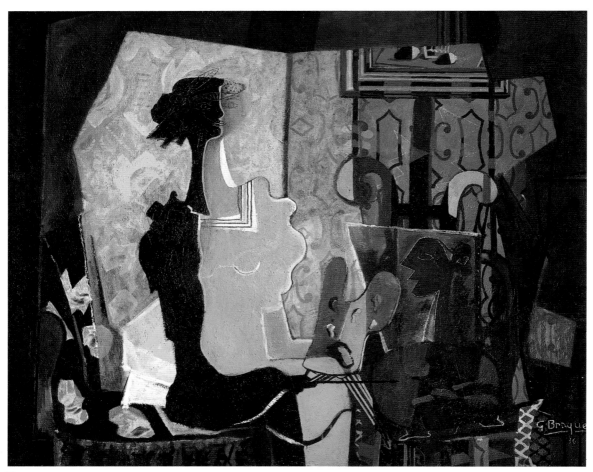

58

59

60

intimate tabletop world of the early days of Cubism. (The only exception might be the bird images that obsessed Braque in his last years, but even the bird seems to enter through a studio window.) Repeated, deliberately restricted imagery is nothing new to Braque, but the notion of working in coherent series seems to have originated with the large interiors of 1936–37—curious jammed pictures such as *Woman at an Easel* or *The Duo,* which amalgamate the salon and the studio. Just as he had conflated many aspects of a single still-life object into an eloquent Synthetic Cubist shape, so Braque conflated the place of ordinary domestic life, of leisure, and—for him, apparently—of music, with the workplace, the room consecrated to a kind of labor and to the visual.

58, 103

The real subject of these pictures is the complexity of the settings themselves, the overwhelming patterning of bourgeois French rooms, perhaps an echo of the decorations Braque had learned how to paint when he left school and almost certainly a reflection of the former bohemian's present surroundings. The canvases are packed with wallpaper, paneling, the intricacies of studio fittings, and living room furniture. Only Braque's acute sense of how to animate and order the whole expanse of a picture saves the series from succumbing to mere *horror vacui.* The figures that, atypically, populate these interiors are more attenuated and complex than the Canephorae but no less papery. At times they seem indistinguishable from their wallpaper backgrounds; indeed, they are often best when they are swallowed by their settings or fuse with them, as in *Woman with a Mandolin,* where the stacked lozenges of wallpaper and music stand read as linear variants of the elongated, nibbled-away shape of the flattened figure.

49

59

What lifts these potentially banal pictures out of the realm of anecdote is their audacious color—edgy harmonies of dull and acidic greens, lively pinks, generous amounts of black and black brown. Corot is somewhere at the back of Braque's mind in these works, as he was in the Canephorae, but to better effect. The surprising color is Braque's own, but paintings like *Woman with a Mandolin* are simply jazzy, updated versions of Corot's celebrated studio interiors. Even the profile poses of Braque's women seem to echo Corot's models, who turn away from the viewer, engaged by the fictive world of the canvas.

The intimate world of his studio, particularly the microcosm of the tabletop, provided Braque with a refuge after the outbreak of World War II in Europe. The austerity and hardship of the period are visible in the sparse still lifes that he painted during the war

58. *Woman at an Easel*, 1936
Oil on canvas, 51³⁄₁₆ x 63¾ in. (130 x 162 cm)
Private collection

59. *Woman with a Mandolin*, 1937
Oil on canvas, 51¼ x 38¼ in.
(130.2 x 97.2 cm)
The Museum of Modern Art, New York;
Mrs. Simon Guggenheim Fund

60. *The Loaf of Bread*, 1941
Oil and sand on canvas,
16⅛ x 47¼ in. (40.9 x 120 cm)
Musée National d'Art Moderne, Centre
Georges Pompidou, Paris

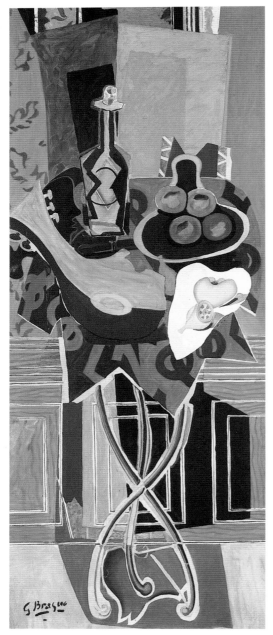

61

years. They range from the elegant simplicity of *The Loaf of Bread*
to the rather literal naturalism of *Vanitas*. Such pictures seem
straightforward enough: a celebration of simple things to eat, an
explicit memento mori, testimony to understandable preoccupa-
tions during these difficult years. Yet the skull that is an apparently
unambiguous, classical reminder of death in *Vanitas* seems to
change meaning depending on its context. In the energetic, cheerful
Studio with Black Vase it is a fragmented studio prop; elsewhere it
is a kind of punning equivalent for an artist's palette; at still other
times it seems interchangeable with the meager foodstuffs in Braque's
frugal wartime still lifes, so that these modest, unassuming paint-
ings stand as reminders of both mortality and the necessities of life.

Such complex relationships of images are typical of Braque's ma-

61. *The Red Pedestal Table*, 1939–52
Oil on canvas, 70⅞ x 28⅝ in. (180 x 73 cm)
Musée National d'Art Moderne, Centre
Georges Pompidou, Paris

62. *Interior with Palette*, 1942
Oil on canvas, 55⅝ x 77 in. (141.2 x 195.6 cm)
The Menil Collection, Houston

63. *Studio with Black Vase*, 1938
Oil and sand on canvas,
38¼ x 51 in. (97.2 x 129.5 cm)
Mr. and Mrs. David Lloyd Kreeger,
Washington, D.C.

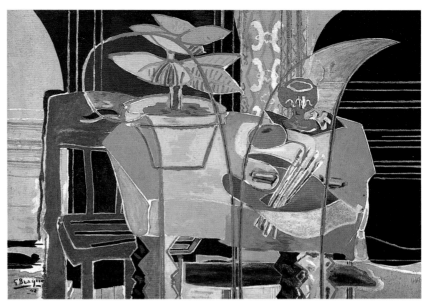

62

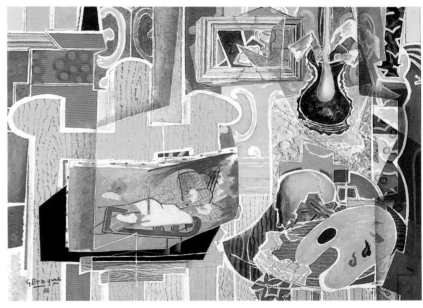

63

ture paintings, evidence of the challenging, intricate connections between works often widely separated by time. The shape of the loaf in *The Loaf of Bread,* for example, which rhymes with the bread knife to the right of the picture, also has cognates in earlier paintings—the rounded shape that we read as a mandolin in *The Pink Tablecloth,* for example. This is no lack of inventiveness on Braque's part. On the contrary, he seems to have courted his tendency to make visual equations of seemingly dissimilar things. In his notebooks he wrote: "Look for points in common that are not points of similarity. It is thus that the poet can say 'The swallow stabs the sky,' and turns the swallow into a dagger."[53]

The notion of visual metaphors may owe something to Braque's longstanding friendships with poets such as Pierre Reverdy and

56

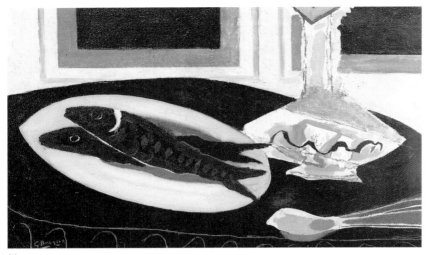

64

65

René Char; it also helps to explain how skulls, palettes, and loaves of bread can generate closely related shapes and even how they transform themselves into the omnipresent bird of the 1950s. It is not simply a question of Braque's repeating an existing composition with variations—substituting, say, a compote for a mandolin, since both are rounded shapes with "stalks"—although this was certainly part of his practice. In some pictures the bird shape exists as an unstable image, unmistakably avian but at the same time comprising the fundamental symbols of nourishment, of the painter's trade, and of the transience of life.

But as Braque wrote: "What the painter attempts is not to reconstitute an anecdote, but to constitute a pictorial event."[54] He would have been wary of any attempt to attach psychological meaning to his images, however ambiguous. A provocative notebook entry reads: "It is a mistake to enclose the subconscious in an outline and

64. *Carafe and Fish*, 1941
Oil on canvas, 13³/₁₆ x 21⁷/₈ in. (33.5 x 55.5 cm)
Musée National d'Art Moderne, Centre
Georges Pompidou, Paris

65. *Vanitas*, 1939
Oil on canvas, 14⁷/₈ x 21⁵/₈ in. (38 x 55 cm)
Musée National d'Art Moderne, Centre
Georges Pompidou, Paris

66. *Washstand with Green Tiles*, 1944
Oil on canvas, 63³/₄ x 25¹/₈ in. (162 x 63.8 cm)
The Phillips Collection, Washington, D.C.

67. *Washstand in Front of the Window*, 1942
Oil on canvas, 51³/₁₆ x 38³/₁₆ in. (130 x 97 cm)
Musée National d'Art Moderne, Centre
Georges Pompidou, Paris

66

67

situate it at the border of rationality."[55] Even the obsessive bird configuration had its origins in daily life—a trip to the Camargue, as Braque explained in an interview. Deeply moved by the sight of birds by the ponds of the region, he said he wished "to make use of the feelings roused in me in my drawings and paintings." But, he cautioned, "The concept, even after the shock of inspiration that the birds raised in my spirit, the concept had to be effaced, to be suppressed, to put it a better way, so that I could come closer to what preoccupies me fundamentally: the construction of pictorial fact."[56]

The German occupation kept Braque from his Varengeville house for almost four years, depriving him of an important source of "pictorial fact." His pleasure in being able to return is manifest in one of the first works he painted after liberation, *The Salon (Interior)*. A paean to both rational "pictorial fact" and domestic order, the painting seems extraordinarily fresh. The suffocating "interiorness" of the fiercely patterned salon-studios of the late 1930s has been replaced by a new lucidity and solidity, in which the space is opened to the outside world by a window. The motif is hardly new to Braque: during the Occupation he painted a series of slender vertical canvases, "portraits" of intimate domestic furniture—such as *Washstand with Green Tiles* and *Washstand in Front of the Window*—in which a glimpse of window provides an escape from the constricted, narrow image. Then, too, at least one of the large interiors of the late 1930s includes the vast window of Braque's studio. But *The Salon (Interior)* translates these familiar ideas into a newly generous and serene image.

Everything in the large horizontal painting merges to serve as a "frame" for the window, one side flung open, that dominates the picture, more by its "otherness" than its size or placement. Cool and pale against the warm planes of the interior, the window is defined by a simplified pattern of broad rectangular mullions and a stylized balcony grille, bold strokes of drawing that contrast with the delicate arabesques of the rest of the picture. The brushy gray blue expanse of the window is a visual equivalent for air, a sign for openness, breadth, freedom. A plane of slightly warmer gray suggests a sheer curtain and presses the cooler blue of the window back, exerting a spatial pull that opens the structure visually as well as symbolically.

The Salon (Interior), with its sense of calm and amplitude, is the antithesis of Braque's congested prewar interiors and no less different from his claustrophobic wartime still lifes. If it has a precedent, it is, oddly, the tentative painting of Normandy, *The Côte de Grace, Honfleur*, which Braque painted in 1905. As in the early landscape, the areas of greatest incident are confined to the periphery, almost pushed out of our field of vision. We are made to concentrate on an unequivocally *painted* nonevent in the center of the canvas—the implied void of the window. The unexpectedness of this composition keeps us off balance.

Although *The Salon (Interior)* would make us expect that Braque's first postwar series would be domestic or studio interiors, continuations of the last large-scale pictures he did before the war, he turned instead to a new motif: the billiard table. The subject was a depar-

89

66, 67

9

68–70

68

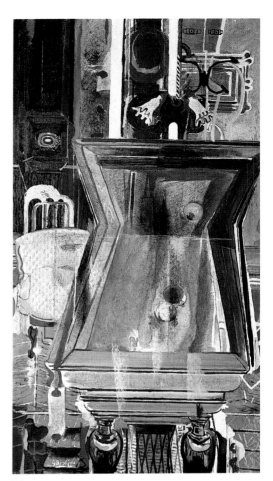

70

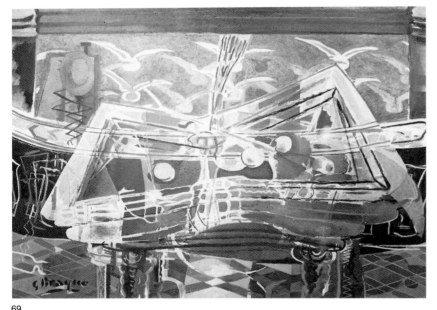

69

ture, but not surprisingly, it derived from his ordinary pursuits. Braque was an adept at the game and played frequently with his brother-in-law. More important than this anecdotal reference is that the motif likely touched some of Braque's most deeply held notions of what a picture could be. The shifting points of view that a billiards player must adopt as he lines up his shots are a functional version of the multiple perceptions of Cubism. In the course of a game a player must contemplate the playing surface from above, the table level, and from various side angles; as in Cubist paintings, no one viewpoint is the truest or most important. For Braque the billiard-table series could have been an elaborate double metaphor, a translation of the game's likeness to simplified Cubist ideas back into Cubist imagery.

The series—painted between 1944 and 1949, with one more picture completed in 1952—is as full of visual events as the patterned

68. *The Billiard Table*, 1944
Oil and sand on canvas,
51⅜ x 77 in. (130.5 x 195.5 cm)
Musée National d'Art Moderne, Centre
Georges Pompidou, Paris

69. *The Billiard Table*, 1947–49
Oil on canvas, 57½ x 76¾ in. (146 x 195 cm)
Museo de Arte Contemporáneo, Caracas,
Venezuela

70. *The Billiard Table*, 1945–52
Oil, sand, and charcoal on canvas,
71¼ x 38½ in. (181 x 97.8 cm)
The Jacques and Natasha Gelman Collection

71. *The Garden Chair*, 1947
Oil on canvas, 24 x 19⅝ in. (61 x 50 cm)
Musée National d'Art Moderne, Centre
Georges Pompidou, Paris

72. *The Mauve Garden Chair*, 1947–60
Oil on canvas, 25⅝ x 19¾ in. (65 x 50.2 cm)
The Jacques and Natasha Gelman Collection

interiors of the late 1930s and nearly as complex as any of Braque's earlier Cubist canvases. He treated the horizontal plane of the billiard table with as much daring as he did the most modest café table, warping and folding it, opposing its sturdy edges with abruptly angled cues, wall paneling, and hanging lights. He experimented with formats, switching, in the last version of the motif, *The Billiard Table*, to a vertical, so that the canvas itself echoes the shape and proportion of the playing surface; he then destroyed the conceit by filling the offered expanse with a host of details about the room. Abrupt planar divisions evoke the concentrated lighting of the billiard room, while the green of billiard cloth seems to provide a basis for color harmonies. Oddly, there is relatively little green in these pictures, but it is extended by ochers and accentuated by warm browns, like old wood paneling, so it appears to dominate. A small note of red—a billiard ball—sparks each painting of the series, like the isolated note of red in Corot's late silver green landscapes.

Braque's work on the billiard series was interrupted in the summer of 1945, when he underwent major surgery and was unable to paint for several months. (A letter from Marcelle Braque records that Picasso was a daily visitor during Braque's convalescence.[57]) That period and the years immediately following were marked by even greater attention to the artist who, in his mid-sixties, was beginning to be regarded as something like a national monument. Several books about Braque were published in the mid- and late 1940s, while important exhibitions of his work were organized in Amsterdam, Brussels, New York, and Zurich. In 1947 Braque had his first one-man exhibition in Paris since his wartime showing in the special room of the 1943 Salon d'Automne—this time at the gallery of his new dealer, Aimé Maeght. (The New York incarnation of Braque's former gallery, Paul Rosenberg and Company, continued to exhibit his work on the other side of the Atlantic.) A

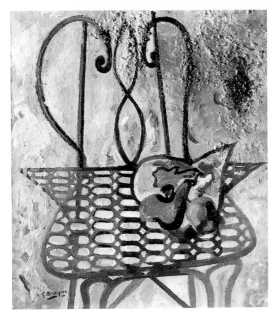

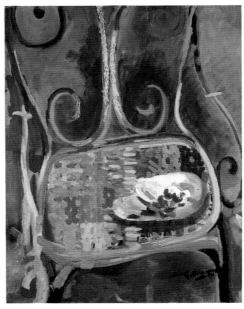

71

72

special section of *Derrière le miroir* was devoted to Braque, the first of many issues of that elegant magazine to be dedicated to him. A year later the 1948 Venice Biennale featured a Braque room, and in 1949 the Museum of Modern Art, New York, organized a retrospective exhibition.

In 1947 the fully recovered Braque began a new series, seemingly unrelated to but concurrent with the billiard-table paintings. These pictures, based on an image that first appeared in a charcoal drawing of 1943 (location unknown), are uncharacteristic, powerful close-ups of a typical French garden chair. Only a late version of the motif, *The Terrace,* expands the image into something like Braque's more usual complexity: the viewer steps back a bit, the two chairs are drawn up to a garden table, their unmistakable outdoor-ness challenged by the overscaled wood graining of the ground, like a parody of the chairbacks. The dialogue of these pictures with those in the billiard-table series is apparent. The waisted form of the chair, the angle of the back and seat, is obviously related to the folded shape that Braque assigned to his billiard tables. Conceptually, however, the two images reverse each other. In the billiard-table series Braque reinvented a flat expanse in terms of discontinuous planes; in the garden-chair series, he flattened and joined planes that, though transparent, are opposed to each other. Each series seems to have extended and altered the visual propositions stated by its counterpart.

Most of the paintings in the garden-chair series are small, so that the chair appears more or less actual size, sharply cropped to the arabesque coil of its back and the grid of its seat. Surfaces are densely brushed, the color is saturated and intense. The scroll-like drawing of the chairbacks clearly derives from the same impulse as the wallpaper patterns in Braque's crowded interiors, but the economy of the image suggests Matisse almost more than it does any-

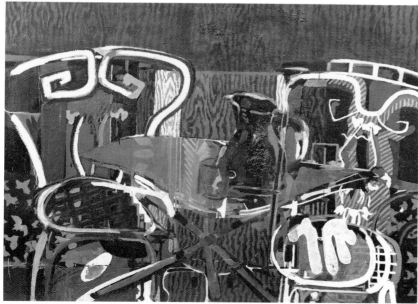

73. *The Terrace,* 1947–61
Oil on canvas, 38¾₁₆ x 51¾₁₆ in. (97 x 130 cm)
Mr. and Mrs. Claude Laurens, Paris

thing in Braque's own past work. (The 1943 charcoal drawing is similarly Matissean.) There is, in fact, a Matisse painting of 1918, *Chair with Peaches* (private collection), which provides a striking prototype. The likeness forcibly reminds us of Braque's early association with Matisse, in his Fauve years, and makes us see persistent affinities between the two artists—a lifelong fascination with pattern, for example—that have perhaps been obscured by Braque's close connection with Picasso. Braque's tendency was to elaborate, whereas Matisse's was to simplify, but they also shared ideas about structure. The broad, rectangular planes of Braque's mantelpiece still lifes, or the exuberant patterning and color of the "tablecloth" paintings of the 1930s, to take only two examples, imply some sort of enduring dialogue with his former colleague's work.

Even some of Braque's more typical paintings of the late 1940s, such as the splendid, angular *Still Life with Bottle, Vase, and Lobster,* make the notion of a connection with Matisse fairly explicit. (The vase, with its out-thrust "hip," has more bodily presence than any of Braque's figures.) Yet he seems to have mistrusted the sparseness of such pictures, to judge by a second version of the motif, *Still Life with Spiny Lobster.* The central image of bottle and vase have been repeated almost verbatim, but the vase is frivolously articulated and decorated. The whole picture is taller and narrower, compressed and extended. The later picture seems less relaxed and more static; the somber colors and the gritty paint texture fix everything immutably on the surface.

If Braque truly felt that his art and his life became more inseparable as he grew older, then the last major cycle of his career, the nine large Studios that he worked and reworked between 1949 and 1956, can be seen as a series of self-portraits. The Studios both reflect Braque's still-evolving concerns and sum up everything that came before. All of his familiar "props" are present—the palettes, pitchers, compotes, easels, and pedestal tables—but combined in new ways in a newly ambiguous space. The series began modestly enough, with a closeup view of a corner of the studio, a "collage" of works in progress or hung on the wall plus edges of frames. But the next painting of the group is *The Studio II,* a bafflingly complex interior. The large bird that haunts Braque's late paintings is woven into an intricate cage of vertical planes—easel? canvases? fragmented space? Like the open window in *The Salon (Interior)* or the illusionistic nail in the 1910 *Violin and Pitcher,* this overscaled, inexplicable image, a denizen of the out-of-doors flattened into a heraldic symbol and fragmented by the painting's shifting darks and lights, changes our perceptions. The pale bird shape flickers across the canvas, its progress blocked visually by a wedge of pattern that further disrupts our sense of coherent space and scale.

Throughout the series Braque shifted and rearranged these components—thrusting some to the side, exposing new images and concealing still others—as though shuffling a stack of completed canvases. The bird remains, sometimes filling an enormous area, sometimes reduced to a casual presence perched on an easel. In *The Studio III* the bird has been tamed and distanced, turned into a painting within a painting, as it was in the first work of the series, but making the space even more unstable and unsettling.

74

75

76

89

29

92, 93

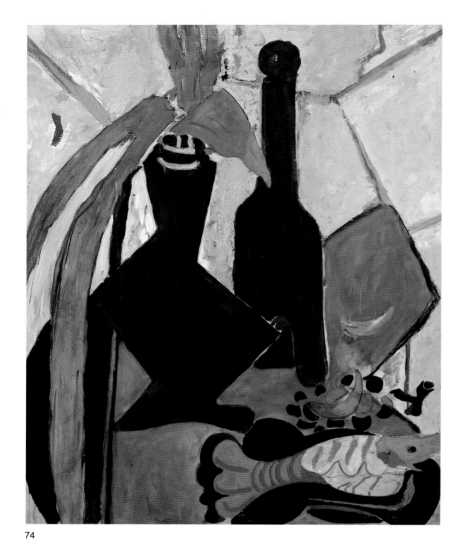

74

75

Toward the end of the series, in 1953, Braque worked simultaneously on the Studios and on several commissioned projects, including the ceiling in the Louvre—he used extremely simplified bird motifs that respond to the volutes of the ceiling's border—and stained-glass windows for a chapel at Varengeville and for a church at Saint-Paul-de-Vence. The uncharacteristically bright palette of the eighth Studio, begun in 1952, may reflect Braque's experience of new media. With this exception, however, the series is virtually monochromatic, ringing changes on brown blacks, sooty grays, and mahogany browns, with occasional flashes of light. Often the graininess of Braque's textured paint all but obscures color and knits together abrupt planar divisions, pulling prismatic bands back to a single surface. Braque's studio is a solemn interior space where illusion is pitted against actuality, a laboratory in which to test perception.

The darkness, the aggressive textures, and the bird images persist throughout Braque's paintings of the 1950s, but as though to refresh himself from the rigors of the Studios, he also returned to earlier, more casual themes. There are reprisals of the terrace and garden-

74. *Still Life with Bottle, Vase, and Lobster*, 1948
Oil on canvas, 71¼ x 55½ in. (181 x 141 cm)
Mr. and Mrs. Claude Laurens, Paris

75. *Still Life with Spiny Lobster*, 1948–50
Oil and sand on canvas,
63¾ x 28⅝ in. (162 x 73 cm)
Galerie Maeght, Paris

76. *The Studio II*, 1949
Oil on canvas,
51½ x 63¹⁵⁄₁₆ in. (130.8 x 162.3 cm)
Kunstsammlung Nordrhein-Westfalen,
Düsseldorf, Germany

77. *Two Windows*, 1952
Oil on canvas, 38³⁄₁₆ x 51³⁄₁₆ in. (97 x 130 cm)
Perls Galleries, New York

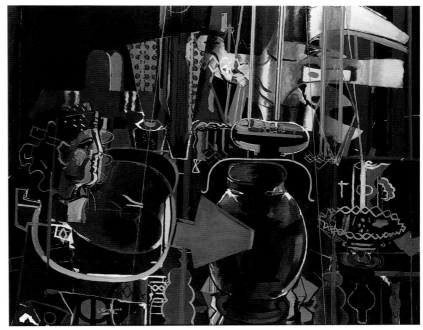

76

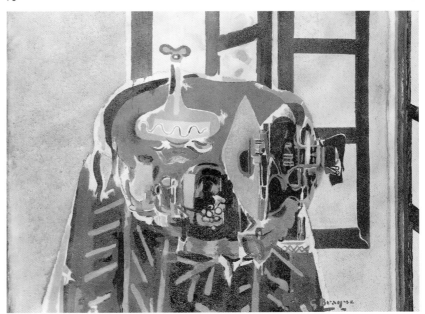

77

chair motifs, such as *The Blind*. Compared to the first versions 1
of the image, these have a new spatial intricacy that may reflect
Braque's preoccupations with the prismatic Studios. At the same
time, pictures like *Two Windows*, with its unbroken stuccolike 77
planes and schematic drawing, are indications that he was rethink-
ing familiar motifs with a new economy, precisely when he was
working on the most complex of the Studios.

 The most extreme alternatives to the dense spatial convolutions
of the Studios are the vast, stripped-down bird images of Braque's
last years. They can be as specific as *Bird and Its Nest* or as schema- 79

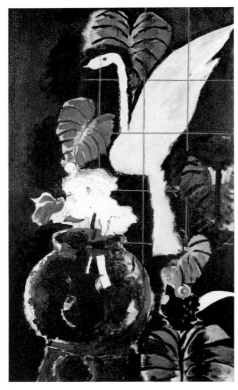

78

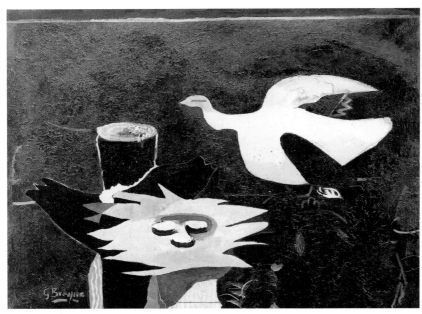

79

80 tic as the elegant and eloquent *In Full Flight*. Pictures such as these seem to be as much about a crusty, built-up surface as about any particular image. There can be no doubt that the monumental flying bird had profound resonance for Braque, yet the evolution of *In Full Flight*, documented in photographs, suggests that his theme was ultimately a meditation on the making of art rather than on whatever meaning the bird held for him. In its first state the picture consisted only of two dark shapes isolated against a light blue

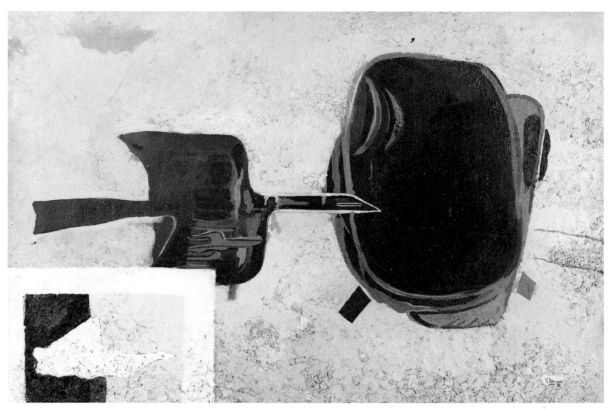

80

81

ground evocative of open sky. Later Braque added the stark image in the lower left of the painting, which is a version of one of his own works and an even more simplified emblem of flight. The cropped border of this "applied" image emphasizes that it has been appropriated from an existing picture, not from nature. The gesture at once destroys any lingering naturalism in Braque's original image and returns us firmly to the world of art making.

As though to confirm the implications of a painting like *In Full*

82

83

Flight, enigmatic pictures such as *The Checkered Bird* make plain the continuing tension between what Braque called "pictorial fact" and allusion. At first glance *The Checkered Bird*, with its combination of still life, window, and bird, appears to be a simplified, clarified version of the Studios. It seems most striking for its rich, subtle color—strange harmonies of blue gray and gray green set off by the red grid. But is the grid really a reference to a studio skylight or is it a literal grid, imposed on an image squared up for enlargement or transfer? The painting was made just at the time that Braque was working on his large commissions, and such gridded preparations were part of his daily practice. Once again, it seems likely that the bird is not a reference to nature but has been transformed into a man-made image, already a work of art.

82. *Seashore, Varengeville*, 1952
Oil on canvas, 9¹³/₁₆ x 25⅝ in. (25 x 65 cm)
Galerie Maeght, Paris

83. *Seascape*, 1956
Oil on canvas, 10¼ x 25⁹/₁₆ in. (26 x 65 cm)
Mr. and Mrs. Claude Laurens, Paris

84. *The Cultivator*, 1961–63
Oil on canvas, 40⅜ x 69½ in.
(102.6 x 176.5 cm)
Musée National d'Art Moderne, Centre
Georges Pompidou, Paris

The increasing simplicity of these late works has elicited the description "archaic" from some writers on Braque. It carries with it an idea that the artist, in his seventies, acclaimed and full of honors, was searching for something elemental, perhaps fundamental in his art. There is no denying that Braque's last work became more and more economical. The elaborate spatial orchestration of the Studios was never repeated after he completed the last of that ambitious series, and in its place arrived a new iconic clarity, a new consolidation of subject matter into hieratic, frontal images. It is this frontality, this reductiveness, and the way configurations are isolated against neutral grounds that have given rise to the idea of Braque's archaicism, not any self-conscious imitation of the primitive.

Not only did Braque's approach change in his last years; from the late 1950s on, his subject matter altered as well. As though recapitulating his own history, he returned to the landscape and beach 82, 83 motifs that he had first tackled as a novice painter and last explored twenty years back. The cliffs of Varengeville and the fields near his house became his primary motifs. The complicated, earthbound shapes of farm machines—ploughs and cultivators isolated against 84 thickly stroked backgrounds of earth and sky—replace the airborne silhouettes of overscaled birds. When birds are present they are reduced to shorthand calligraphy. There is also the occasional playful "portrait" of another kind of machine, the bicycle that a p. 2 younger Braque once rode tirelessly through the countryside.

84

Some of the economy and the frequently small scale of Braque's pictures of these last years is due to the precarious state of his health. By about 1959 he was forced to reduce his painting time and to concentrate instead on drawing and print making. But diminished energy accounts only partly for what was apparently a reconception of what a painting could be. On the one hand, there is a logical development of notions already present in Braque's earliest Cubist paintings: the late pictures are all foreground, all surface, and their reductive, isolated silhouettes can be seen as a continuation of the condensed shapes of Synthetic Cubism. On the other hand, these pictures are simultaneously overloaded and weak in ways that seem completely at odds with anything that preceded them. Braque reduced the farm landscape to bands of earth and sky punctuated with birds and machinery, then seemed to lose faith in what he had done. It is as though the aged painter was trying to reinvent van Gogh's last painting of crows over a wheatfield, admitting into his own work things that he had deliberately excluded for years but losing van Gogh's ferocity along the way. Instead, Braque substituted elegance and a kind of desperate insistence.

Braque clearly was well aware of van Gogh from the very beginning, when he is supposed to have copied his work. Given Braque's fascination with the expressive and structural possibilities of stroke and texture, he must have paid attention to van Gogh's obsessively worked surfaces. Paintings such as Braque's last work, *The Cultivator,* suggest that, if not trying to emulate van Gogh, he was at least trying to force comparable energy back into his minimalist image, loading more and more paint onto the inert surface as though unable to stop himself.

The imagery of the last landscapes, the ploughs and cultivators excavated from the surrounding hills of thick paint, make two entries in Braque's notebook especially provocative. "The plough at rest gets rusty and loses its normal meaning," Braque wrote and accompanied the phrase with a drawing of a still life with a stylized palette made to resemble the foreshortened blade of a plough. Somewhat later, he returned to the theme: "Blood. The sharp blade of the plough. The inevitable holds our ideas in check. Chance puts them to rout."[58]

Braque has probably been discussed as often as a pioneer of Cubism and particularly as Picasso's collaborator as he has been as an individual. The importance of what the two men achieved together, in light of the subsequent course of twentieth-century art, and the glamour of the connection in light of Picasso's subsequent reputation, makes this understandable, but it is not particularly enlightening. No one can deny the fruitfulness, the excitement, or the fascination of the years Braque and Picasso spent working closely together, nor the high quality and radicalism of the work their collaboration produced. No one can deny the significance of the ideas embodied in that work to Braque's own later development, but to think of him primarily in relation to Picasso is to underestimate him and to miss some of what makes Braque unmistakably "Braque."

There is in Braque's art an apparently contradictory alliance of severe rationality, intense sensuality, and—unexpected in a mem-

85

85. Braque at Varengeville, 1953

ber of a true avant-garde—a profound appreciation of the everyday and the domestic, a combination that could be called, in an expedient shorthand, Braque's *Frenchness*. A Cartesian clearheadedness is already visible in the archetypical geometry of the vernacular buildings and landscape forms in his 1908 paintings of L'Estaque. The same sense of underlying geometry, of rational order, permeates even the most complex of his Analytic Cubist pictures. Even in the most florid of Braque's Synthetic Cubist works, austere geometry is implicit. Lush patterns and textures are kept in check by their rela-

tion to the surface; skewed planes are made more expressive by the distance they have traveled from vertical-horizontal alignment; complex shapes at once recall the irregular objects that generated them and the Platonic ideal beneath those irregularities.

That Braque was able to accomplish this without having his paintings succumb to a stultifying rigidity is part of his genius and his originality. No matter how aware we are of the geometric reference points in his work, we are equally aware that the pull they exert is elastic. Braque's paintings always breathe and pulse; however cool or restrained they may be, they rarely suffer from the static idealism of, for example, the work by his colleague and friend Gris. Part of this is due to Braque's inherent sensuality, which manifests itself in the rich paint quality that distinguishes even the most severe (or the slightest) of his pictures. His deep appreciation of the physical character of his medium is evident from first to last, sometimes declaring itself as texture, sometimes as gesture, sometimes as color and pattern.

Braque himself would have been impatient with any attempts to classify his work. "To define a thing," he wrote, "is to replace it with its definition." Process was always more important to him than end result, as he declared in two notebook entries, many years apart: "It is not the goal that is interesting, it is the means of reaching it." And, "For me, application to my work has always taken precedence over anticipated results. In seeking the inevitable, you discover yourself."[59]

The self that Braque discovered is manifest in his paintings, and happily, they speak for themselves. The qualities that Braque's work exemplifies—clarity, logic, invention, unexpectedness—are personal as much as they are national, yet it is irresistible to cite these as defining some of the best of French art: painting, literature, and architecture alike. In the end Braque's work was good enough to withstand whatever labels we choose to put on it. He emerges as one of the most elegant, intelligent, and disciplined of painters, passionate but restrained. As he wrote in 1917: "Nobility grows out of contained emotion. Emotion cannot be rendered by an excited trembling; it can neither be added on or imitated. It is the seed, the work is the flower. I like the rule that corrects the emotion."[60]

NOTES

Unless otherwise indicated, translations are by the author.

1. Daniel-Henry Kahnweiler, with Francis Crémieux, *My Galleries and Painters,* trans. Helen Weaver (New York: Viking, 1971), p. 44.

2. Ibid., p. 81.

3. Toklas, in Janet Flanner, "Profiles: Master (Georges Braque)," *New Yorker,* October 6 and October 13, 1956; in Flanner, *Men and Monuments* (New York: Harper, 1957), p. 132.

4. Braque, in an interview by Dora Vallier, "Braque, la peinture et nous," *Cahiers d'art* 29 (October 1954): 13. Translation by Sonia Joyce Rouve.

5. Ibid.

6. West, in Serge Fauchereau, *Braque* (New York: Rizzoli, 1987), p. 32.

7. Braque, in Vallier, "Braque," p. 16. Translation by Rouve.

8. Georges Braque, *Illustrated Notebooks: 1917–1955* (New York: Dover, 1971), p. 13. Translation by Stanley Appelbaum.

9. Ibid., p. 33.

10. Braque, in Vallier, "Braque," p. 13. Translation by Rouve.

11. Ibid. Dufy, although five years older than Braque, was still a schoolboy when they first knew each other in Le Havre.

12. Braque, *Poésie* 43 (March–April 1943); in Jean Paulhan, *Braque, le patron* (Geneva and Paris: Trois Collines, 1946), pp. 34–35.

13. Braque, in Flanner, *Men and Monuments,* p. 128, and in Jacques Lassaigne, "Un Entretien avec Georges Braque," *XXᵉ Siècle,* December 1973, p. 4; interview conducted in 1961. Translation by Museum of Modern Art, New York.

14. Braque, in Vallier, "Braque," p. 14.

15. Braque, in Lassaigne, "Un Entretien," p. 3.

16. Braque, in Vallier, "Braque," p. 14.

17. Braque, in Paulhan, *Braque, le patron,* p. 35.

18. Lassaigne, "Un Entretien," p. 4.

19. Gertrude Stein, *The Autobiography of Alice B. Toklas* (New York: Random House, 1955), p. 96.

20. Braque, in Lassaigne, "Un Entretien," p. 6.

21. Daniel-Henry Kahnweiler and Georges Bernier, "When the Cubists Were Young," a recorded interview in *L'Oeil: The Selective Eye,* 1955, p. 122.

22. Braque, in Vallier, "Braque," p. 14.

23. Ibid.

24. Flanner, *Men and Monuments,* p. 132.

25. Braque, in Vallier, "Braque," p. 14.

26. André Salmon, *L'Art vivant;* in *Cahiers d'art* 8, nos. 1–2 (1933, special issue on Georges Braque): 28.

27. Kahnweiler, "When the Cubists Were Young," pp. 124–25.

28. Kahnweiler, in Pierre Daix, "Les Trois Périodes de travail de Picasso sur les trois femmes," *Gazette des Beaux-Arts* 111 (January–February 1988): 147. Translation by Museum of Modern Art, New York.

29. Gelett Burgess, "The Wild Men of Paris [1908]," *Architectural Record* 27 (May 1910): 405.

30. Braque, ibid.

31. Braque, in Lassaigne, "Un Entretien," p. 4.

32. LeRoy C. Breunig, ed., *Apollinaire on Art: Essays and Reviews, 1902–1918, by Guillaume Apollinaire* (New York: Viking, 1972), p. 51. Translation by Susan Suleiman.

33. Louis Vauxcelles, review in *Gil Blas,* November 14, 1908. Translation by Flanner.

34. Lassaigne, "Un Entretien," p. 8.

35. Vauxcelles, *Gil Blas.* Translation by Flanner.

36. Braque, *Illustrated Notebooks,* p. 12.

37. Braque, in Vallier, "Braque," p. 16. Translation by Rouve.

38. Ibid.

39. Guillaume Apollinaire, *The Cubist Painters* (1913; New York: Wittenborn and Schultz, 1949), pp. 17 and 18. Translation by Lionel Abel.

40. Braque, in John Richardson, ed., *Georges Braque: An American Tribute* (New York: Public Education Association, 1964), n.p.

41. Braque, in Vallier, "Braque," p. 16. Translation by Rouve.

42. Ibid.

43. Braque, in Lassaigne, "Un Entretien," p. 6.

44. Braque, in Vallier, "Braque," p. 16.

45. John Russell, *Georges Braque* (London: Phaidon, 1959), p. 18.

46. Braque, in Vallier, "Braque," p. 16. Translation by Rouve.

47. Braque, *Illustrated Notebooks,* p. 103.

48. Braque, in Vallier, "Braque," p. 17. Translation by Rouve. All of Braque's comments in this paragraph are from this source.

49. Ibid.

50. Braque, *Illustrated Notebooks,* pp. 32, 84.

51. Braque, in Jean Leymarie, "Braque's Journey," in *Georges Braque* (New York: Solomon R. Guggenheim Museum; Munich; Prestel-Verlag, 1988), p. 9.

52. Braque, *Illustrated Notebooks,* p. 93.

53. Ibid., p. 70.

54. Ibid., p. 22.

55. Ibid., p. 49.

56. Braque, in André Verdet, *Georges Braque* (Geneva: René Kister, 1956), p. 10.

57. Marcelle Braque, in Fauchereau, *Braque,* p. 32.

58. Braque, *Illustrated Notebooks,* pp. 50, 73.

59. Ibid., pp. 35, 65, 116.

60. Georges Braque, "Pensées et réflexions sur la peinture," *Nord-Sud* 10 (December 1917): n.p.

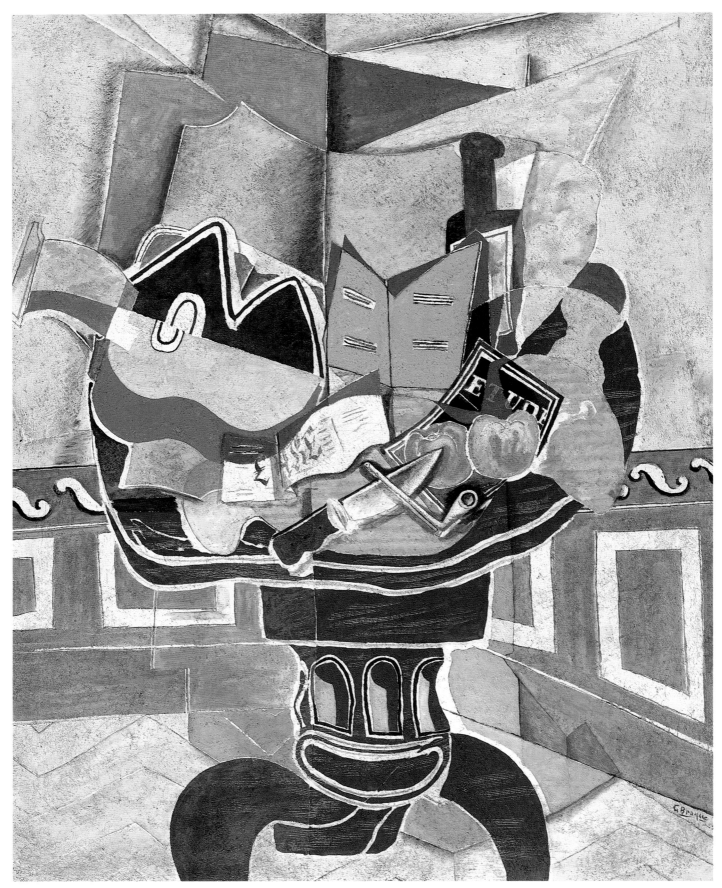

Artist's Statements

Braque trusted his art to speak for him, and he left little in the way of written statements or discussions of his intentions. His writings consist largely of the brief, enigmatic meditations on painting, aesthetics, life, and perception itself, with which he filled his notebooks almost from the beginning of his life as a painter, accompanying them with tenuously related calligraphic illustrations.

These statements are so oblique and so compressed that they prompted interviewers to question Braque about his relationship to Zen Buddhism. He did profess an interest in Zen, but his epigrammatic habit predated his discovery of Buddhist thought by a good thirty years. (The first selection of Braque's aphorisms was published as extracts from his *Cahiers* in 1917, but he didn't come across a copy of D. T. Suzuki's *Essais sur le Bouddhisme Zen* until shortly after the war.) Braque's replies to interviewers suggest that he found Zen a confirmation rather than a cause of deeply held attitudes.

Meaning in Modern Art

"In art, progress does not consist in extension, but in the knowledge of limits.

Limitation of means determines style, engenders new form, and gives impulse to creation.

Limited means often constitute the charm and force of primitive painting. Extension, on the contrary, leads the arts to decadence.

New means, new subjects.

The subject is not the object, it is a new unity, a lyricism which grows completely from the means.

The painter thinks in terms of form and color.

The goal is not to be concerned with *reconstituting* an anecdotal fact, but with *constituting* a pictorial fact.

Painting is a method of representation.

One must not imitate what one wants to create.

One does not imitate appearances; the appearance is the result.

To be pure imitation, painting must forget appearance.

To work from nature is to improvise.

86. *The Round Table*, 1929
Oil on canvas, 57¼ x 44¾ in.
(145.4 x 113.7 cm)
The Phillips Collection, Washington, D.C.

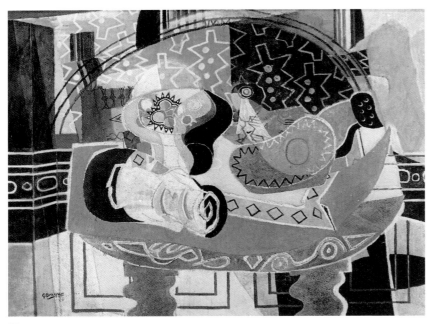

87

One must beware of an all-purpose formula that will serve to interpret the other arts as well as reality, and that instead of creating will only produce a style, or rather a stylization. . . .

The senses deform, the mind forms. Work to perfect the mind. There is no certitude but in what the mind conceives.

The painter who wished to make a circle would only draw a curve. Its appearance might satisfy him, but he would doubt it. The compass would give him certitude. The pasted papers [*papiers collés*] in my drawings also gave me a certitude.

Trompe l'œil is due to an *anecdotal chance* which succeeds because of the simplicity of the facts.

The pasted papers, the *faux bois*—and other elements of a similar kind—which I used in some of my drawings, also succeed through the simplicity of the facts; this has caused them to be confused with *trompe l'œil*, of which they are the exact opposite. They are also simple facts, but are *created by the mind*, and are one of the justifications for a new form in space.

Nobility grows out of contained emotion.

Emotion should not be rendered by an excited trembling; it can neither be added on nor be imitated. It is the seed, the work is the blossom.

I like the rule that corrects the emotion."

> Georges Braque, "Pensées et réflexions sur la peinture," *Nord-Sud* 10 (December 1917): n.p. Reprinted in *Artists on Art*, comp., ed., and trans. Robert Goldwater and Marco Treves (with translation adjustments by Karen Wilkin) (New York: Pantheon, 1958), pp. 422–23.

Most of Braque's less cryptic statements about art come from interviews conducted, for the most part, in the 1950s. Though limited, they help to complete our picture of this most private of painters.

87. *Still Life with Mandolin I*, 1936
Oil on canvas, 38¼ x 51¼ in. (97 x 130 cm)
Norton Gallery and School of Art, West Palm Beach, Florida

88. *The Table*, 1935
Oil on sand on canvas,
71 x 29 in. (180.3 x 73.7 cm)
San Francisco Museum of Modern Art

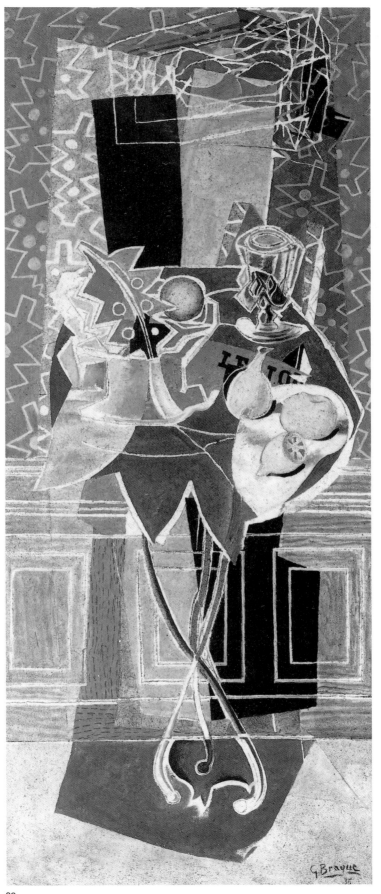

88

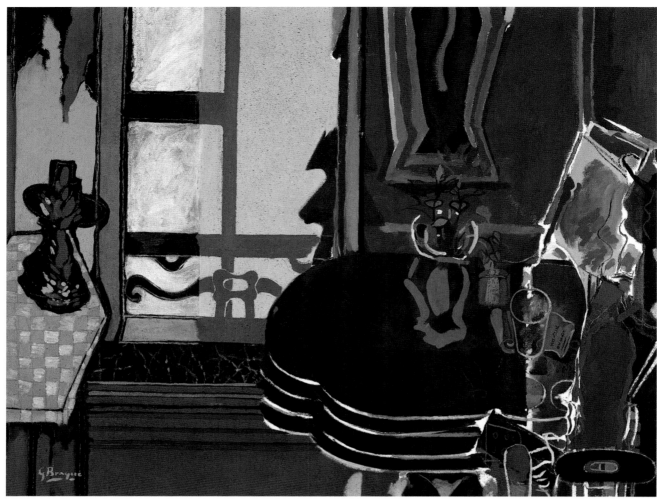

89

"I don't do what I wish, I do what I can.

Painting can't escape from the movement of the whole. You can't isolate yourself from your times.

The invention of mechanical perspective was a catastrophe. . . . All philosophies have been constructed on the principles of perspective. If you are in the exact spot where you ought to be, it's all very well, everything links up, you are deceived by it. But if you move two meters to the right or left, everything collapses. Descartes was the father of all modern thinkers."

> Georges Braque, "Sens de l'art moderne," *Zodiaque*, nos. 18–19 (Cahiers de l'atelier du Coeur-Meurtry, Atelier Monastique de Sainte Marie de la Pierre-qui-Vire, Yonne, France) (January 1954): 12–13. Translated by Karen Wilkin.

"Classical perspective had become something mechanically applied. It ended up making tactile reality more distant, instead of rendering it more visible. It imposed its dictatorial power on things, closed off the paths of independence, smothered them. . . . We, following Cézanne, have implanted a perspective that brings objects within reach of the hand and that describes them in relation to the artist himself. To bring things closer to the spectator's view, to en-

90

courage the communion of the tactile and the visible: I have so often explained this subject in relation to my work."

Quoted by André Verdet, *Entretiens, notes et ecrits sur la peinture: Braque, Léger, Matisse, Picasso* (Paris: Editions Galilée, 1978), p. 27. Translated by Karen Wilkin.

"What artists have particular significance for me? It's difficult to say. You see the whole Renaissance tradition is antipathetic to me. The hard and fast rules of perspective which it imposed on art were a ghastly mistake which it has taken four centuries to redress: Cézanne and, after him, Picasso and myself can take a lot of the credit for this. Scientific perspective is nothing but eye-fooling illusionism; it is simply a trick—a bad trick—which makes it impossible for an artist to convey a full experience of space, since it forces the objects in a picture to disappear away from the beholder instead of bringing them within his reach, as painting should. That's why I have such a liking for primitive art: for very early Greek art, Etruscan art, Negro art. None of this has been deformed by Renaissance science. Negro masks in particular opened up a new horizon to me.

You see, I have made a great discovery: I no longer believe in anything. Objects don't exist for me except in so far as a rapport exists between them, and between them and myself. When one attains this harmony, one reaches a sort of intellectual non-existence—what I can only describe as a state of peace—which makes everything possible and right. Life then becomes a perpetual revelation."

"Metamorphosis and Mystery," based on John Richardson's conversations with Georges Braque, in *Georges Braque: An American Tribute*, ed. John Richardson (New York: Public Education Association, 1964). Originally "The Power and Mystery of Georges Braque," *Observer* (London), December 1, 1957.

"In my paintings, if fantasy is non-existent, the effect of surprise nonetheless plays a role. Take my large canvas *In Full Flight*, which is in the exhibition at the Louvre. So. It is finished, as harmonious as anyone could wish. At the end of four months, after seeing it every day, living with it, I noticed that I had become too used to it. Too comfortable for the eye. I therefore decided to create a disruption by painting in the lower left of the picture another bird confined in a sort of white rectangular frame, everything imposed there like a trademark, a stamp. By creating contradiction, and not disharmony, the entire picture comes to life in a more unexpected manner. Sometimes these effects of surprise are necessary. It prevents routine from setting in."

André Verdet, *Entretiens, notes et écrits sur la peinture: Braque, Léger, Matisse, Picasso* (Paris: Editions Galilée, 1987), p. 13. Translated by Karen Wilkin.

89. *The Salon (Interior)*, 1944
Oil on canvas,
47⅜ x 59¼ in. (120.5 x 150.5 cm)
Musée National d'Art Moderne, Centre Georges Pompidou, Paris

90. *The Pot of Ivy*, 1945
Oil on canvas, 15¾ x 15 in. (40 x 38 cm)
Galerie Louise Leiris, Paris

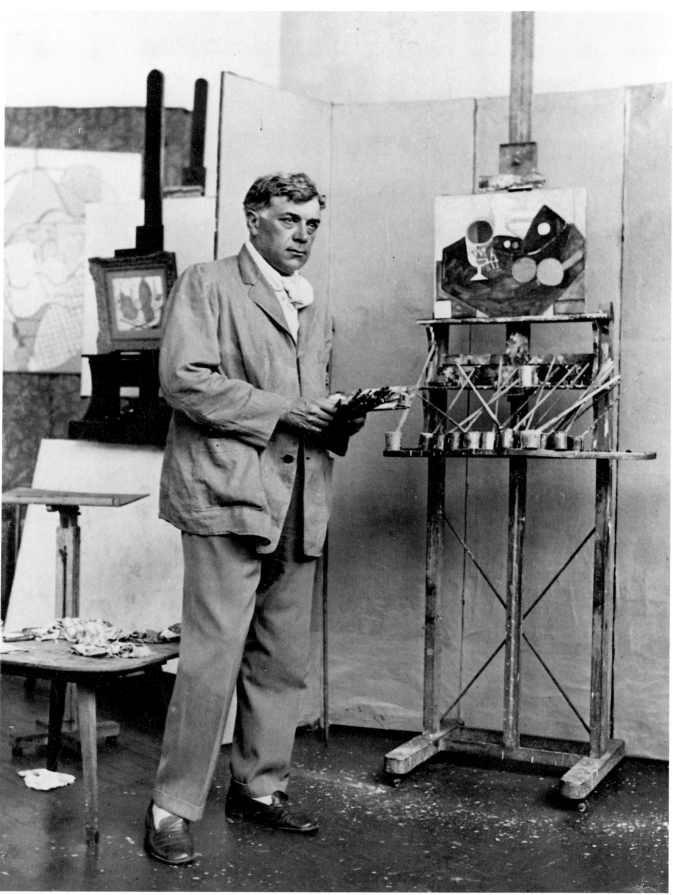

Notes on Technique

Most of what we know about Braque's working methods comes from observations by those he permitted to visit his studios in Paris and Varengeville. Such visitors were all struck by the ordered chaos of the workplace, by the multiplicity of objects in the studio that might find their way into his still lifes, by the number of paintings and drawings in various stages of completion.

In the early 1940s Jean Paulhan, a critic and friend of Braque's, published several articles on the artist. In 1943 he included a chapter describing Braque at work in an article (later a book) entitled *Braque, le patron*. The setting is probably the artist's studio in his house in Montparnasse, since during the war years and the Occupation, Braque was unable to use his Varengeville property.

He is a little stooped. He works on ten sketches at the same time, some of them set on easels, others on the ground on a sort of grill. He sometimes moves a dead leaf, a crab leg, the skeleton of a lizard. What were they waiting for on the table? He touches up. He prunes. Like a gardener among his plants. . . .

Braque applies a spot of blue or green somewhere, walks away, looks at it and comes back to crush it with his thumb. Suddenly, there he is moving toward the opposite corner of the canvas. . . .

He . . . applies a new spot and [says]: "You can never know ahead of time where the call will come from. You just have to wait."

Braque is a patient man. His face is so humble that he seems to have known peace. But his shoulders are those of a lumberjack and his size, that of a giant. He says: "You must have time to dream about it." So, he sits down. "When I was young, I couldn't imagine that one could paint without a model. I came to understand that little by little. To paint a portrait! And of a woman in an evening dress, for example. No, my mind isn't domineering enough."

He explains: "A portrait is dangerous. You have to pretend to be thinking about the model. You hurry. You answer questions even before they are asked. You have ideas."

For Braque, to have ideas is not a compliment. When people say that a painter is intelligent, watch out.

At this point, Braque hums a little tune.

He has begun a large painting that I see in progress. At first, it was only a window. On the pane, a graffito in the shape of an eye has been added. The eye has become a cloud; then the cloud, a gray sky. A sky before dawn. Meanwhile, the window is surrounded by a fairly thick dark: the bedroom. Where an arrow, a bird, a trapeze, a woman's back have been sketched in.

91. Braque in his Paris studio, c. 1932

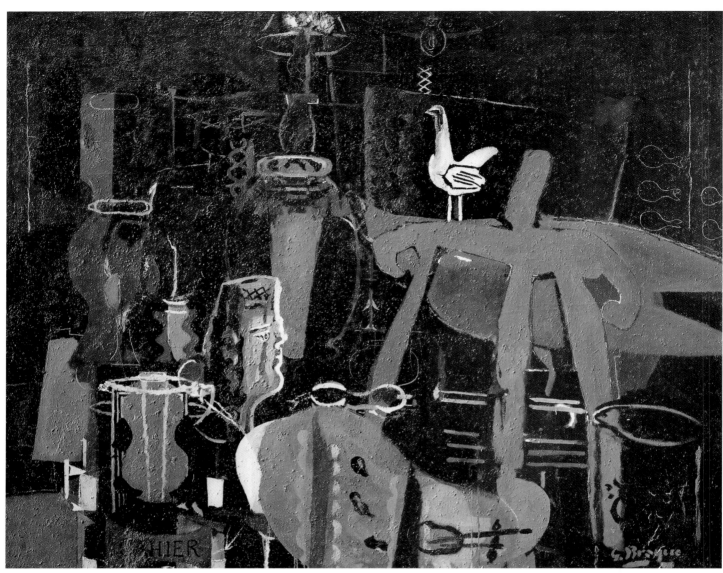

92

"Do you also happen to know where you are headed?" "Yes. Everything depends on the point where things meet: my desire and the delusion. When I really become impregnated with the subject, the canvas always surprises me. I've been preoccupied with that for ten years."

"That" is an anxious young woman with long arms, telling her fortune with cards in a crowded room where the checkerboard, the sherry bottle and the hanging lamp zigzag. "Satisfied? — Well, I didn't expect anything when I started it. But some elements will remain. It will not be useless."

There are quite a lot of these canvases where he has run aground, in the corners of the studio, behind the curtain and in the storeroom next door. Precisely (as far as I can judge) this boat had a good start, with its canvas jib and its blushing cliffs. Then, this bunch of green must have landed on the cliff at the right. Really shapeless, without a reason and impossible to explain. Let us not linger on it. Nor on this half-naked girl, divided in between black and white, with one side of her face caressing the other. More tender than the women painted by Braque. Yet grace is a risk and necessity comes from elsewhere. In fact, here grace was showing off a bit too much.

92. *The Studio VI*, 1950–51
Oil on canvas, 51³⁄₁₆ x 64 in. (130 x 162.5 cm)
Fondation Maeght, Saint-Paul-de-Vence, France

93. *The Studio IX*, 1952–53/56
Oil on canvas, 57½ x 57½ in. (146 x 146 cm)
Musée National d'Art Moderne, Centre Georges Pompidou, Paris

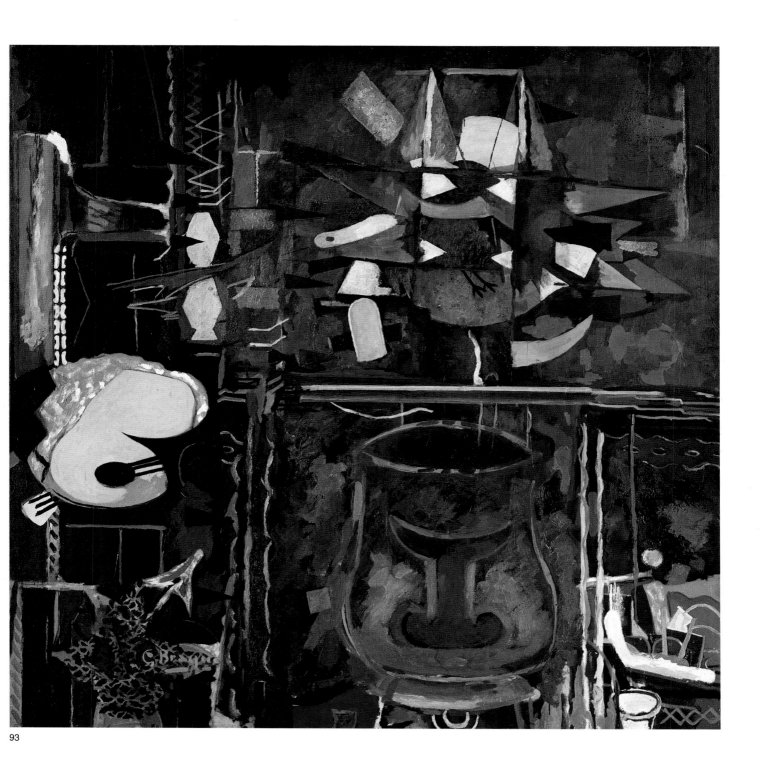

Braque walks away from the canvas, comes closer, hesitates between two calls. As if he painted without seeing.[1]

Some years later, when Janet Flanner, the *New Yorker* magazine's Paris correspondent, visited Braque, she provided a detailed description of his new Varengeville studio. It seems to have been the embodiment of Braque's ideal workplace, and Flanner's article pro-

vides a vivid picture of the habits of a painter who had been working seriously for almost half a century:

Behind the house is his modern glass studio, built in 1948 and unquestionably the most carefully planned, efficient and luxurious—and clean and orderly—of any of the painting quarters of the great artists in France. A huge, high-ceilinged room, largely walled with opaque milky glass, it is an elegant, functional shell, filled with extravagant working conveniences installed by an artisan become a rich artist. It unconventionally faces south. (Braque says that the northern exposures required by painters in the nineteenth century ceased to have value when modern painting came along, since painters now paint not from models but from memory or imagination, where the outer light plays no part.) Inside, it has been organized into areas of use. The largest is allotted to painting; others are given over to preliminary drawing, to engraving and to water colors; and a final area is devoted to relaxation, brooding, contemplating or talking. These areas are set out like parts of a pictorial composition, with concentrations of color always furnished by bouquets of red and yellow flowers, which are the ones Braque likes best, taken from his cutting garden. All the studio materials are arranged for saving the labor of hand and eye. Movable suspended louvers of brown paper control the light for whatever canvas Braque is working on; the heights of the various tables in the room have been calculated to the veriest centimeter, according to their function; different palettes, each with its own color harmonies, are arranged on small shelves branching out like limbs from a tree trunk that Braque has cobbled into a palette stand. Former tomato cans—little economies are part of his practicality—hang from his easel, each containing enough paint, already mixed, for the picture's dominant coloring, so there need be no interruptions for mixing and matching. All these are the artisan touches of the house painter's apprentice that Braque once was.[2]

Flanner continued:

He recently told a visitor that he has long had the habit of working on perhaps twenty pictures at a time, perhaps devoting the whole morning to one—he cannot paint all day as he used to—and sometimes an hour each to two or three of them and perhaps five minutes to a fourth. When he is through with a particular spell of painting on any picture, he puts it aside, later taking it out from time to time to paint some more, with refreshment and familiarity. Then, one day, he will take it out and discover that he finished it the last time—that there is no more painting to be done. He said that the moment he knows he has finished a painting he has no more interest in it.[3]

From time to time, during interviews Braque might speak of the technical aspects of making art. To Flanner he said: "I have a heavy hand for drawing. Whenever I start doing a drawing, it turns into a painting, with cross hatching, shadows and ornamentation."[4]

The remarks that give the fullest picture of how Braque went about making a picture come from a long interview conducted by Dora Vallier:

I've always worked a lot. My habit of keeping a sketchbook began in 1918. Before that I used to draw on bits of paper that I would lose. So I told myself I must get a notebook. Since then I've always had a notebook at hand and I draw anything, I fix anything that goes through my mind. And I realized that it's very useful to me. There are times when you want to paint but don't know what to paint. I don't know why, but there are times when you feel empty. You have a great appetite for work and then I use my sketchbook the way you would use a cookbook when you are hungry. I open it and the slightest sketch may offer me the wherewithal to work. I always work on several canvases at once, eight, ten, as you can see. I spend years finishing them, but I look at them every day. Stacked as they are, one next to the other, I have them in front of me all the time. I confront them. I work some-

times on one, sometimes on another, as memory dictates. You see the advantage of working without a model—the apples would be rotten long before I finished the picture. . . . I find I must work slowly. The person who looks at the painting follows the same path as the artist, and since it is the path that counts more than the thing, you are more interested in the journey.[5]

Braque prided himself on his mastery of his craft, just as he had at the beginning of his career, when he achieved recognition as a decorative painter. In the same interview with Vallier, he spoke at some length about his use of materials, even suggesting that he conceived of an intimate relationship between a painting's physical and metaphysical presence:

You see that canvas that I have just primed, hanging up there? I call it "coffee grounds" because I can read things in it that others cannot see. I do the backgrounds of my canvases with the greatest care because the background supports the rest, like the foundation of a house. I've always thought a lot about the material and worried about it because there is as much sensitivity in technique as there is in the rest of the picture. I prepare my colors myself, I grind them. I'm absolutely convinced that to get the maximum from anything, the artist must intervene personally. I remember the horrified face of a paint merchant who, after boasting to me about the fine grain of his color grinding, learned that I intended to add sand. How this feeling for grinding works, I don't know myself. It's something indefinable. I mess around. I work with matter and not with ideas. If sometimes I leave certain parts of the canvas bare, it's because I am interested in making the picture live and not the idea. I've even written it: "A painting is finished when the idea is obliterated. . . ." And then, in painting, the contrast of materials plays as great a role as the contrast of colors. I take advantage of all the differences materials can offer and then color takes on a much more profound meaning.[6]

NOTES

1. Braque, *Poésie* 43 (March–April 1943); in Jean Paulhan, *Braque, le patron* (Geneva and Paris: Trois Collines, 1946). Translation by Chantal Combes.

2. Janet Flanner, "Profiles: Master (Georges Braque)," *New Yorker,* October 6 and 13, 1956, p. 165; in Flanner, *Men and Monuments* (New York: Harper, 1957).

3. Ibid., p. 171.

4. Ibid., p. 167.

5. From an interview with Braque by Dora Vallier, "Braque, la peinture et nous," *Cahiers d'art* 29 (October 1954): 21–22. Translation by Karen Wilkin.

6. Ibid., p. 22.

94

Chronology

By Carol Lowrey

1882 May 13—Georges Braque is born in Argenteuil-sur-Seine, France, son of Charles Braque, a house painter, building contractor, and amateur painter, and Augustine Johannet. The family resides at 40, rue de l'Hotel.

1890 Family moves to 33, rue Jules Lecesne, Le Havre, on the Normandy coast.

1893 Braque enters the lycée in Le Havre. Develops an interest in drawing and music. Later receives flute lessons from Gaston Dufy, Raoul Dufy's brother. Enrolls in evening classes under Monsieur Courchet at the local Ecole des Beaux-Arts. Makes drawings after plaster casts of antique sculpture. Meets fellow painters Raoul Dufy and Othon Friesz.

1899 Abandons his secondary schooling with the intention of joining his father's business. Begins an apprenticeship with Monsieur Roney, a local painter-decorator.

1900 Travels to Paris to continue his apprenticeship under the painter-decorator Monsieur Laberthe. Learns a number of technical skills, including sign painting, hand lettering, and the art of painting *faux bois* and other types of simulations. Resides at rue des Trois-Frères in Montmartre. Attends drawing classes under Eugène Quignolot at the Cours Municipal des Batignolles.

1901 October—returns to Le Havre for a year's military service. Paints portraits and landscapes during his spare time.

1902 October—returns to Paris. With his parents' support, decides to pursue a career as a painter. Settles on rue Lepic in Montmartre. Enrolls at the Académie Humbert. Meets Marie Laurencin and Francis Picabia. Continues his association with Dufy and Friesz. Makes regular visits to the Louvre; is attracted to Greek and Egyptian art, as well as the work of Jean-Baptiste-Camille Corot and Nicolas Poussin. Sees Impressionist painting at the Musée du Luxembourg and at the galleries of Durand-Ruel and Vollard.

1903 Fall—spends two months studying at the Ecole Nationale des Beaux-Arts under Léon Bonnat. Dissatisfied with Bonnat's academic approach, he resumes training at the Académie Humbert.

1904 Summer—paints in Brittany and Normandy. Fall—returns to Paris and rents a studio on rue d'Orsel. Begins painting in an Impressionist manner.

1905 Summer—paints in Honfleur and Le Havre, accompanied by the sculptor Manolo (Manolo Martinez Hugué) and the art critic Maurice Raynal (both members of the so-called "Picasso Gang"). Fall—visits the Salon d'Automne and is deeply inspired by the Fauve paintings of Henri Matisse and André Derain. Dufy and Friesz also exhibit at the Salon.

1906 March 20–April 30—exhibits seven works (later destroyed) at the Salon des Indépendants. Spring—the Cercle de l'Art Moderne is founded at Le Havre by Charles Braque and others. Georges Braque, Friesz, and Dufy are appointed to the committee on paintings. May 26–June 30—Braque exhibits two paintings at the inaugural exhibition of the Cercle de l'Art Moderne. June 12–July 12 and August 14–September 11—paints in Antwerp with Friesz. Produces his earliest Fauve works, including *Landscape near Antwerp* (plate 11). September—returns to Paris. October—first visits L'Estaque, in Provence.

1907 February—returns to Paris. March 20–April 30—exhibits six paintings at the Salon des Indépendants. All are sold, five of them purchased by the German art critic and collector Wilhelm Uhde. The sixth painting is believed to have been sold to Daniel-Henry Kahnweiler. At the opening of the exhibition Braque meets Matisse, Derain, Maurice de Vlaminck, and other members of the artistic vanguard. March

or April—Braque leaves Pablo Picasso his calling card with the message "Anticipated memories." Spring—Braque exhibits two paintings in the second exhibition of the Cercle de l'Art Moderne. Probably sees the exhibition of watercolors by Paul Cézanne at Galerie Bernheim-Jeune in Paris before traveling to the south of France with Friesz. Summer—Kahnweiler buys more of Braque's paintings and becomes his dealer. Late summer—Braque paints at La Ciotat, a resort town near Marseilles; his work begins to be influenced by Cézanne's structural principles. September—visits L'Estaque, remaining until late October, when he returns to Paris. Exhibits *Red Rocks* at the Salon d'Automne (the rest of his submissions are rejected). Sees the important Cézanne retrospective at the Salon. Returns to L'Estaque by early November, and goes back to Paris by about November 16. Late November—visits Picasso's studio in the Bateau Lavoir, accompanied by Guillaume Apollinaire. Sees Picasso's *Demoiselles d'Avignon* (Museum of Modern Art, New York). December—begins to focus on figural themes. Abandons Fauvism for good and moves even closer to a Cézannesque manner. Produces an etching, *Standing Nude*.

1908 Mid-March—completes *Woman* (begun December 1907). Spends spring and summer at L'Estaque with Dufy. Produces a series of proto-Cubist landscapes. March 20–May 2—exhibits four works at the Salon des Indépendants. Apollinaire, writing in the May 1 issue of *Revue des lettres et des arts,* claims that Braque's work represents the "most original effort of the Salon." Braque spends spring and summer at L'Estaque with Dufy. Produces a number of Cubist landscapes. Submits a number of these new pieces to the Salon d'Automne. The jury, consisting of Matisse, Georges Rouault, and Albert Marquet, rejects all but one, which Braque withdraws. Upon viewing Braque's work, Matisse is the first to make reference to "cubes." November 9–28—Braque's first one-man exhibition, held at Galerie Kahnweiler, includes several L'Estaque landscapes as well as Braque's first Cubist still lifes of musical instruments. In his preface to the catalog Apollinaire states that each of Braque's paintings "is a monument to an endeavor which nobody before him had ever attempted." The critic Louis Vauxcelles notes Braque's reduction of forms to "geometric patterns, to cubes." Late November—Braque visits Le Havre but returns to Paris in late November–early December. Attends banquet given by Picasso at the Bateau Lavoir in honor of the painter Henri Rousseau.

1909 January 24–February 28—sends four paintings to the second exhibition of the Toison d'Or in Moscow. March 25–May 2—exhibits two works at the Salon des Indépendants. In an article in *Mercure de France* the critic Charles Morice uses the term *Cubism* in print for the first time. June—Braque travels to La Roche-Guyon, in the Seine Valley, near Mantes, where Cézanne painted in 1885. Paints views of the medieval castle and surrounding forest, using a palette dominated by grays and greens. September 7–October 6—puts in another period of military service at Le Havre. Early October—joins Derain at Carrières-Saint-Denis, near Chatou. Late October—returns to Paris. Produces a series of large still lifes based on musical themes, including *Guitar and Fruit Dish* (plate 24). Paints *Lighter and Newspaper: "Gil Blas"* (private collection), the first Cubist painting to feature lettering. Begins a period of close collaboration with Picasso that will last until 1914.

1910 Establishes a new studio on the rue Caulaincourt, on the top floor of the Roma Hotel. Spring—in *Woman with a Mandolin* (Bayerische Staatsgemäldesammlungen, Munich, Germany), uses an oval canvas for the first time. July 27—goes to Saint-Aquilin-de-Pacy, near Mantes. Returns to Paris by August 16. Arrives in L'Estaque by early September. September 1–15—exhibits with Picasso at the Thannhauser Gallery in Munich. Late November—spends a few days at Le Havre before returning to Paris about December 1.

1911 March 27–April 12—performs military service at Saint-Mars-la-Brière. About August 17—joins Picasso at Céret in the Pyrenees, after visiting Orléans, Guéret, and Limoges. Incorporates typographic elements into paintings. September—visits Figueras and Collioure. Develops friendship with the sculptor Henri Laurens and the poet Pierre Reverdy. Abandons landscape and turns increasingly to still-life and figure subjects. Late fall—begins working on *Le Portugais* (*The Emigrant*) (plate 26), the first Cubist painting to feature stenciled lettering, and *Homage to J. S. Bach* (Carroll and Conrad Janis), the earliest example of Braque's use of imitation wood grain.

1912 January 19—returns to Paris. Exhibits in the Cologne Sonderbund and with the Blaue Reiter in Munich. Marries Marcelle Lapré.

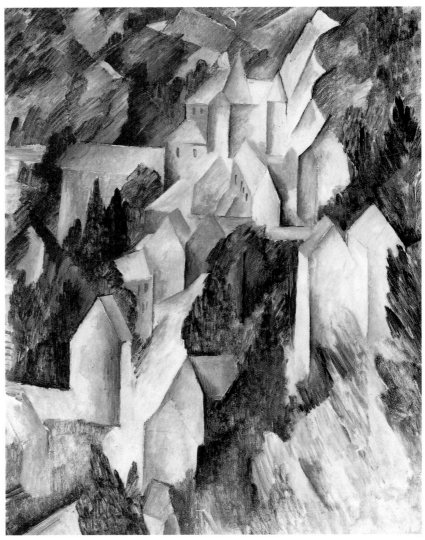

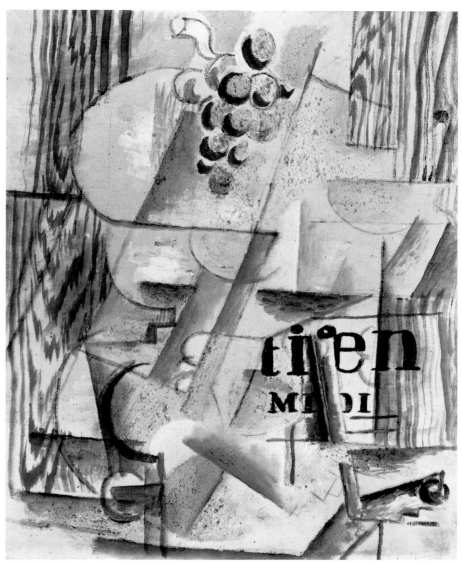

96

95. *Castle at La Roche-Guyon*, 1909
Oil on canvas, 31½ x 23⅜ in. (80 x 59.5 cm)
Moderna Museet, Stockholm

96. *Fruit Dish: "Quotidien du Midi,"* 1912
Oil on canvas, 16 x 13 in. (40.6 x 33 cm)
Yves St. Laurent and Pierre Bergé

April 26–28—visits in Le Havre with Picasso. Late July—joins Picasso and Reverdy at Sorgues-sur-l'Ouveze, near Avignon. August 9—Braque and Picasso purchase African masks and statuettes in Marseilles. Braque begins to add sand and sawdust to his pigment. Also makes several paper sculptures. September—uses simulated wood-grain wallpaper in *Fruit Dish and Glass* (plate 31), his first *papier collé*. October 9—Picasso writes to Braque: "I am using your latest papery and powdery procedures." November 29—Braque signs a one-year contract with Kahnweiler.

1913 February 17–March 15—exhibits three works in the *International Exhibition of Modern Art* (the Armory Show) in New York. June—visits Sorgues; makes brief visits to Avignon, Martigues, Marseilles, Nîmes, and Arles

in the ensuing months. Returns to Paris from Sorgues in early December.

1914 June—takes bicycle trip to the Midi, visiting Sens, Avallon, Dijon, and other cities; arrives in Sorgues by July 5. August—called up for military duty. Assigned to the 224th Infantry Regiment, based in Le Havre, with rank of sergeant; promoted to lieutenant in December. December 9–January 11, 1915—joint exhibition with Picasso held at Alfred Stieglitz's gallery, 291, in New York.

1915 Kahnweiler, living in Switzerland, begins writing *Der Weg zum Kubismus* (*The Rise of Cubism*), identifying Braque and Picasso as the founders of Cubism. May 11—Braque receives a serious head wound at Carency; convalesces in Sorgues.

1916 Mid-April—Braque is assigned to Bernay, in the Eure region. Later receives a medical discharge. In recognition of his bravery at the front, he is decorated with the Croix de Guerre and the Légion d'Honneur.

1917 January 15—friends and colleagues in Paris organize a banquet to celebrate Braque's recovery. Summer—resumes painting and continues his association with Gris, Reverdy, and Laurens. Begins to edit his *Cahier*. December—Braque's article, "Pensées et réflexions sur la peinture" appears in Reverdy's review, *Nord-Sud*. Léonce Rosenberg becomes Braque's new dealer.

1918 Returns to still lifes with pedestal tables and clarinets. Rosenberg opens Galerie de l'Effort Moderne, exhibiting the work of many of the Cubist painters.

1920 January—displays four works at the Salon des Indépendants. Executes his first plaster sculpture, *Standing Nude*. September 1—Kahnweiler opens Galerie Simon and becomes Braque's dealer again. October—Braque exhibits three works at the Salon d'Automne. Roger Bissière publishes the first monograph on Braque, as part of the series Les Maîtres du Cubisme (Masters of Cubism).

1921 Produces three woodcuts for Erik Satie's comedy, *Le Piège de Méduse* (Medusa's Trap). November 17–18—second Kahnweiler sale, at the Hôtel Drouot, includes thirty-eight works by Braque.

1922 Displays eighteen works, including the Canephorae, in the room of honor at the Salon d'Automne. Leaves Montmartre and settles on avenue Reille in Montparnasse. July 4—third Kahnweiler sale includes three of Braque's *papiers collés*.

1923 Produces sets and costumes for Boris Kochno's ballet, *Les Facheux* (The Bones), staged by Serge Diaghilev in January 1924 at Monte Carlo and in Paris in May. Paul Rosenberg becomes Braque's new dealer. Fourth Kahnweiler sale features fifty-six works by Braque.

1924 Produces sets for *Les Soirées de Paris* (Paris Evenings) and costumes for *Salade,* a ballet by Léonide Massine.

1925 Moves to a new house built by Auguste Perret at 6, rue du Douanier (now rue Georges Braque). Designs the sets for *Zéphyr et Flore,* a ballet by Diaghilev. Visits Rome.

1928 Spends summer at Dieppe; decides to build a summer home-studio at Varengeville.

1931 Moves into his new home at Varengeville. Travels to Florence and Venice. Produces his first engraved plaster casts featuring heroic figures from Greek mythology.

1932 Produces sixteen etchings as illustrations for Hesiod's *Theogonie,* published by Ambroise Vollard.

1933 April 9–May 14—his first major retrospective exhibition is held at the Kunsthalle, Basel, Switzerland. *Cahiers d'art* devotes an entire issue to Braque in commemoration of the exhibition. Contributors include Apollinaire, André Breton, André Salmon, Christian Zervos, and others.

1934 Produces the illustrations for Carl Einstein's monograph, *Georges Braque.*

1937 Awarded first prize at the Carnegie International Exhibition in Pittsburgh for *The Yellow Tablecloth* (1935).

1938 Begins still-life series, focusing on the vanitas theme.

1939 Begins sculpting in stone. Spends winter at Varengeville. Devotes the majority of his time to sculpture. November 2–27—first important retrospective exhibition of Braque's work in the United States is held at the Arts Club of Chicago; tours to Washington, D.C., and San Francisco.

1940 June—Braque goes to Limousin and later to the Pyrenees as a result of the German invasion. Fall—returns to Paris. Leads a reclusive existence until the end of the war.

1943 September 25–October 31—displays twenty-six paintings and nine sculptures in a special room at the Salon d'Automne.

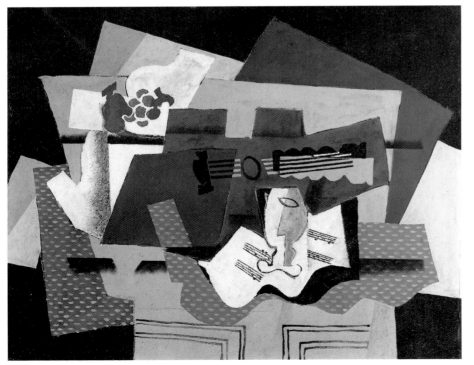

97. *Guitar, Glass, and Fruit Dish on Sideboard,* 1919
Oil on canvas, 31¼ x 38¾ in. (79.4 x 98.4 cm)
Solomon R. Guggenheim Museum, New York; Gift of Justin K. Thannhauser

98. *Black Rose,* 1927
Oil on canvas, 20 x 37 in. (50.8 x 94 cm)
The Tremaine Collection

99. *Pitcher and Skull,* 1943
Oil on canvas, 17 x 28¾ in. (43 x 73 cm)
Saarland Museum, Saarbrücken, Germany

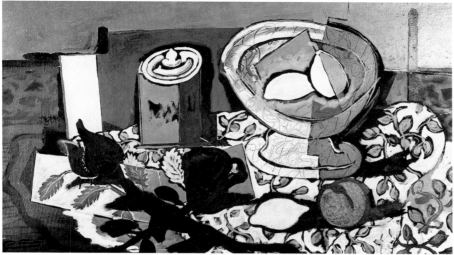

98

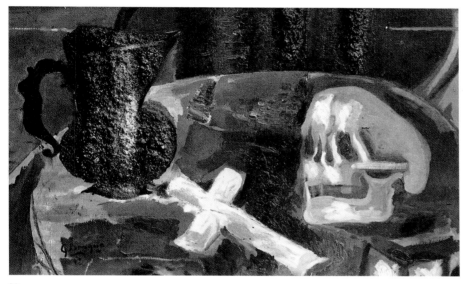

99

1944 September—Paris is liberated and Braque returns to Varengeville. Begins billiard-table series.

1945 Summer—undergoes a stomach operation, which interrupts his artistic activity for several months. Fall—retrospective exhibitions of his work are held at the Stedelijk Museum in Amsterdam and at the Palais des Beaux-Arts in Brussels. Produces the illustrations for Jean Paulhan's book *Braque, le patron* and for Antoine Tudal's *Soupente* (The Garret). Becomes an officer of the Légion d'Honneur.

1947 Spring—develops pneumonia. June—Aimé Maeght becomes his new dealer.

1948 At the 24th Venice Biennale, Braque receives the Grand Prize for Painting for *The Bil-*

liard Table (plate 68). Begins working on his series of Terraces.

1949 January–June—a major retrospective exhibition of his work is held at the Cleveland Museum of Art and at the Museum of Modern Art, New York. Produces his first Studios, focusing on the image of the bird.

1950 January—exhibits five works from the Studio series at Galerie Maeght.

1951 Works on a series of small-scale pastoral landscapes. Becomes a commander in the Légion d'Honneur.

1952 September–October—retrospective exhibition held at the National Museum in Tokyo.

1953 At the invitation of Georges Salles, director of the Museums of France, Braque decorates three coffers in the ceiling of the Salle Henri II in the Louvre. Spring and summer—solo exhibitions of his work are held at the Kunstmuseum in Bern and at the Kunsthaus, Zurich.

1954 Designs a set of stained-glass windows for the church at Varengeville. Produces decorations for the Mas Bernard at Saint-Paul-de-Vence.

1956 The Arts Council of Great Britain organizes an exhibition of Braque's paintings, which is shown at the Scottish Royal Academy in Edinburgh and at the Tate Gallery in London. He receives an honorary doctorate from Oxford University. Experiences a serious decline in health. December—*The Sculpture of Georges Braque* opens at the Contemporary Arts Center in Cincinnati.

1958 Two rooms are devoted to Braque's work at the 29th Venice Biennale. November–January 1959—solo exhibition is held at the Palazzo Barberini in Rome, where he is awarded the Feltrinelli Prize by the Accademia di Belle Arti.

1959 Braque's continuing ill health forces him to curtail his activities, although he does complete a number of drawings and engravings.

1960 June 24—exhibition of Braque's graphic work opens at the Bibliothèque Nationale, Paris. Produces twelve lithographs for Reverdy's *La Liberté des mers* (Open Sea).

1961 November—Jean Cassou, chief curator at the Musée National d'Art Moderne in Paris, organizes the exhibition *L'Atelier de Braque*, which is held at the Louvre. Poor health continues to disrupt Braque's painting activity, although he designs a number of pieces of jewelry.

1963 August 31—Braque dies in Paris. A state funeral is held in his honor. André Malraux delivers a eulogy in the Cour Carrée of the Louvre. Braque is buried in the cemetery at Varengeville.

Exhibitions

Solo Exhibitions

1908

Georges Braque, Galerie Kahnweiler, Paris, November 9–28.

1919

Georges Braque, Galerie de l'Effort Moderne, Paris, March 5–31.

1924

Georges Braque, Galerie Paul Rosenberg, Paris, May 2–21.

1925

Georges Braque, Galerie Vavin-Raspail, Paris, March.

1926

Exposition d'oeuvres de Braque, Galerie Paul Rosenberg, Paris, March 8–27.

1930

Georges Braque, Galerie Paul Rosenberg, Paris, May.

1933

Georges Braque, Kunsthalle, Basel, Switzerland, April 9–May 14.

1934

Exhibition of Recent Painting by Georges Braque, Valentine Gallery, New York, November 26–December 15.

1936

Oeuvres récentes de Georges Braque, Galerie Paul Rosenberg, Paris, January 8–31.
 Thirty-six Paintings by Georges Braque, Alex Reid and Lefevre Galleries, London, July.
 Georges Braque, Palais des Beaux-Arts, Brussels, November–December.

1937

Oeuvres récentes de Georges Braque, Galerie Paul Rosenberg, Paris, April 3–30.

1938

L'Epoque fauve de Braque, Galerie Pierre, Paris, February 4–21.
 Some Selected Paintings by Georges Braque, Buchholz Gallery, New York, October 14–29.
 Braque, Galerie Paul Rosenberg, Paris, November 16–December 10.

1939

G. Braque, Galerie Paul Rosenberg, Paris, April 4–29.
 Georges Braque: Retrospective Exhibition, Arts Club of Chicago, November 2–27, and tour to Phillips Memorial Gallery, Washington, D.C., and San Francisco Museum of Art.

1941

An Exhibition of Paintings by Georges Braque, Valentine Gallery, New York, January 13–February 8.

1942

Exhibition of Paintings by Braque, Paul Rosenberg and Co., New York, April 7–25.
 Georges Braque, Baltimore Museum of Art, November 22–December 27.

1943

Douze peintures de Georges Braque, 1908–1910, Galerie de France, Paris, May 21–June 19.

1945

Georges Braque, Stedelijk Museum, Amsterdam, October 20–November 12.
 Georges Braque, Palais des Beaux-Arts, Brussels, November 24–December 13.

1946

Paintings by Braque, Paul Rosenberg and Co.,

New York, April 29–May 18.

Georges Braque, Kunsthaus, Zurich, September.

1947

Georges Braque, Galerie Maeght, Paris, May 30–June 30.

1948

Georges Braque, Paul Rosenberg and Co., New York, January 5–24.

Salle Braque, 24th Venice Biennale, May–September. (Also included in 1958.)

1949

Georges Braque, Cleveland Museum of Art, January 25–March 13, and tour to Museum of Modern Art, New York.

1950

Georges Braque, Galerie Maeght, Paris, January.

1952

Georges Braque, Galerie Maeght, Paris, June–July.

Exposition des oeuvres de Georges Braque à Tokio, National Museum, Tokyo, September–October.

Braque, 1924–1952, Paul Rosenberg and Co., New York, October 6–25.

1953

Braque, Kunsthalle, Bern, April 25–May 31.

Braque, Kunsthaus, Zurich, June 7–July 19.

L'Oeuvre graphique de Braque, Musée des Beaux-Arts, Liège, Belgium, November 14–December 6.

1955

Braque, Paul Rosenberg and Co., New York, October 3–November 29.

1956

Oeuvres récentes de Georges Braque, Galerie Maeght, Paris, April–May.

Georges Braque: An Exhibition of Paintings, Royal Scottish Academy, Edinburgh, August 18–September 15, and tour to Tate Gallery, London. Organized by the Arts Council of Great Britain in association with the Edinburgh Festival Society.

Georges Braque, Museum Boymans–van Beuningen, Rotterdam, Netherlands, December.

The Sculpture of Georges Braque, Contemporary Arts Center, Cincinnati, December–January 1957.

1958

Mostra antologica di Georges Braque, Palazzo Barberini, Rome, November–January 1959.

1960

Le Tir à l'arc, mis en lumière par Georges Braque, Galerie Gérald Cramer, Geneva, April 5–May 6.

Georges Braque, Kunsthalle, Basel, Switzer-

land, April 9–May 29.

Georges Braque: Oeuvre graphique, Bibliothèque Nationale, Paris, June 24–October 16.

1961

L'Atelier de Braque, Musée du Louvre, Paris, November.

1962

Georges Braque: Dessins, Galerie Adrien Maeght, Paris, June 21–July 26.

Homage to Georges Braque, Contemporary Arts Center, Cincinnati, September 22–October 22, and tour to Arts Club of Chicago and Walker Art Center, Minneapolis.

L'Ordre des oiseaux. Saint-John Perse. Georges Braque, Bibliothèque Nationale, Paris, December 12–January 17, 1963.

1963

Georges Braque: Papiers collés, 1912–1914, Galerie Maeght, Paris, May.

Georges Braque, Haus der Kunst, Munich, West Germany, October 18–December 15.

1964

Georges Braque, An American Tribute: Fauvism and Cubism, Saidenberg Gallery; *The Twenties,* Perls Galleries; *The Thirties,* Paul Rosenberg and Co.; *The Late Years, 1940–1963* and *The Sculpture,* M. Knoedler and Co., all New York, April 7–May 2.

Hommage à Georges Braque, Salles des Expositions du Grenier à Sel, Honfleur, France, July 26–August 31.

Georges Braque, 1882–1963, Malerier, Grafik, Sculptur, Kunstnerns Haus, Oslo, November 14–January 3, 1965, and tour to Kunsterner Hus, Bergen, Norway.

1967

Georges Braque, Nouveau Musée, Le Havre, France, April 15–May 31.

Georges Braque: Derniers Messages, Galerie Maeght, Paris, June.

1968

Cinquante Bijoux de Georges Braque, Galerie Stadler, Paris, April 5–May 4.

Georges Braque, Galerie Beyeler, Basel, Switzerland, July–September.

1971

Georges Braque: Das Lithographische Werk, Rheinischen Landesmuseum, Bonn, November 7–December 4.

1972

Georges Braque, Herzog August Bibliothek, Wolfenbüttel, West Germany, March 22–July 16.

Braque: The Great Years, Art Institute of Chicago, October 7–December 3.

1973

Georges Braque, Orangerie des Tuileries, Paris, October 16–January 14, 1974.

1974

Braque, Accademia di Francia, Villa Medici, Rome, November 15–January 20, 1975.

1978

Georges Braque, Fondation Anne et Albert Prouvost à Septentrion, Marcq en Baroeul, France, October 7–January 21, 1979.

Georges Braque: Oleos, gouaches, relieves, dibujos y grabados, Fundación Juan March, Madrid, September–November.

1980

Georges Braque, Fondation Maeght, Saint-Paul-de-Vence, France, July 5–September 30.

1981

Georges Braque: Ausstellung zum 100. Geburtstag, Staatsgalerie Stuttgart, Stuttgart, West Germany, November 22–January 31, 1982.

1982

Georges Braque en Europe: Centenaire de la naissance de Georges Braque (1882–1963), Galerie des Beaux-Arts, Bordeaux, France, May 14–September 1, and tour to Musée d'Art Moderne, Strasbourg, France.

G. Braque et la mythologie, Galerie Louise Leiris, Paris, June 16–July 17.

Georges Braque: Les Papiers collés, Musée National d'Art Moderne, Centre Georges Pompidou, Paris, June 17–September 27, and tour to National Gallery of Art, Washington, D.C.

Oeuvres de Georges Braque (1882–1963): Collections du Musée National d'Art Moderne, Musée National d'Art Moderne, Centre Georges Pompidou, Paris, June 17–September 27.

Georges Braque: The Late Paintings, 1940–1963, Phillips Collection, Washington, D.C., October 9–December 12, and tour to four other museums, January 1–September 14, 1983.

1983

Georges Braque: Opere 1900–1963, Castello Svevo, Bari, Italy.

1985

Georges Braque: Sculpture, Galerie Adrien Maeght, Paris.

Georges Braque: Engravings and Lithographs, 1911–1963, Waddington Graphics, London, April 3–May 4.

1986

Bonjour Georges Braque! Musée National Fernand Léger, Biot, France, March.

Georges Braque, 1882–1963, Fundación para el Apoyo de la Cultura, Barcelona, Spain, summer.

1988

Georges Braque, Kunsthalle, Hypo-Kulturstiftung, Munich, West Germany, March 4–May 15, and tour to Solomon R. Guggenheim Museum, New York.

1990

Braque: Still Lifes and Interiors, South Bank Touring Exhibition, Walker Art Gallery, Liverpool, England, September 7–October 21, and tour to Bristol Museum and Art Gallery, Bristol, England, October 27–December 9.

Selected Group Exhibitions

1906

Société des Artistes Indépendants, Cours la Reine, Paris, March 20–April 30. Also included in 1907, 1908, 1909, 1920.

Cercle de l'Art Moderne, Le Havre, France, May 26–June 30. Also included in 1907, 1908, 1909.

1908

Notre-Dame-des-Champs, Paris, December 21–January 15, 1909.

1909

Berthe Weill Gallery, Paris, January 22–February 28.

Toison d'Or, Moscow, January 24–February 28.

1910

Thannhauser Gallery, Munich, Germany, September 1–15.

1911

22d Berliner Sezession, Berlin, May.

1912

Modern Kunst Kring, Amsterdam, October.

Second Post-Impressionism Exhibition, Grafton Gallery, London, October 5–December 12.

1913

International Exhibition of Modern Art (Armory Show), Armory of the 69th Infantry, New York, February 17–March 15, and tour.

1914

Société du Salon d'Automne, Grand Palais, Paris, November 1–December 20.

Drawings and Paintings by Picasso and Braque, Little Galleries of the Photo-Secession (291), New York, December 9–January 11, 1915.

1926

An International Exhibition of Modern Art, Brooklyn Museum, November 19–January 1, 1927. Organized by the Société Anonyme.

1936

Cubism and Abstract Art, Museum of Modern Art, New York, March 2–April 19, and tour.

1948

Collage, Museum of Modern Art, New York, September 21–December 5.

1949

Twentieth Century Art from the Louise and

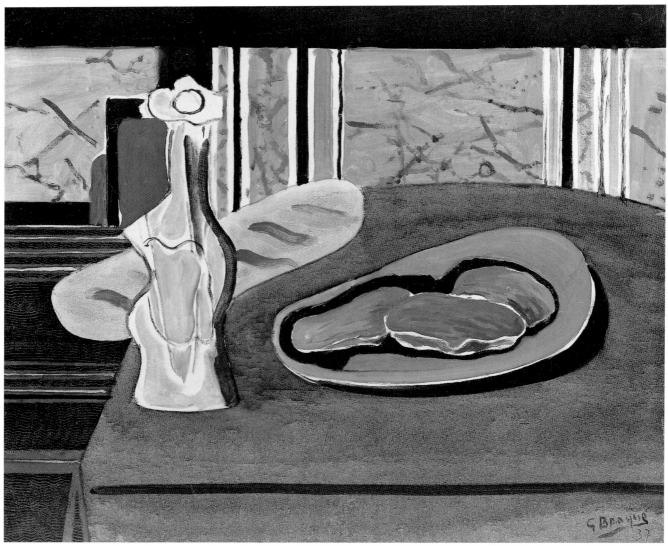

Walter Arensberg Collection, Art Institute of Chicago, October 20–December 18.

1952

L'Oeuvre du XXᵉ siècle, Musée National d'Art Moderne, Paris, May–June.

1953

Le Cubisme, 1907–1914, Musée National d'Art Moderne, Paris, January 30–April 9.

1954

Exposicão do Cubismo, Museu de Arte Moderna, Rio de Janeiro.

1960

Les Sources du XXᵉ siècle, Musée National d'Art Moderne, Paris, November 4–January 23, 1961.

1961

The Art of Assemblage, Museum of Modern Art, New York, October 2–November 12, and tour.

1963

Die Schenkungen Raoul La Roche, Kunstmuseum, Basel, Switzerland, March 16–April 28.

Cézanne and Structure in Modern Painting, Solomon R. Guggenheim Museum, New York, June–August.

1965

Apollinaire et le cubisme, Palais de Beaux-Arts,

Lille, France, April 3–May 4.

1967

Jean Paulhan et ses environs, Galerie Krugier, Geneva, April.

Autour de Cubisme, Galerie Jean-Claude Bellier, Paris, May 3–June 30.

1968

Look Back: An Exhibition of Cubist Paintings and Sculptures from the Menil Family Collection, University of St. Thomas, Houston, March 13–September 13, and tour to eight North American museums.

Collagen, Kunstgewerbemuseum, Zurich, June 8–August 18.

1969

Twentieth-Century Art from the Nelson Aldrich Rockefeller Collection, Museum of Modern Art, New York, May 26–September 1.

A Selection of Drawings, Pastels and Watercolors from the Collection of Mr. and Mrs. Lester Francis Avnet, New York Cultural Center, December 9–January 25, 1970.

1970

Collection de Menil: Oeuvres cubistes, Musée des Beaux-Arts, Rouen, France, and tour to four French museums.

Pierre Reverdy à la rencontre de ses amis, Fondation Maeght, Saint-Paul-de-Vence, France, summer.

The Cubist Epoch, Los Angeles County Museum of Art, December 15–February 21, 1971, and tour.

1971

Kubisme, Tekeningen en prenten vit het Kupferstichkabinett, Basel, Stedelijk Museum, Amsterdam, April 17–May 31.

1972

Look Back: An Exhibition of Cubist Paintings and Sculptures from the Menil Family Collection, Museum of New Mexico, Santa Fe, and tour.

1973

Les Cubistes, Galerie des Beaux-Arts, Bordeaux, France, May 4–September 1, and tour.

1974

Jean Paulhan à travers ses peintres, Galeries Nationales du Grand Palais, Paris, February 1–April 15.

1975

Picasso, Braque, Léger: Masterpieces from Swiss Collections, Minneapolis Institute of Arts, October 30–January 4, 1976, and tour.

1978

Aspects of Twentieth-Century Art, National Gallery of Art, Washington, D.C., June 1–September 4.

1979

Zeichnungen und Collagen des Kubismus: Picasso, Braque, Gris, Kunsthalle, Bielefeld, West Germany, March 11–April 29.

1980

Apollinaire et l'avanguardia, Villa Giula, Galleria Nazionale d'Arte Moderna, November 30–January 4, 1981.

1983

The Essential Cubism: Braque, Picasso, and Their Friends (1907–1920), Tate Gallery, London, April 27–July 10.

1984

"Primitivism" in Twentieth-Century Art: Affinity of the Tribal and the Modern, Museum of Modern Art, New York, September 19–January 15, 1985.

1987

Douglas Cooper und die Meister des Kubismus = Douglas Cooper and the Masters of Cubism, Kunstmuseum, Basel, Switzerland, November 22–January 17, 1988.

1989

Picasso and Braque: Pioneering Cubism, Museum of Modern Art, New York, September 24–January 16, 1990.

1990

The Fauve Landscape, Los Angeles County Museum of Art, October 4–December 30, 1990, and tour.

100. *Bread, Oysters, and Carafe,* 1937
Oil on canvas, 21¼ x 25⅝ in. (54 x 65 cm)
Hamburger Kunsthalle, Hamburg, Germany

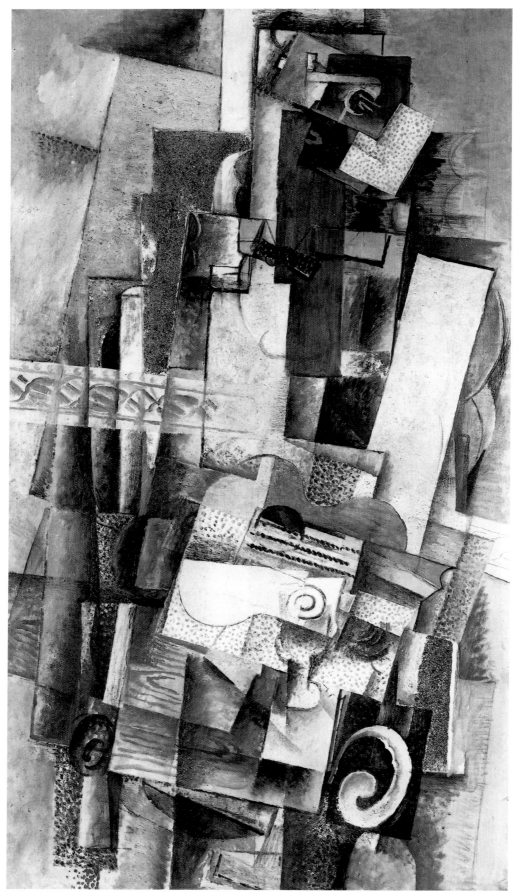

Public Collections

Basel, Switzerland, Kunstmuseum
Bergen, Norway, Bergen Billedgalleri
Berlin, Germany, Nationalgalerie
Bern, Switzerland, Kunstmuseum
Cambridge, England, King's College
Cambridge, Massachusetts, Fogg Art Museum, Harvard University Art Museums
Caracas, Venezuela, Museo de Arte Contemporáneo
Chicago, Illinois, Art Institute of Chicago
Cleveland, Ohio, Cleveland Museum of Art
Cologne, Germany, Museum Ludwig
Cologne, Germany, Walraf-Richartz Museum
Columbus, Ohio, Columbus Museum of Art
Copenhagen, Denmark, Statens Museum for Kunst
Düsseldorf, Germany, Kunstsammlung Nordrhein-Westfalen
Edinburgh, Scotland, Scottish National Gallery of Modern Art
Eindhoven, Holland, Stedelijk van Abbemuseum
Essen, Germany, Museum Folkwang
Fort Worth, Texas, Kimbell Art Museum
Hamburg, Germany, Kunsthalle
Hanover, Germany, Kunstmuseum Hannover mit Sammlung Sprengel
Houston, Texas, Museum of Fine Arts
Le Havre, France, Musée des Beaux-Arts André Malraux
London, England, Tate Gallery
Los Angeles, California, Los Angeles County Museum of Art
Lyon, France, Musée des Beaux-Arts
Milwaukee, Wisconsin, Milwaukee Art Center
Minneapolis, Minnesota, Minneapolis Institute of Arts
Moscow, USSR, Pushkin State Museum of Fine Arts
Munich, Germany, Bayerische Staatsgemäldesammlungen
New Haven, Connecticut, Yale University Art Gallery

New Orleans, Louisiana, New Orleans Museum of Art
New York, New York, Metropolitan Museum of Art
New York, New York, Museum of Modern Art
New York, New York, Solomon R. Guggenheim Museum
Norfolk, Virginia, Chrysler Museum
Ottawa, Canada, National Gallery of Canada
Otterlo, Netherlands, Rijksmuseum Kröller-Müller
Paris, France, Musée National d'Art Moderne, Centre Georges Pompidou
Paris, France, Musée d'Art Moderne de la Ville de Paris
Paris, France, Musée Picasso
Pasadena, California, Norton Simon Museum
Philadelphia, Pennsylvania, Philadelphia Museum of Art
Prague, Czechoslovakia, National Gallery
Saarbrücken, Germany, Saarland Museum
Saint Louis, Missouri, Saint Louis Art Museum
Saint-Tropez, France, Musée de l'Annonciade
San Francisco, California, San Francisco Museum of Modern Art
Stockholm, Sweden, Moderna Museet
Stuttgart, Germany, Staatsgalerie Stuttgart
Troyes, France, Musée d'Art Moderne
Ulm, Germany, Ulmer Museum
Villeneuve-d'Ascq, France, Musée d'Art Moderne
Washington, D.C., National Gallery of Art
Washington, D.C., Phillips Collection
West Palm Beach, Florida, Norton Gallery and School of Art
Winterthur, Switzerland, Kunstmuseum
Worcester, Massachusetts, Worcester Art Museum
Wuppertal, Germany, Von der Heydt-Museum
Zurich, Switzerland, Foundation E. G. Bührle Collection
Zurich, Switzerland, Kunsthaus

101. *Man with a Guitar*, 1914
Oil and sand on canvas,
51⅛ x 28¾ in. (129.8 x 73 cm)
Musée National d'Art Moderne, Centre Georges Pompidou, Paris

Selected Bibliography

Statements, Writings, and Interviews

Braque, Georges. "Pensées et réflexions sur la peinture." *Nord-Sud* 10 (December 1917): 3–5.

_____. "Réponses à une enquête: A propos de l'art et le public." *Les Lettres françaises*, March 15, 1946.

_____. *Cahiers de Georges Braque, 1917–1947*. Paris: Maeght, 1948. Reprint ed., with supplement, 1947–55. Paris: Maeght, 1956.

_____. "Sens de l'art moderne." *Zodiaque*, no. 18–19 (Cahiers de l'atelier du Coeur-Meurtry, Atelier Monastique de Sainte Marie de la Pierre-qui-Vire, Yonne, France) (January 1954): 11–17.

_____. "Gedanken zur Kunst." *Das Kunstwerk* 13 (March 1960): 15–16.

_____. "Entretien: Pierre Reverdy et Georges Braque, le 10 fevrier 1958." *Derrière le miroir*, nos. 144–46 (May 1964): 74–76.

_____. *Illustrated Notebooks, 1917–1955*. New York: Dover, 1971.

Diehl, Gaston. "L'Univers pictural et son destin, une conversation avec Georges Braque." In *Les Problèmes de la peinture*, pp. 307–9. Paris: Editions Confluences, 1945.

Jedlicka, Gotthard. "Begegnung mit Georges Braque." In *Begegnungen: Künstlernovellen*, pp. 127–52. Basel, Switzerland: Benno Schwabe, 1933.

Lassaigne, Jacques. "Un entretien avec Georges Braque [1961]." *XXᵉ Siècle*, December 1973, p. 4.

Tériade, E. "Confidences d'artistes: Georges Braque." *L'Intransigeant*, April 3, 1928. Reprinted in *Montparnasse*, no. 51 (May–June 1928): 1–2.

_____. "Emancipation de la peinture." *Le Minotaure*, nos. 3–4 (1933): 9–20.

_____. "Propos de Georges Braque." *Verve* 7 (December 1952): 71–82.

Vallier, Dora. "Braque, la peinture et nous." *Cahiers d'art* 29 (October 1954): 13–24. Interview.

Verdet, André. *Entretiens, notes et écrits sur la peinture: Braque, Léger, Matisse, Picasso*. Paris: Editions Galilée, 1978.

Monographs and Solo-Exhibition Catalogs

L'Atelier de Braque. Preface by Jean Cassou. Paris: Editions des Musées Nationaux, 1961.

Benincasa, Carmine. *Georges Braque: Opere 1900–1963*. Venice: Marsilio, 1982.

Bissière, Roger. *Georges Braque: Vingt Tableaux*. Paris: Editions de l'Effort Moderne, 1920.

Brion, Marcel. *Georges Braque*. Reprint. New York: Harry N. Abrams, 1976.

Brunet, Christian. *Braque et l'espace, langage et peinture*. Paris: Klincksieck, 1971.

Cafritz, Robert C. *Georges Braque*. Washington, D.C.: Phillips Collection, 1982.

Cassou, Jean. *Georges Braque*. New York: Harry N. Abrams, 1957.

Chipp, Herschel B. *Georges Braque: The Late Paintings, 1940–1963*. Washington, D.C.: Phillips Collection, 1982.

Cogniat, Raymond. *Georges Braque*. Translated by I. Mark Paris. New York: Harry N. Abrams, 1980.

Cooper, Douglas. *Georges Braque: Paintings, 1909–1947*. London: Lindsay Drummond, 1948.

———. "Georges Braque: The Evolution of a Vision." In *Georges Braque: An Exhibition of Paintings*. London: Arts Council of Great Britain, 1956.

———. Introduction in *Georges Braque*. Munich, West Germany: Haus der Kunst, 1963.

———. *Braque: The Great Years*. Chicago: Art Institute of Chicago, 1972.

Damase, Jacques. *Georges Braque*. Translated by Tony White. New York: Barnes and Noble, 1967.

Einstein, Carl. *Georges Braque*. Paris: Editions des Chroniques du Jour, 1934.

Elgar, Frank. *Braque, 1906–1920*. New York: Tudor, 1958.

Fauchereau, Serge. *Braque*. New York: Rizzoli, 1987.

Fortunescu, Irina, and Dan Grigorescu. *Braque*. Bucharest, Romania: Editura Meridiana, 1977.

Fumet, Stanislas. *Braque*. New York: Tudor, 1946.

———. *Sculptures de Braque*. Paris: Jacques Damase, 1951.

———. *Georges Braque*. Paris: Maeght, 1965. *G. Braque*. Basel, Switzerland: Editions Beyeler, 1968.

G. Braque et la mythologie. Paris: Galerie Louise Leiris, 1982.

Gallatin, Albert E. *Georges Braque: Essay and Bibliography*. New York: George Wittenborn, 1943.

Gieure, Maurice. *G. Braque*. New York: Universe, 1956.

———. *Georges Braque: Dessins*. Paris: Editions des Deux Mondes, 1956.

Golding, John. *Georges Braque: Still Lifes and Interiors*. London: South Bank Centre, 1990.

Grenier, Jean. *Braque: Peintures, 1909–1947*. Paris: Les Editions du Chêne, 1948. English edition, with text by Douglas Cooper, London: Lindsay Drummond, 1948.

Grohmann, Will, and Antoine Tudal. *The Intimate Sketchbooks of Georges Braque*. With an appreciation by Rebecca West. New York: Harcourt Brace, 1955.

Heron, Patrick. *Braque*. London: Faber and Faber, 1958.

Hofmann, Werner. *Georges Braque: His Graphic Work*. New York: Harry N. Abrams, 1961.

Hope, Henry R. *Georges Braque*. New York: Museum of Modern Art; Cleveland: Cleveland Museum of Art, 1949.

Isarlov, George. *Georges Braque*. Paris: Jose Cortí, 1932.

Laufer, Fritz. *G. Braque*. Bern: Alfred Scherz Verlag, 1954.

Lejard, André. *Georges Braque*. Paris: Fernand Hazan, 1949.

Leymarie, Jean, ed. *Georges Braque*. With essays by Jean Leymarie, Magdalena M. Moeller, and Carla Schulz-Hoffmann. New York: Solomon R. Guggenheim Museum; Munich, West Germany: Prestel-Verlag, 1988.

Martin, Alvin. "Georges Braque: Formation and Transition, 1900–1909." Ph.D. diss., Harvard University, 1979.

Martin-Mery, Gilberte, et al. *Georges Braque en Europe: Centenaire de la naissance de Georges Braque (1882–1963)*. Bordeaux, France: Galerie des Beaux-Arts, 1982.

Masini, Lara Vinca. *Georges Braque*. Florence: Sadea Sansoni, 1969.

Monod-Fontaine, Isabelle, with E. A. Carmean, Jr. *Braque: The Papiers Collés*. Washington, D.C.: National Gallery of Art, 1982.

Mourlot, Fernand, and Francis Ponge. *Braque: Lithographe*. Monte Carlo: Sauret, 1963.

Mullins, Edwin. *The Art of Georges Braque*. New York: Harry N. Abrams, 1968.

Paulhan, Jean. *Braque, le patron*. Geneva and Paris: Trois Collines, 1946.

Ponge, Francis. *Braque, le reconciliateur*. Geneva: Albert Skira, 1946.

———. *Braque: Dessins*. Paris: Braun, 1950.

———, Pierre Descargues, and André Malraux. *G. Braque*. Translated by Richard Howard. New York: Harry N. Abrams, 1971.

Pouillon, Nadine. *Braque*. Paris: Nouvelles Editions Françaises, 1970.

——— and Monod-Fontaine, Isabelle. *Braque: Oeuvres de Georges Braque (1882–1963)*.

Paris: Musée National d'Art Moderne, Centre Georges Pompidou, 1982.

Raphael, Max. *Raumgestaltungen: Der Beginn der modernen Kunst im Kubismus und im Werk von Georges Braque*. New York: Edition Qumran im Campus Verlag, 1986.

Raynal, Maurice. *Georges Braque*. 2d ed. Rome: Editions de "Valori Plastici," 1924. Reprint of 1921 text with different plates.

Reverdy, Pierre. *Georges Braque: Une Aventure méthodique*. Paris: Mourlot, 1950.

Richardson, John. *Georges Braque*. Greenwich, Conn.: New York Graphic Society, 1961.

Richet, Michele, and Nadine Pouillon. *Georges Braque*. Paris: Ministère des Affaires Culturelles, Editions des Musées Nationaux, 1973.

Romilly, Nicole Worms de. *Catalogue de l'oeuvre de Georges Braque: 1907–1957*. 7 vols. Paris: Maeght, 1959–82.

Russell, John. *G. Braque*. London: Phaidon, 1959.

Seuphor, Michel. *L'Oeuvre graphique de Braque*. Paris: Berggruen, 1953.

Vallier, Dora. *Georges Braque, 10 Oeuvres*. Basel, Switzerland: Editions Phoebus, 1962.

———. *Braque: L'Oeuvre gravé—Catalogue raisonné*. Paris: Flammarion, 1982.

Valsecchi, Marco, and Massimo Carrà. *L'Opera completa di Braque dalla scomposizione cubista al recupero dell'ogetto, 1908–1929*. Milan: Rizzoli, 1971. French edition, with preface by Pierre Descargues, Paris: Flammarion, 1973.

Verdet, André. *Georges Braque*. Geneva: René Kister, 1956.

———. *Braque, le solitaire*. Paris: Fernand Hazan, 1959.

Zervos, Christian. *Braque: Nouvelles Sculptures et plaques gravées*. Paris: Albert Morancé, 1960.

Zurcher, Bernard. *Georges Braque: Life and Work*. Translated by Simon Nye. New York: Rizzoli International, 1988. Contains the most extensive bibliography to date, including a list of films on Braque.

Periodicals, Books, and Group-Exhibition Catalogs

Adrian, Dennis. "Georges Braque's Monumental Still-Lifes." *Artnews* 71 (November 1972): 30–33.

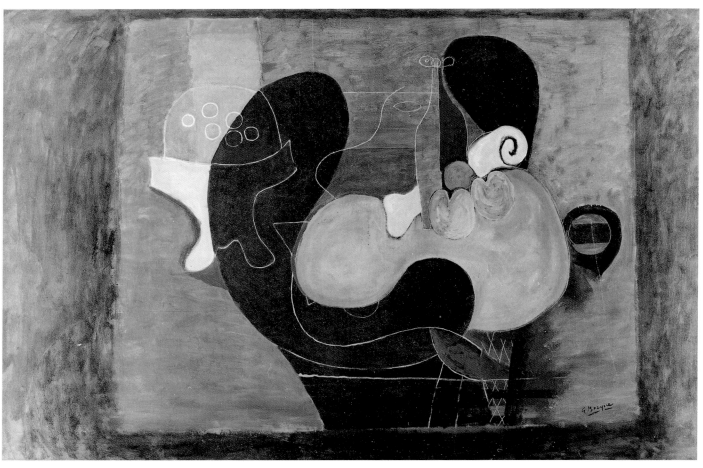

102

Apollinaire, Guillaume. *The Cubist Painters.* 1913; New York: Wittenborn, Schultz, 1949.

Barr, Alfred H., Jr., *Cubism and Abstract Art.* Reprint. New York: Arno, 1966.

Bazin, G. "Sur l'espace en peinture: La Vision de Braque." *Journal de psychologie normale et pathologique* 45 (October–December 1952): 439–48.

Cahiers d'art 8, nos. 1–2 (1933). Special issue devoted to Braque in commemoration of his retrospective exhibition at the Kunsthalle, Basel.

Char, René. "Peintures de Georges Braque." *Cahiers d'art* 26 (1951): 141–55.

Chastel, A. "Braque et Picasso: 1912. La Solitude et l'échange." In *Pour Daniel-Henry Kahnweiler,* pp. 80–86. Edited by Werner Spies. Stuttgart, West Germany: Gerd Hatje, 1965.

Chevalier, Denys. "Georges Braque." *Aujourd'hui art et architecture* 34 (December 1961): 4–12.

Cooper, Douglas. "G. Braque." *Town and Country* 103 (March 1949): 43, 92, 95–96, 99.

———. "Georges Braque." *L'Oeil,* no. 107 (November 1963): [26–33].

———. *The Cubist Epoch.* Reprint. New York: E. P. Dutton, 1976.

———, and Gary Tinterow. *The Essential Cubism: Braque, Picasso and Their Friends, 1907–1920.* London: Tate Gallery, 1983.

Derrière le miroir, nos. 144–46 (March–May 1964). Special issue devoted to Braque.

Fauchereau, Serge. *La Revolution cubiste.* Paris: Denoël, 1982.

Flanner, Janet. "Profiles: Master (Georges Braque)." *New Yorker,* October 6 and October 13, 1956. Reprinted in Flanner, *Men and Monuments* (New York: Harper, 1957).

Fry, Edward. *Cubism.* New York: McGraw-Hill, 1966.

Gleizes, Albert, and Jean Metzinger. *Du Cubisme.* 5th ed. Paris: Figuière, 1912.

Golding, John. *Cubism: A History and an Analysis, 1907–1914.* 3d ed. Cambridge, Mass.

Harvard University Press, 1988.

Greenberg, Clement. "The Pasted-Paper Revolution." *Artnews* 57 (September 1958): 46–49, 60–61.

———. "Braque." In *Art and Culture: Critical Essays,* pp. 87–90. Boston: Beacon, 1961.

Hubert, Etienne-Alain. "Georges Braque selon Guillaume Apollinaire." In *Mélanges à Michel Décaudin: L'Esprit nouveau dans tous ses états, en hommage à Michel Décaudin.* Paris: Librairie Minard, 1986.

Judkins, Winthrop. *Fluctuant Representation in Synthetic Cubism: Picasso, Braque, Gris, 1910–1920.* New York: Garland, 1976.

Kahnweiler, Daniel-Henry. *The Rise of Cubism.* Translated by Henry Aronson. 1920; New York: Wittenborn, Schulz, 1969.

———. *Les Années Héroïques du cubisme.* Paris: Editions Braun et Cie, 1950.

——— with Francis Crémieux. *My Galleries and Painters.* Translated by Helen Weaver. New York: Viking, 1971.

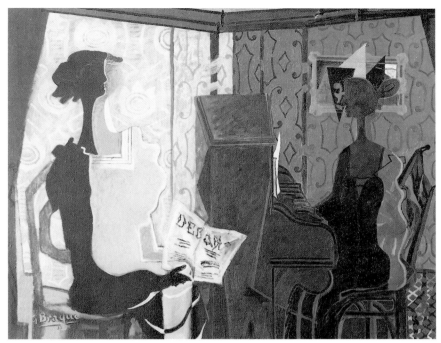

103

Kim, Youngna. *The Early Works of Georges Braque, Raoul Dufy and Othon Friesz: The Le Havre Group of Fauvist Painters.* Ann Arbor, Mich.: UMI Research Press, 1986.

Kosinski, Dorothy M. *Douglas Cooper und die Meister des Kubismus = Douglas Cooper and the Masters of Cubism.* With a contribution by John Richardson. Basel, Switzerland: Kunstmuseum; London: Tate Gallery, 1987.

Kramer, Hilton. "Cubism's Conservative Rebel." *New York Times Magazine,* May 20, 1962, pp. 28, 97–99.

Marcus, Susan. "The Typographic Element in Cubism, 1911–1915: Its Formal and Semantic Implications." *Art International* 17 (May 1973): 24–27.

Metzinger, Jean. "Note sur la peinture." *Pan* (October–November 1910): 649–652.

Mosele, Franz. *Die kubistische Bildsprache von Georges Braque, Pablo Picasso und Juan Gris unter besonderer Berucksichtigung der Farbe.*

102. *Large Brown Still Life: Le Comptoir,* 1932
Oil on canvas, 51 9/16 x 74 13/16 in. (131 x 190 cm)
Musée National d'Art Moderne, Centre Georges Pompidou, Paris

103. *The Duo,* 1937
Oil on canvas, 51 5/8 x 64 in. (131 x 162.5 cm)
Musée National d'Art Moderne, Centre Georges Pompidou, Paris

Zurich: Juris-Verlag, 1973.

Paulhan, Jean. *La Peinture cubiste.* Paris: Denöel-Gonthier, 1971.

Richardson, John. "The Ateliers of Braque." *Burlington Magazine* 97 (June 1955): 164–70.

———. "Braque." *Realities* (American ed.) 93 (August 1958): 24–31.

———. "Braque: Pre-cube to post-Zen." *Artnews* 63 (April 1964): 29–31, 54.

Rosenblum, Robert. *Cubism and Twentieth-Century Art.* Rev. ed. New York: Harry N. Abrams, 1982.

Roskill, Mark W. *The Interpretation of Cubism.* Philadelphia: Art Alliance, 1985.

Rubin, William. "Cézannisme and the Beginnings of Cubism." In *Cézanne: The Late Work.* Edited by William Rubin. New York: Museum of Modern Art, 1977.

———. "Pablo and Georges and Leo and Bill." *Art in America* 67 (March–April 1979): 128–47.

———. *Picasso and Braque: Pioneering Cubism.* New York: Museum of Modern Art, 1989.

———, ed. *"Primitivism" in Twentieth-Century Art: Affinity of the Tribal and the Modern.* 2 vols. New York: Museum of Modern Art, 1984.

Tériade, E. "Les Dessins de Georges Braque." *Cahiers d'art* 2, nos. 4–5 (1927): 141–45.

———. "L'Épanouissement de l'oeuvre de Braque." *Cahiers d'art* 3, no. 10 (1928): [409–17].

Verdet, André. "Braque, le solitaire." *XXe Siècle* 20, no. 11 (December 1958): [9–17].

———. "Le Sentiment du sacre dans l'oeuvre de Braque." *XXe Siècle* 24, no. 20 (December 1962): [17–23].

Waldemar, George. "Georges Braque." *L'Esprit nouveau,* no. 6 (1921): 639–56.

Weisner, Ulrich. *Zeichnungen und Collagen des Kubismus: Picasso, Braque, Gris.* Bielefeld, West Germany: Kunsthalle, 1979.

Wilkin, Karen. "Georges Braque at the Guggenheim." *New Criterion,* October 1988, pp. 52–58.

———. "O pioneers! Picasso and Braque, 1907–1914." *New Criterion,* December 1989, pp. 29–35.

Zervos, Christian. "Georges Braque et la peinture française." *Cahiers d'art* 2, no. 1 (1927): 5–[16].

———. "Le Classicisme de Braque." *Cahiers d'art* 6, no. 1 (1931): 35–[40].

———. "Georges Braque et le développement du cubisme." *Cahiers d'art* 7, nos. 1–2 (1932): 13–[27].

———. "Braque et la grèce primitive." *Cahiers d'art* 15, nos. 1–2 (1940): 3–[13].

INDEX

Photography Credits

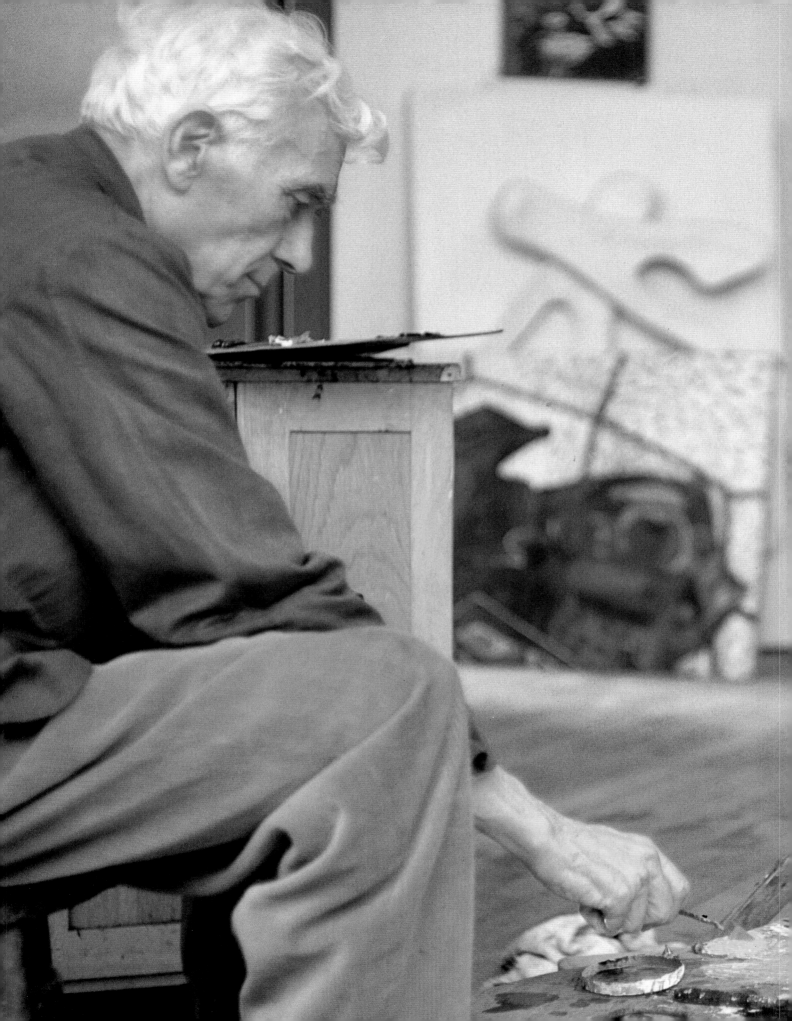